The
EVERYTHING®
Drawing Book

Dear Reader:

Want to learn how to draw? Great! This book is for you, whether you are just starting out or if you're simply returning to a long forgotten love of art. If you only know how to draw stick figures, don't worry—just start at the very beginning of the book, take it a step at a time, and you'll be drawing like a pro in no time.

Perhaps you would like to learn to draw but think you can't? I've met a lot of people who think art is all about talent. Unfortunately, this view stops many people from even thinking about trying. The truth is, drawing is a learned skill, and working through this book will enable you to draw a good likeness of any subject. Along the way, you'll look at some creative methods of exploring ideas and feelings by drawing.

I'm really excited about this opportunity to share my love of drawing with you. Remember, it's only paper and pencil, so relax and have fun.

Happy drawing!

Helen South

The EVERYTHING® Series

Editorial

Publishing Director	Gary M. Krebs
Managing Editor	Kate McBride
Copy Chief	Laura M. Daly
Acquisitions Editor	Bethany Brown
Development Editor	Courtney Nolan
Production Editor	Jamie Wielgus

Production

Production Director	Susan Beale
Production Manager	Michelle Roy Kelly
Series Designers	Daria Perreault
	Colleen Cunningham
	John Paulhus
Cover Design	Paul Beatrice
	Matt LeBlanc
Layout and Graphics	Colleen Cunningham
	Rachael Eiben
	Michelle Roy Kelly
	John Paulhus
	Daria Perreault
	Erin Ring
Series Cover Artist	Barry Littmann
Interior Illustrator	Helen South

Visit the entire Everything® Series at *www.everything.com*

THE
EVERYTHING®
DRAWING
BOOK

From basic shapes to people
and animals, step-by-step
instructions to get you started

Helen South

Adams Media
Avon, Massachusetts

To Daryl, my beloved, and our children, Alexandra and Thomas.

An Everything® Series Book.
Everything® and everything.com® are registered trademarks of F+W Publications, Inc.

Published by Adams Media, an F+W Publications Company
57 Littlefield Street, Avon, MA 02322 U.S.A.
www.adamsmedia.com

ISBN: 1-59337-213-2

Printed in the United States of America.

J I H G F E D C B A

Library of Congress Cataloging-in-Publication Data
South, Helen.
The everything drawing book / Helen South.
p. cm.
(An everything series book)
ISBN 1-59337-213-2
1. Drawing—Technique. I. Title. II. Series: Everything series.

NC730.S668 2004
741.2--dc22

2004019140

This book is available at quantity discounts for bulk purchases.
For information, please call 1-800-872-5627.

Contents

Acknowledgments

Thank you to everyone who has contributed in any way to the creation of this book for your support, advice, and help. Many artists have generously shared their wisdom and expertise with me. A special thanks to my colleagues at About.com—the forum members and those who have kindly contributed reference photographs.

Thanks also to my agent Barb Doyen, and my editor at Adams, Courtney Nolan.

I am indebted to all my past teachers for their commitment and inspiration, especially Sybil Small and Peter Jacobs, and to my students and art group members, from whom I learn as much as I teach. And of course, thank you to my parents Jim and Helen, and my sister Elaine, for their lifelong love and support.

Top Ten Ways to
Unleash Your Drawing Talent

1. Train your eye, mind, and hand by drawing the people and things around you.
2. Draw with energy and confidence.
3. Learn to draw realistically—and it will empower you to draw creatively.
4. Keep an open mind and try using your materials in different ways.
5. Learn from other artists, visit galleries, and learn all you can about art history.
6. There are no rules in drawing—the choice of materials and techniques is up to you.
7. Don't be discouraged by thoughtless criticism or differing taste.
8. Value constructive suggestions that can help you improve.
9. Regular practice is a sure-fire way to improve your drawing ability.
10. Remember that drawing is a learned skill, not a natural talent.

Introduction

▶ You'll note that the demonstrations in this book are step-by-step rather than "line-by-line." That type of drawing book gives you a repertoire of subjects you can copy, but often does little to help you draw anything different. This book aims to give you the guidance and explanation of beginner techniques you need so that you can draw whatever you want.

A cookbook might give you quick results for an immediate dinner, but a course in cooking will give you the knowledge to create your own dishes from whatever you have available.

Don't be afraid of copying, whether it is other artists' work, photographs, or from life. Depending on the exercise, copying allows you to concentrate on making accurate lines or achieving correct values. This helps develop your hand-eye coordination and will not squash your creativity. On the contrary, building solid, basic techniques in traditional drawing will give you the freedom to express yourself in any way you choose. Traditionally, apprentice and student artists have spent long hours copying from plaster casts and making studies of figures and drapery, and this traditional training has produced some of our greatest modern artists. Even though observational drawing can seem frustrating at times, and perhaps boring if you prefer imaginative work, it is the best way to improve your skills.

First Things First

When most people start a new hobby, they get very enthusiastic and try to do too much too soon. Who hasn't nearly crippled themselves on their first day at the gym, or tied their fingers in knots trying to play a difficult song after their first guitar lesson? Don't let your enthusiasm lead to frustration. If you take your time and master the basics, you'll find it much easier to tackle complex subjects with confidence. Drawing is a combination of skills: observing, remembering, and recording an image, and then applying compositional principles and creative energy to that image. Even if you have done some drawing before, doing simple exercises can refine your skills, allowing you to focus fully on each component of the drawing process.

Practice Makes Picture Perfect

Practice does make perfect, and nothing will improve your drawing like consistent practice. Create a routine for yourself and complete each lesson thoroughly. Ideally,

you should draw a little every day, but if you can manage a couple of sessions a week, then you will make good progress. If you've always thought of yourself as talent-less, you might be in for a surprise. Think of how many automatic skills you have that you had to be taught: driving a car, cooking, writing. We engage in these activities with-out thinking, but we were once taught step-by-step how to do them. In just the same way, drawing can become effortless, allowing you to focus on expressing your unique creativity.

Once you've got a toolbox of techniques at your disposal, your natural talents will have a chance to shine!

Chapter 1

Drawing Tools and Materials

An art store holds an abundance of creative goodies, selling everything from the finest artist's materials to the cheapest products available. This chapter will give you the information you need to make the wisest choices and the most economical purchases. Most of the materials you need to complete drawings in this book are relatively inexpensive. You can get started with whatever pencil and paper you have, though you will eventually want to get some artist's pencils, pen and ink, and charcoal, all of which are quite affordable. Most artists love experimenting, but start off with the basics and get to know them well before you start collecting a variety of products.

Paper

Most of the drawings in this book can be created on cheap office paper or sketch paper, but for permanent artworks, you will want a better quality paper. It might seem strange to spend good money on something as simple as paper; usually it seems plentiful and cheap. As the "foundation" upon which your artwork is created, the quality of paper can greatly influence the quality of your finished piece. You might also want to use a range of paper textures for different effects. A good-quality, acid-free paper will last well for many years, while most cheap papers become yellow and brittle after time.

Paper Pulps

Paper is made from a plant fiber called *cellulose*, with most paper—such as newsprint, office paper, and books—being made from wood pulp. Wood pulp paper contains the chemical *lignin*, which naturally occurs in the timber. Lignin causes the paper to darken upon exposure to air and sunlight and becomes acidic over time, weakening the paper. The acid in the pulp can be neutralized with calcium carbonate, (a process called *buffering*), but the effectiveness of this treatment diminishes as the paper ages.

Alpha cellulose papers are made from a very pure wood pulp and are considered stable. One hundred percent cotton paper is made from cotton linter, the short, leftover fibers from cotton ginning. The best paper is made from cotton rags. The fibers from textile manufacturers are long and strong; therefore, they yield a paper with superior strength and stability.

Paper is "sized" with gelatin or starch mixed into the pulp, which gives strength and helps protect the fibers from oxidization. Watercolor paper is also surface-sized, so that the paint tends to sit on the surface rather than sink into the paper.

There are advantages and disadvantages to every type of paper, and different media will have varying effects on different papers. Some expensive papers are designed for printmaking, so they are too soft and fibrous for drawing. Others, such as some heavily-sized watercolor papers, may have a slippery surface that seems to reject ink. The most effective way to learn about paper is through trial and error, by buying loose sheets of various types and experimenting with them. In this way, you will discover which paper suits your way of working.

Alert

Don't get hung up on finding the perfect paper or the right pencil. Great drawings can be produced with any old number 1 pencil and sketch paper. Good art materials offer consistent results, long-term preservation, and occasionally open up creative possibilities, but real drawing ability only comes from learning different techniques and practicing them.

Sketching Paper

Rough-sketching and line-drawing exercises can be done on any type of paper. Size A4 office paper is a perfect choice—just be sure to choose a paper made from a renewable, local resource, not a tropical rainforest! Many of the drawings in this book, even the ink and wash, have been done on a good brand of photocopier paper. You will also want a larger-sized paper for big sketches, roughly A3 and A2 sizes. Choose any inexpensive, large sketch paper such as newsprint, MG litho, cartridge paper, or a large sketchpad. The purpose of this paper is for large, quick sketches, so you need to be able to use it without worrying about cost. While the lifespan of this paper can be limited, it will remain intact for many years, especially if stored away from sunlight. You can photograph or scan your work for a permanent record.

Drawing Paper

For detailed value drawings or anything that you will spend long periods of time working on, you will want to invest in a good-quality paper. For pencil drawing, you need paper with a bit of "tooth"—enough to hold the particles of graphite from your pencil, but smooth enough to release them when erasing or blending. The surface must be tough enough that it won't disintegrate under repeated working. The best tooth is naturally provided by the fibers in the paper; it should feel faintly rough or velvety to the touch. Lightweight hot-pressed (smooth) watercolor paper is reasonably priced and suitable for pencil and ink work. Hot-pressed illustration board, or Bristol board, is popular with many artists and has a wear-and-tear surface, that tolerates erasing well and is available in varying weights. Its smooth surface is ideal for subtle pencil shading, especially in portraiture, where a flawless texture is important.

Pen-and-Ink Paper

Watercolor paper is available in hot-pressed (think "ironed"), which has a smooth surface; medium; and cold-pressed paper, which has a rough texture. I use a lightweight (185 gsm), smooth watercolor paper for pen and ink, and a medium-weight paper if I'm going to be adding a wash. When using washes, tiny puddles settle in the texture of the paper, so a smooth surface will give a smooth finish, while a rough surface can have a pleasing mottled effect, adding interest to simple sketches but not really suitable for detailed work.

Charcoal Drawing Paper

Charcoal can be used on regular sketch paper, though the surface tends to be resistant to erasing and blending, as the coarse, rough particles of charcoal catch on the large fibers. Surprisingly, the best paper is cheap, slightly shiny newsprint, with the short fibers of the wood pulp holding the particle well, but the smooth,

rolled surface allowing for excellent blending and erasing. Regrettably, newsprint is highly acidic and deteriorates quickly, so it can't really be recommended for serious art-works.

Most pastel papers have a pronounced tooth, which is mechanically impressed on the paper; some have a meshlike pattern; others have a "laid" pattern, created by the vertical arrangement of wires in the paper mold. Velour papers are brushed to create a velvety texture, and some pastel papers have fibers added to the surface. Highly textured pastel papers are designed to take multiple layers of chalky pigment and are not really suitable for charcoal drawing, as it is difficult to manipulate the charcoal once it is applied.

Sketchbooks

Sketchbooks with a spiral binding are useful as they allow you to lay them flat, as well as remove pages without spoiling the book. Hardbound book-style bindings look attractive, are durable, and sit well on the bookshelf. A standard left-bound book format is popular, though some people like the notebook-style top binding that does not get in the way and is useful for lefthanders. An A5 sketchbook is good for travel, though an A4 has a much more practical page size while not being overly large.

Pencils

Graphite pencils (sometimes called lead or gray lead pencils) are made from a mixture of clay and powdered graphite that is extruded into sticks, fired, and encased in timber (usually cedar). A well-established grading system has been developed, with pencils numbered according to how hard (H) or soft (B) they are. They range from very soft, 9B; to B; to HB, which is roughly in the middle; to H; to very hard, 9H. The harder grades are generally used in technical drawing. The most useful pencils for drawing are from 4B to H, with 2H sometimes used for fine work.

Each grade slightly overlaps the other, so throughout the book, whenever a particular pencil is recommended, you may need to go up or down one grade depending on your natural strength of line (i.e., rather than a 2B, you may prefer a B or a 3B) and what you have available. You can start drawing with any pencils that you have handy, with a standard "number 1" (equivalent to B) being an appropriate choice. A "number 2," or HB, is the grade most people use for writing, and is a bit hard for line drawing.

At some point you will want to get some good-quality artist's drawing pencils. Cheap pencils may have impurities or imperfections, lumps of clay that can scratch your paper, or unexpected patches of soft graphite that can leave dark streaks; they will not sharpen well, may break more easily, and could produce unreliable tonal values. When selecting loose-stock pencils, check both ends to see that the core is centered.

The good news is that good pencils don't cost much anyway, and for the exercises in this book, you will only need four: H, B, 2B, and 4B. Add a 6B if you can. Later on, you might like to add to this selection, as you will find that your personal style of drawing might call for something different. Alternatively, you might decide to go right for a varied complete set of pencils in a tin or in a box.

Essential

Unless your pencils are all organized in a box or tin, you can often find yourself hunting for the right grade of pencil in your kit or on the table. Solve this problem by putting white paint or tape on the ends and writing the grade number all the way around. You could also color-code them with light to dark shades of paint, or dip more or less of the pencil body in paint depending on the grade.

As a beginner, basic artist's drawing pencils (the standard timber-cased variety, or clutch pencils) are probably the best to start with. Many artists recommend using clutch pencils with 2mm leads, due to their constant balance, size, and weight. Though more expensive to purchase initially, they are quite economical, as you simply replace the lead rather than constantly sharpening down a timber-cased pencil. If you choose this option, purchase a holder and core (lead) for each grade you wish to use.

There is a range of other variations now available on the pencil theme, which can be fun to experiment with. These include:

- *Woodless pencils*—pencils with cores as thick as a regular pencil, coated to keep your hands clean. These are useful for energetic, large pieces.
- *Graphite sticks*—thick, chunky pencils shaped like large crayons. These are great for large expressive works, but can be very messy to use.
- *Water-soluble pencils*—versatile pencils for straight drawing and wash effects. However, they do smudge easily with any stray moisture.

Charcoal

Charcoal is a popular medium, with its rich matte blacks and grays offering dramatic expressive possibilities. Charcoal particles have a naturally rough surface that reflect light irregularly, giving the medium its characteristic velvety quality. Charcoal is available in various forms. For the exercises in this book, a couple of sticks of thin willow charcoal, a good piece of vine charcoal, and a medium-compressed charcoal stick or pencil will be all you need. You can add to these later on if you enjoy using this medium.

Willow Charcoal

Willow charcoal produces a beautiful, velvety gray-black color, smudges with just a touch of the finger, and erases perfectly. It is essential to use spray fixative to protect willow charcoal drawings, as this type of charcoal virtually falls off the page.

Compressed or Stick Charcoal

Compressed charcoal is powdered charcoal mixed with binders and pressed into regular-sized sticks or bars. It is available in grades—usually soft, medium, and hard. Sometimes it is given 2b, 4b, and 6b grading—though these tones bear little resemblance to the pencil weights of the same grades. Try several brands if you can, to see how they handle. Charcoal should have a dry, slightly abrasive feel on application, but it should deposit an even tone and not scratch the paper; such irregularities are a sign of an inferior product.

Charcoal Pencils

These handy drawing tools are compressed charcoal cores encased in timber. Clean to handle and easy to sharpen, these are versatile and convenient. Like compressed charcoal, the consistency can vary depending on the manufacturer. Some brands have a smoother, waxy texture, but these can be a little sticky and difficult to blend and erase. Though they cost a little more to buy than stick charcoal, ease of handling make these a good choice for beginners.

Ink Drawing

Drawing with ink offers many creative possibilities, and is an excellent way to develop confidence. Traditional Indian and Chinese inks, quills, and dip pens have been around for centuries, while manufacturers are now making an exciting range of archival inks for drafting pens and felt-tip pens. For the pen-and-ink exercises in this book, you will need a small bottle of Indian ink, a nib holder, and a fine drawing nib. If you don't have a dip pen and ink, you could also use a fiber-tip pen or even ballpoint and black watercolor for the washes, but it is well worth the effort to explore pen and ink for the beautiful quality of line that is unique to the medium.

Ink Pens

Basic drawing pens consist of a simple plastic pencil-shaped holder with a removable metal drawing nib. Art shops stock a variety of drawing nibs; choose a simple fine-pointed

steel drawing nib to start with. Don't be confused by the wide selection of calligraphy nibs, most of which are not suitable for drawing.

Get a few as spares, and if there is a range, choose a few different ones to experiment with. Some people are more heavy-handed than others and will need a stronger nib. Mapping pens have very fine, almost scratchy nibs, while Copperplate writing nibs are more flexible and give greater variation in line weight.

You can also draw with fountain pens and technical drawing pens, though these give a rather mechanical, less-expressive line.

Indian Ink

Indian Ink is made from soot mixed with ammonia and varnish (traditionally shellac). It has a bluish undertone and slight gloss. Indian ink is water-resistant when dry, which is useful if you wish to add watercolor washes to the drawing, or it may be thinned with distilled water for washes. Until recently, Indian ink has been unsuitable for fountain and drafting pens, as it clogged their fine capillary systems. However, manufacturers are now producing fine Indian inks specifically for these pens. Check the labels carefully and be sure to buy the correct (lightfast, permanent) ink for your pen type.

Chinese Ink

Chinese ink comes in a dry stick form that has to be rubbed on a stone with water to make the liquid ink. This ink is usually used with a brush. Winsor and Newton make a "Liquid Indian Ink," which is actually a Chinese ink made from ink sticks. It has a more watery consistency than regular ink and is not water-resistant. It is ideal for use in pen-and-wash drawings where a soft look is required.

Colored Ink

Most of the inks you'll see in art shops are nonpigmented inks made with chemical dyes. These are intended for illustrators and should be avoided for works of fine art, as they are not lightfast. If you wish to use colored ink, several major brands produce acrylic-based pigment inks; these are identified on the label as pigmented and lightfast. Watercolors can also be used to add color to an ink drawing, which is especially effective when subtle warm sepia tones or cool gray-blues are used. You might like to get a tube of burnt umber or Prussian blue watercolor paint for this. Many artists like to use tea or coffee to tint their washes or stain the paper, but it should be noted that these colorings are not lightfast, so they may change or fade over time.

Fiber-Tip Pens

A range of fiber-tip and brush-tip pigment pens are available, which are handy for sketching and journaling, and you'll see many examples in this book done with these pens. Try them in the shop to see which style and size of nib you like best. Choose an archival-quality pen—one that has lightfast ink, made for drawing or scrapbooking. Permanent pens (meaning simply that it won't wash off) sold for writing often contain ink made from unstable chemical dyes that will fade over time. That said, some artists create wonderful drawings using a plain old ballpoint pen and have the finished picture scanned and printed for an archival copy of the image.

Alert

Always try to keep artist-quality materials on hand. Over time, it's heartbreaking to watch the colors in that special sketch you made disappear before your eyes. If you do draw something with dubious materials, such as a ballpoint pen or newsprint paper, scan or photograph the picture so you have a permanent record of it.

Tools of the Trade

There are numerous tools you'll need in your drawing kit, many of which you'll already have hanging around your home. Some of these items, such as erasers and sharpeners, are essential, while others are nice to have or are extras. You'll probably want to get some type of bag (an army surplus shoulder bag is inexpensive and works well), or a box (a fishing tackle box is a good option) to hold your drawing kit, so that everything you need is at hand. If you have a large collection of materials, using a small portable storage unit or an empty set of shelves saves valuable table space when working.

Keep a sketching kit ready to go. A bag like this one from an army surplus store has handy pockets to organize supplies.

Erasers

You will need two erasers: a soft white plastic eraser (a good one will be less likely to drag fibers from your paper) and a kneadable putty eraser. The latter are sold in small squares, wrapped in plastic (don't confuse these with rough, hard gum erasers). Kneadable erasers can be squished to a point to erase small areas, and when the surface is dirtied, can be folded over for a clean surface. Abrasive ink erasers are also available, sometimes attached to a white eraser, but can be damaging to the paper and are of limited value. Household removable poster adhesive such as Blu-Tack is excellent for lifting off graphite pencil.

Sharpeners

A standard pencil sharpener does the job just fine. Using good-quality pencils with centered cores and a sharpener with a good, straight, new blade will help avoid breakage. You may prefer to use a craft knife to sharpen pencils, especially charcoal ones. This must be done with great care! Turn the blade away from your body and hold the pencil with your fingers behind the blade. Firmly drag the pencil backward against the cutting edge, levering your thumb on the back of the blade. This minimizes movement and the chance of accidental cuts.

Alert

Take responsibility for your health and safety. Many drawing materials are harmless, but some may not be. For example, a dust mask is necessary when working with pastels, and the pigments in some colored pencils and most pastels are toxic. Check with your art supplier for information about specific products, and store all art materials and equipment away from children.

Craft Knives and Scalpels

In addition to sharpening pencils, blades are useful for spot erasing, incising, and sgraffito (scratching) techniques. Please take extreme care with these! A new scalpel blade is so sharp that you can give yourself a nasty cut with a careless wave of the hand. A craft knife is a bit safer, but must also be handled with care. A small craft knife with snap-off blades allows you to get a fresh point when it blunts. Always use appropriate supports when cutting, sheath the knife after use, and keep away from children.

Blending Tools

When blending or smudging pencil or charcoal, use a blending tool rather than your fingers so that you have finer control and to avoid fingerprints. You can use a piece of cloth, chamois leather, or a blending stump. Stumps are sometimes called *torchons*, from the French for "cloth" or "duster," but are usually referred to as *tortillons*, from the French for "twist," as they are traditionally made from tightly rolled paper—though the manufactured ones are usually compressed paper sticks.

Brushes

A small hog-hair brush (the stiff-bristled kind used for oil painting) can be used to spot-remove excess charcoal or pastel before erasing. Use a large, soft brush, such as a hake (a Japanese watercolor brush), or even a makeup brush, to lightly flick away particles and debris from the drawing. For ink washes, a medium, round, synthetic brush is perfect (such as a Number 7 Round Taklon). You may want a larger brush for bigger work.

Fixative Spray

You don't need to fix pencil drawings, and most artists don't like the way it alters the drawing. Fixative is essential for charcoal drawings; otherwise, the charcoal won't stick to the page. Don't use hairspray, which is acidic. Choose a reputable brand of workable fixative. Workable fixative is preferable to varnish, as you can continue to modify the drawing after using it.

Art Folder

A cardboard folder for holding loose pieces of sketch paper can be purchased, or made from an appliance box. Use bulldog clips to hold your drawings securely during transport, otherwise they slide down and become buckled and creased. At some point you will want to get a plastic folder, as chemicals from cheap cardboard can seep into your paper during storage, diminishing archival qualities.

Useful Extras

You'll need a few extra items to complete your drawing kit. You'll already have some of the following items, though you might want to keep them with your artwork so they aren't unexpectedly used up or dirtied from other uses:

- Large bulldog clips are very handy for attaching paper to a drawing board. Small clips are also useful for keeping sketchbook pages under control on windy days.
- Very fine sandpaper (1,000 grit) is useful for brightening the points on pencils (a scrap of coarse cardboard will do the same thing), and 600-grit sandpaper is best for cleaning blending stumps (tortillons).
- Masking tape (any inexpensive, wide adhesive tape) is needed for sticking drawings to windowpanes for tracing, holding paper in place, and a multitude of other uses.
- Ammonia-based window cleaner is useful for cleaning ink pens.
- Sea sponges, table salt, and wax crayons or candles are useful for creating texture effects with ink washes.
- A ruler and set-square (or other right-angled rule).
- A plumb-line (a string with a weight on the end).

Tables, Easels, and Boards

You can create most of your drawings at the kitchen table, although having your own workspace specifically for drawing is ideal. If you want to do larger pieces or spend more time drawing, you might want to get an easel or clipboard.

Drawing Board

A portable drawing surface is very useful. A piece of thin timber board (such as MDF or Masonite) around eighteen by twenty-four inches (or as big as the largest piece of paper you want to use) works well. It can be set on your lap and propped on a chair or table edge for a conveniently tilted drawing surface, or placed on an easel if you have one.

Easels

An easel is not essential for drawing, and most of your work can be done on the kitchen table. However, they are wonderful when working on large pieces and essential for studio figure drawing (most studios offering figure drawing classes will have easels available for use). For working indoors, select a large, sturdy easel—a traditional A-frame construction is the best. These are quite simple to build, and relatively inexpensive to buy. Choose the most solid easel you can afford—you don't want it moving about or falling over when

you are vigorously attacking a large drawing! If an easel is not available, large work can be attached to a wall using removable poster adhesive. If you plan to be doing a lot of outdoors work, a portable tripod easel with pointed legs to push into the ground is the most stable. There are an enormous variety of easels available, from all-in-one box easels to lightweight bare-minimum tripods. The choice here is largely a financial one. A minimal tripod will strap easily onto a backpack containing your other materials, while a luxury model with a palette/materials drawer and carry strap is certainly a pleasure to use. A portable easel tends to feel rather flimsy when used indoors; setting it up on a nonslip surface or mat improves stability a little.

Drafting Boards and Tables

The surface of a drafting table can be tilted to varying degrees and sometimes comes with sliding rulers, pencil holders, and other gizmos attached. Many professional artists, especially illustrators and cartoonists, consider them essential. A great advantage of drafting tables is the adjustable angle, which lifts the top of the page, reducing distortion of the image due to viewing angle.

Shopping List

The following lists include all the materials required for each medium in this book. The basic drawing lessons use pencil and pen, then value drawing with graphite pencil is introduced. Charcoal and ink drawing are treated as separate techniques. Later chapters use a variety of media, but you can stick to pencil for these if you wish.

Prices can vary wildly between different shops and different manufacturers, so spend some time browsing online to get an idea of typical prices and the different products that are available. Many art stores offer a student discount, and many colleges that offer visual arts classes will have a shop nearby that caters to student needs.

The essentials you'll need for the lessons in this book are: some good-quality office paper, a 2H, B, 2B, and 4B pencil, a kneadable eraser, and a pencil sharpener. Make your own blending stump. For ink drawing, have on hand a black fine-point pen and a tube or a pan of black watercolor paint, or a dip-pen holder, drawing nib, and bottle of ink, plus a number 6 round watercolor brush. For charcoal drawing, purchase a soft charcoal pencil, a white conte pencil, some large, cheap paper, and a few sheets of size A4 mid-gray paper.

For Basic Drawing Techniques

- ❏ Artist's-quality graphite pencils: B, 2B, 4B
- ❏ Kneadable putty eraser
- ❏ White plastic eraser
- ❏ Pencil sharpener
- ❏ Sketchbook: size A4
- ❏ Cheap sketch paper: large newsprint paper, MG litho, or similar
- ❏ Optional: fiber-tip artist's pen (fine/medium)

For Value Drawing

- ❏ Erasers and pencils as listed for basic drawing
- ❏ Drawing paper: size A4 or larger good-quality drawing paper for graphite pencil
- ❏ Additional pencils: 2H, HB, 6B
- ❏ Blending stump (tortillon or torchon)
- ❏ Optional: additional pencils, 3H, H, 3B, 5B
- ❏ Optional: best-quality drawing paper, or Bristol board, for very fine work

For Charcoal Drawing

- ❏ Newsprint paper
- ❏ Size A4 sheets of mid-gray paper
- ❏ Several sticks of thin willow and vine charcoal
- ❏ Medium-compressed charcoal stick
- ❏ Kneadable eraser (keep a separate one for charcoal drawing)
- ❏ Blending stump (again, a separate one for use with charcoal)
- ❏ White charcoal or chalk pencil
- ❏ Optional: charcoal pencils, hard, medium, and soft

For Ink Drawing

- ❏ Pen holder and nib(s)
- ❏ Number 6 round watercolor brush (synthetic or blend)
- ❏ Small bottle of Indian ink
- ❏ Lightweight hot-pressed watercolor paper

Drawing Techniques

Learning to draw is a gradual process. You need to train your eye to observe, your mind to remember, and your hand to faithfully record. This takes time and patience, but with regular practice, you'll see remarkable progress. You should do the exercises in this chapter in order, as they are designed to gradually introduce the basic skills of drawing. Later, you might like to come back to them from time to time, and use them as warm-up exercises.

Seeing with an Artist's Eye

The emphasis on seeing can often seem a bit confusing when you first learn to draw, making a natural, everyday ability somehow complex and difficult. In fact, seeing like an artist isn't that complicated, but involves learning to trust your eyes and remembering what you see. Drawing exercises focus on different elements of the process, including:

- Observing and remembering the shape of lines and planes (more complex forms are simply collections of or variations on these basic shapes)

- Observing the relationships (angles and distance) between key points

- Perceiving an object as three-dimensional

- Recognizing variation in tonal value, from light to dark

Memory is also important when drawing. The few seconds between viewing the subject and viewing your page are long enough to allow memories and expectations to interfere with your visual memory of the scene. This might mean, for example, that you draw the sides of a building straight, as you know them to be, rather than in perspective, as they appear to be. Artists use various conventions—contour drawing, perspective, and value drawing—to represent the subjects on paper. In the course of this book, you'll perform many drawing exercises to develop various skills of perception and draftsmanship, some focusing on specific areas, and some more general. With practice, these skills will begin to work together seamlessly.

alert

The artist—yes, that's you! It doesn't matter if you've been drawing for a day or a decade, or how technically good your artwork is. If you value making pictures as a way to express yourself, then you are an artist, and what you draw is art.

Does all of this mean that you have to slavishly copy everything before you? Certainly not! If a picture is to have artistic value, rather than being a mere copy, aesthetic decisions and some sense of emotional and intellectual force need to be imposed upon the image. Sometimes this happens naturally, as artists make almost subconscious alterations to create an image that is visually satisfying. A darker tone here or a softened curve there—these, and the unique quality of mark-making that every artist has—imprint even the most realistic of drawings with the artist's character. Sometimes artists make deliberate choices in composing and modifying a subject, and sometimes they leave perceived

reality behind altogether. But by mastering the fundamental process of drawing what you see, you then have the freedom to draw anything you choose.

Pencil Basics

There is a lot of nonsense written about how pencils ought to be held and how lines ought to be drawn. Generally speaking, the pencil is your fundamental drawing tool, and like any other tool, there is a right and wrong way to use it. Remember that this is the basic foundation of all your drawing, so while it might seem strange to think about something as basic as holding a pencil or drawing a line, it will pay off by making your drawing more efficient, fluid, and expressive.

How to Hold the Pencil

For small sketches, there isn't much wrong with your usual tripod grip, though to allow more freedom you might try to slide your fingers a little higher up the pencil. For large sketches, try a relaxed version of the tripod grip, holding the pencil about halfway up. Tilting the hand over slightly gives you what is described as the "long" sketching grip.

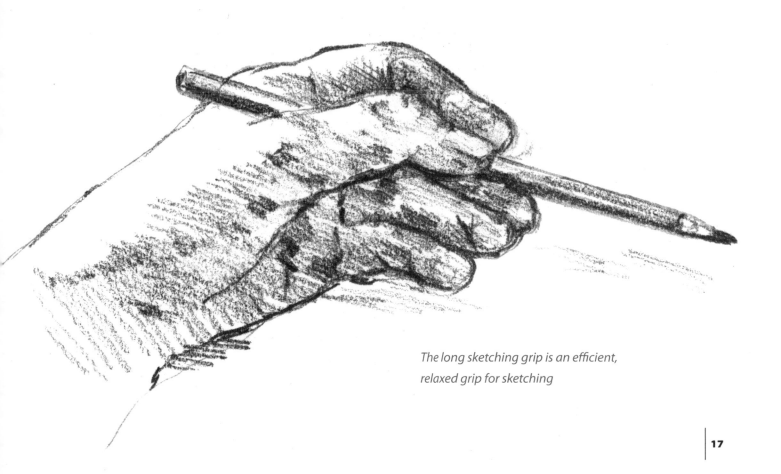

The long sketching grip is an efficient, relaxed grip for sketching

in what is called the overhand grip. This is useful if you tend to hold the pencil too firmly (you'll notice this if your hand quickly tires when drawing).You might also want to try a more relaxed grip if your work is too stiff and tightly controlled. This is evident in heavy and unvaried line work, lines that gouge the paper, lack of value variation, and coarse textures. The overhand grip is also useful when using charcoal sticks or shading with the side of a pencil.

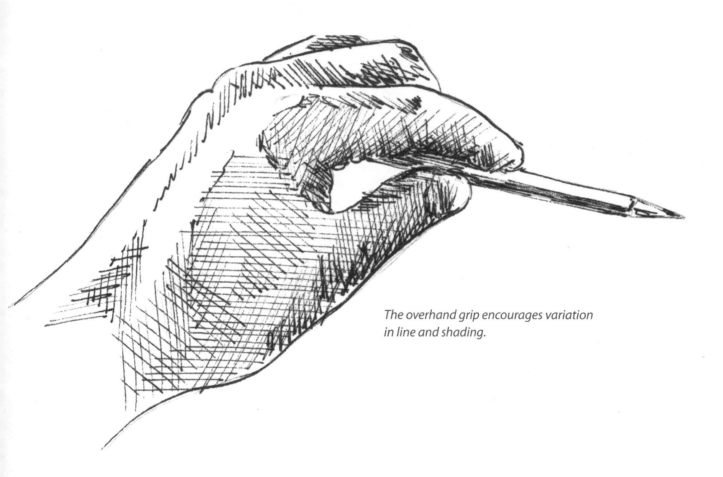

The overhand grip encourages variation in line and shading.

A common problem is the habit of bracing the side of the hand on the paper, as when writing. This is fine for very detailed work (though you'll need to protect the page with a spare sheet of paper under your hand) but can be very limiting when you are trying to create more expressive lines. Try bracing your arm against the table, on or near your elbow, using that point as a pivot to allow you to engage your wrist in the drawing action. For very large or energetic works, the whole arm needs to be involved, and you'll want to work standing up at a table or easel.

Line weight is the darkness or lightness of a line, created by more or less pressure on the pencil. Soft pencils and charcoal produce a thicker, darker line when more pressure is applied, while harder pencils or pens may only change slightly.

Drawing Lines

Many people advocate short, overlapping strokes for building up an outline. I can't disagree more with this approach. It results in heavy, overworked outlines, encourages indecision, and draws attention to the weakest areas, as these become heavily worked with a network of second-guesses. Work on trying to create a smooth, unbroken line, as continuously drawn as possible. In the beginning, you will want to stop frequently to check your subject, but you should aim at a flowing style that permits confident, smooth lines to express the form you are drawing. The exercises that appear later in the book will help to develop this quality. Of course, mark-making will vary if you want to show a textured surface or use expressive lines, but this is different from your basic drawing technique. Choose a pencil hardness (usually B) that will allow you to create a reasonably definite but erasable line with a moderate pressure of the hand—relaxed but firm. This allows you maximum control of line weight, as you can lift for a lighter line or press harder for a darker one.

Beginning to Draw

You can get started right now. Yes, now—before the trip to the art store, before you rearrange the house to make a studio space, before you schedule a field trip. You can use any old paper and pencil you have. Just reading a book won't improve your drawing; you have to do the exercises and try the techniques. Lack of materials is no excuse. You can do these on an old, lined notepad with a blue ballpoint if you really have to!

Don't feel daunted, as though starting some huge project. Just take that first step, and you are on your way. Don't worry about the more involved-looking drawings later on in the book—just start at the beginning. If you have already done some drawing, try not to skip the "easy" stuff. Think of these exercises as a warmup. The first exercises will get your hand and eye on the same wavelength, and then we will explore the possibilities of a pencil line. Have Fun!

Drawing Simple Shapes

Aim: To practice hand-eye coordination

Materials: Paper and pencil or pen

Time: 5 to 10 minutes

Set Up: Place your paper close to the examples here, so that you can quickly look back and forth from the book to your drawing.

Start Drawing: Copy each line and shape freehand. This means *you cannot use a ruler.* To draw a curve, turn the paper so that your hand is on the inside of the arc. It is usually easier to draw a straight line sideways, rolling the wrist slightly, than to move the hand down the page. Take your time and try to make your freehand drawings as close as possible in size and shape to these ones.

Review: If you do a lot of handiwork, such as sewing or woodwork, or writing, you should be able to match the shapes closely. If you aren't used to doing detailed work with your hands, you might find it more challenging. Stencils and rulers were used to draw some of the shapes in the examples, so don't expect yours to be perfect; it's the practice that matters. Do the exercise several times, very slowly, to get your mind and hand working together. If you like, trace the shapes and draw right over them.

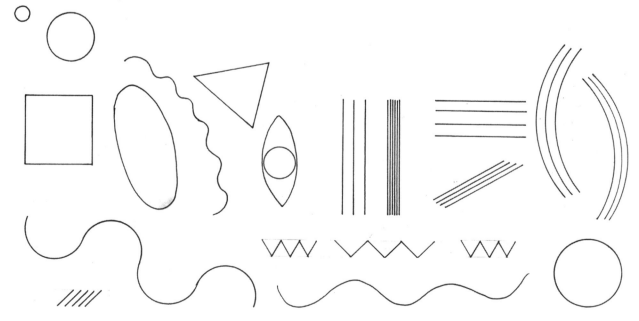

Taking a Line for a Walk

Aim: To explore line

Materials: Paper, pencil

Time: 5 minutes

Start Drawing: Now that you've practiced following some set lines, experiment with making some of your own. The artist Paul Klee spoke of drawing as "taking a line for a walk"—so start off in one corner of your page, and take your pencil for a stroll across it. Start off slow and meandering, then add some detours. Experiment with the weight of the line, pressing heavily and lightly. Do some zigzag sprints, flicking skips, and twirling spirals. See how many different marks you can create with a single pencil.

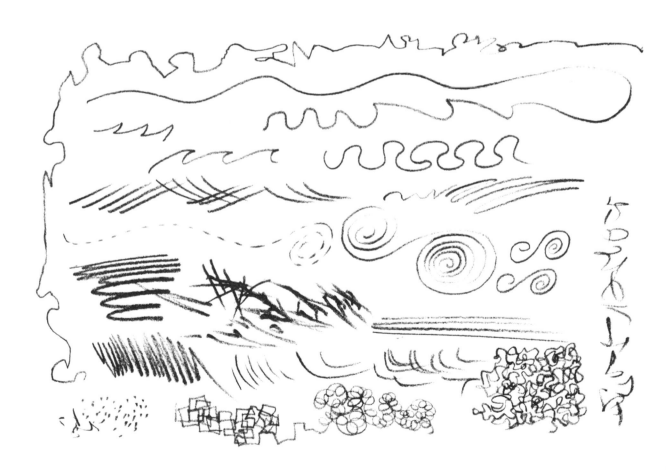

Two-Dimensional Drawing

Aim: To explore two-dimensional outline drawing

Materials: Paper, B pencil, eraser, and small, flat objects

Time: Anywhere from 5 to 15 minutes per drawing

Set Up: Leaves in various shapes are perfect objects to choose for this exercise, and flowers such as daisies or pansies are also good options; old-fashioned keys, seashells, feathers, old jewelry, and small, flat pebbles are all suitable as well. Natural, irregular shapes are easier to draw than manufactured objects.

For this exercise, you will draw a frame on a piece of paper that your object can fit inside. Sit your object on this as you draw so that you have clear reference points to help you get the size and shape right. The size doesn't matter, so long as your object fits mostly inside it, and the frame isn't too much bigger. This will give you clear horizontal and vertical points of reference. Draw another frame of the same size on a piece of drawing paper for your sketch. >>>

Practice drawing all kinds of small objects.

Start Drawing: Choose a distinctive spot along the edge of your object, close to one edge of the frame you've drawn. Estimate the position of this spot in relation to the sides of the frame, and find the corresponding spot in the empty drawing frame. Now you simply follow along the edge of the object with your eyes, moving the pencil along as you go, looking frequently from the object in its box and back to the drawing in its box. Take your time, and don't worry about mistakes. See if you can draw the whole outline in one try, using the sides of the drawn frames as references to help you get the position right. Once you've drawn the outline, you can add some detail if you wish. If you have trouble, try using a ruler to measure a couple of reference points.

Review: Don't be too critical of your work at this stage. Remember, it takes time to develop drawing skills. Check that you have drawn all the visible outlines and edges of your object. If it was too easy, you might like to choose something more complex.

Explore Further: Do some more arrangements of simple objects to draw. Add some details—veins in the leaves, ridges on the shell, and so on. Try some small household objects or tools from the garage. You can set small items like these right on your drawing page so you can look at the object and your drawing at the same time.

Keep in mind as you learn more about drawing that there are no rules about art. What works for one person might not work for another. Try everything, and persevere with difficult problems, but feel free to discard anything that isn't useful to you.

Let's Go Three-D

You could see drawing as a complex process, representing a three-dimensional form on a two-dimensional surface. However, it is easier when you start with very small items that you can draw the same size—this removes the mental gymnastics involved in scaling down a large object to fit on your page. It also helps to choose "user-friendly" objects when starting out. Natural forms, such as fruit or plants, are the easiest to draw. Once you've built up some confidence with these, then you'll be ready to draw something more challenging.

Contour Lines

When drawing a three-dimensional object, look for any clear outlines (between the object and the space around it) and any changes of plane on the object itself. These are called *contour lines*. A **pure contour** would virtually be a silhouette, but artists often include details within the form—folds, creases, and sometimes surface features—when referring to contour lines.

Cross-Contour

Cross-contour lines travel across the surface of the object and help describe the three-dimensional form you are trying to represent. With a line drawing, a few well-chosen cross-contours can be enough to suggest the form. Often shading will follow a cross-contour to heighten the solidity of a drawing. Outlines often migrate into the form to become cross-contours, such as the line of an arm turning into the bend in the elbow. Sometimes only the lines across the front of an object will be visible, but often the unseen lines are drawn to help describe the three-dimensional shape.

Continuous Contour

Continuous contours are a modified form of cross-contour that use a continuous line winding around the object to describe its form.

Just as a cool-headed singer improvises to catch up with the band when she's forgotten the words, you can carry on and head for the right spot when you've made a mistake, and chances are, nobody will be any the wiser—they might just think you're being creative!

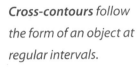

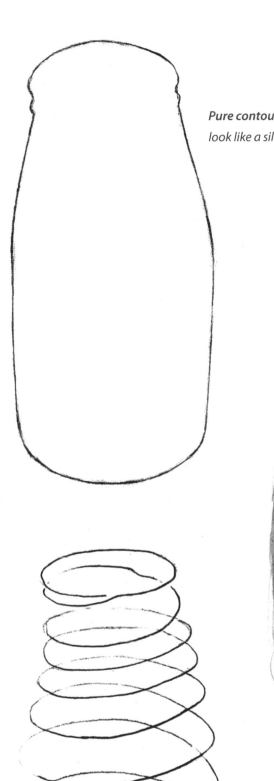

Pure contour drawings can look like a silhouette.

Cross-contours follow the form of an object at regular intervals.

Continuous contour drawings follow the entire form, depicted as a line winding around the object.

Looking at Objects

When beginning to draw a three-dimensional object with line, the most obvious line is usually the contour line (outline) that defines the shape against the background. Then you should note any major changes of plane within the form—the corners of a box, for instance. It can get tricky when you have a more subtle edge to define, or one with an unclear ending. How sharp does an edge need to be before you use a line to define it? When does a visible edge (change of plane) need to be defined by a line, and when does it need to be left out? Or does its presence need to be indicated by an implied line? This is something that you will learn to judge intuitively.

The brain is very good at making inferences from available information. You don't need to draw every line; sometimes a broken line works better, where the space between the ends of the line is implicitly part of the drawn line, suggesting a change of plane without overtly drawing it. Depending on the scale of the drawing and strength of line, there is a limit to how far an implied line can go. A forcefully drawn line that gradually lifts off the page, leaves a space, and gradually returns successfully directs the eye across an empty space. A weakly drawn, wandering line of the same type tends to lose the viewer's eye before the continuing line is picked up again.

Blind Contour Drawing

Aim: To develop hand-eye coordination and observational skills

Materials: Paper, B pencil

Time: At least 15 minutes, preferably longer

Set Up: Have your sketchbook or a piece of paper on a board so that you can place it on your lap under the table where you can't see the paper, or place your paper on the table and set up an object as a screen. For this exercise, you are going to draw a picture of your nondrawing hand resting on the table. Remember, the point is to look at your subject, not your drawing.

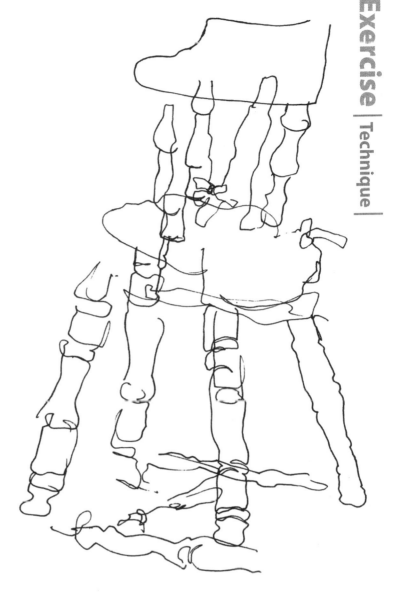

Blind contour drawings look strange but are excellent practice.

Start Drawing: With blind contour drawing, it is important to go very slowly. Working too quickly will defeat the purpose of the exercise; try to draw as slowly and deliberately as possible. You are training your eye to observe every little detail and teaching your hand to follow. The end result does not matter, only the activity of drawing.

Review: If you have done very little drawing, you will probably find that your completed exercise looks quite abstract, with little sections of detail that look like part of the hand. If you have had some practice, you will find that your proportions are more correct. You might also be surprised at just how accurate some parts are. Most beginners do this exercise far too quickly—if your lines seem simple and featureless, try drawing more slowly.

Explore Further: Try this exercise with a complex, natural form, such as a leafy plant or bunch of flowers. If someone will pose for you, a figure makes a great subject. Faces can turn out pretty funny! You might like to find other objects to try. Just remember to work very slowly; don't rush.

Modified Contour Drawing

Aim: To practice observing contours

Materials: Paper, B pencil, simple objects

Time: At least 15 minutes, preferably longer

Set Up: Choose simple objects, such as interesting fruits or vegetables, for your first subjects. Well-worn boots are a favorite for this exercise!

Start Drawing: Modified contour drawing is basically outline drawing with the addition of lines within the object as well as the silhouette. Just start at any point on your object and gradually work your way around, following its lines just as you did with blind contour drawing, but looking back to your drawing as you go to check the position of your hand.

Review: Don't worry too much if your proportion is a bit off with your first drawings—it takes a while to get that right. You should have plenty of interesting lines with bumps and squiggles, depending on your object. If it looks too plain and flat, perhaps you might like to choose a more complicated object. Or did you miss lines and creases that go across the object to help describe its shape?

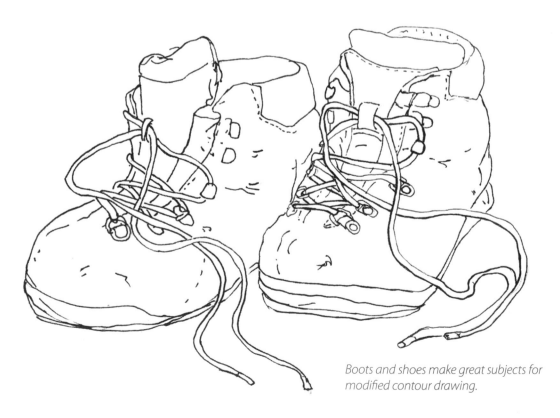

Boots and shoes make great subjects for modified contour drawing.

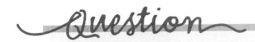

What does drawing "from life" actually mean?
Drawing "from life" means to draw while observing your subject, an actual person, animal, object, or scene, as opposed to using a photograph or copying an artwork.

Thinking Like a Sculptor

Visualizing three-dimensional form is an essential skill in drawing. This is why drawing from life is such good practice: it is only through studying real, three-dimensional objects that you are able to make good inferences about the form of objects in photographs.

To simplify the drawing of complex objects, try looking at them as if you were about to make a sculpture rather than a drawing. There are two ways of approaching this: from the inside out, building a skeleton and adding to it; or from the outside in, starting with a block and cutting pieces away. Which approach you choose depends on the object, though often we use the "inside out" approach for figure drawing, while the simple block technique is useful for solid still-life objects. Often, you'll use a combination of the two. With this approach to looking at the structure of an object, it is useful to imagine that the object is transparent and to draw the "invisible" sides.

Perspective is naturally an element in drawing three-dimensional objects. To begin with, you may find that some of your sketches don't seem quite right, and faulty perspective is the likely problem. This issue will be addressed in the next chapter, so don't worry about it too much for now.

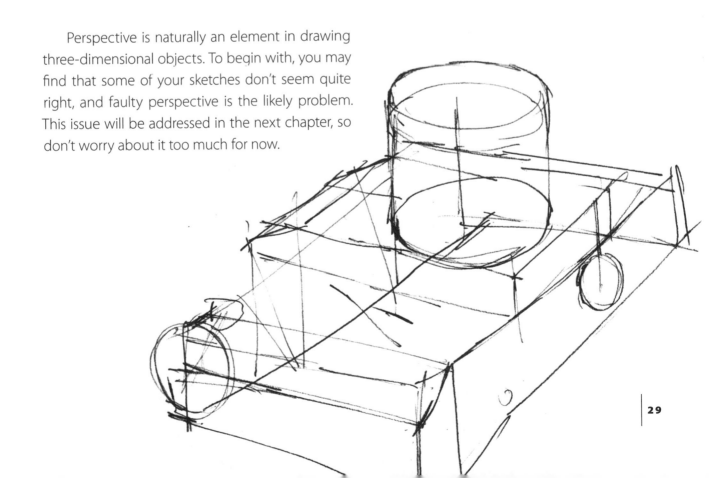

Sculptural Structure

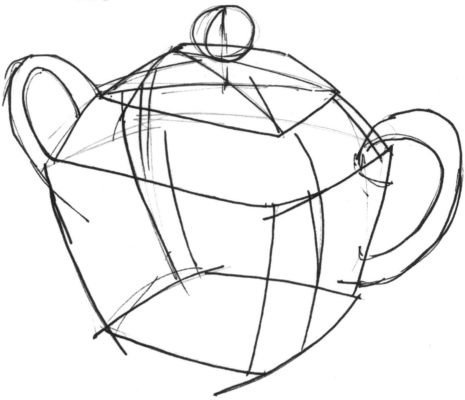

Aim: To practice looking for simple structure in complex forms

Materials: Size A4 paper, pencil or pen, household objects

Time: 20 minutes

Set Up: You can do this exercise anywhere in your home. Try working your way around the room, sketching the structure of whatever you can see.

Start Drawing: Remember not to be distracted by surface details. What you are look-ing for is the basic, essential form of the object. What simple boxes could you construct such an object out of? Look for clear relationships, curves, and edges. Think in terms of big changes of plane. You don't need to finish these drawings; they are simply observa-tional exercises.

Review: Don't worry too much about perspective at this stage, though it will be an ele-ment in these drawings. If your drawings look distorted, you might need to pay extra attention to the perspective lessons in the next chapter. Make sure your overall pro-portions are roughly correct, too. Did you find some forms trickier than others? Some objects don't lend themselves well to this exercise, but the practice is still of benefit to your drawing.

Using Shading to Describe Form

Pure line drawings can often look very beautiful, and it is amazing how much information a well-drawn line can communicate. Take a look at Picasso's etchings to see just how eloquent an unadorned line can be. Adding shading to a drawing helps give it a solid, three-dimensional feel, and allows you to describe surface detail much more clearly. Shading can also add expression to a drawing.

Shading with the point of the pencil gives a smooth, fine grain and allows good control over detail. Avoid erasing to keep the drawing looking clean and fresh. Use a kneaded eraser or Blu-Tack to lift excess pencil but remember that stray lines can add energy and interest.

Shading with the point of a pencil gives a smooth line and makes the direction of the pencil stroke clear.

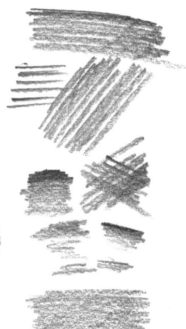

Shading with one side of a pencil creates a grainy effect.

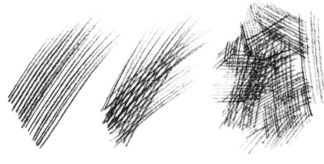

Pencil hatching is a versatile technique.

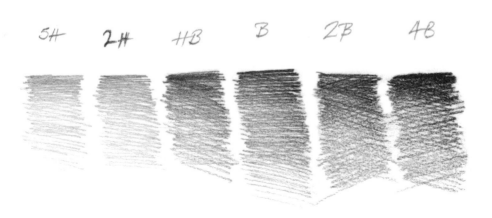

Using different grades of pencil gives you better control over the strength of shading.

Shading with one side of a pencil also allows more of the paper texture to show, with the pencil skimming over the tiny pits in the paper, leaving specks of white.

Hatching and crosshatching can also be used in pencil drawing to describe form. Hatching is creating parallel lines, evenly spaced, to create the impression of tone. Crosshatching uses two sets of hatched lines, often at right angles, though a more acute angle can create a pleasing effect. Find out more about hatching in the pen-and-ink section of this book.

Essential

Some artists also like to use a chisel-point pencil for shading, which is a pencil sharpened with a knife to produce a tip that is broad on one side and narrow on the other. This can be useful, as it gives a versatile line—broad or narrow according to how you turn the pencil—which is ideal for quick sketching.

Try adding some shading to a contour drawing. Leave the brightest areas white, add a single layer of pencil strokes to the middle values, then add more layers to darken the shadows. Pencil strokes that follow the contours help to describe the form.

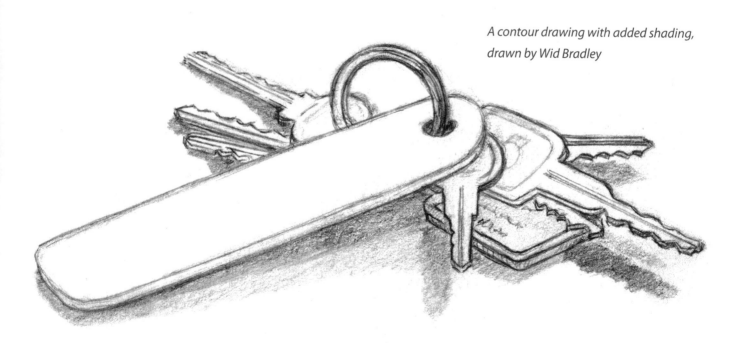

A contour drawing with added shading, drawn by Wid Bradley

Negative Space

Negative space is how we describe the areas of a picture that you aren't drawing. So, if you are drawing a chair, the negative spaces are the shapes between the rungs, and all the space around the chair. Why is this important in drawing? Negative spaces often form useful shapes that you can check to determine if your drawing is in proportion. To do a negative-space drawing correctly, you need to draw the negative-space shapes, and ideally any detail within them, carefully placing them on the page so that they all add up to reveal the positive space taken up by the object.

Details can be drawn in, or they can be left as shaded spaces to give a silhouette. Either is correct, so long as the focus is on the small shapes between the parts of the foreground object, not on the outlines of the object itself.

The correct approach to negative-space drawing focuses on creating the shapes between objects or parts of an object. When talking about negative space, most drawing books will show you an example where the outline of the object is drawn and the negative spaces are shaded in. This may result in a silhouette, but this is not negative-space drawing. Sure, the shaded areas are indeed the negative spaces, but you haven't drawn them. You've drawn the positive ones, focusing on the outline of the object.

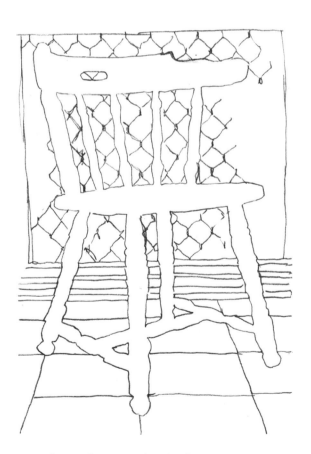

A negative-space drawing in progress

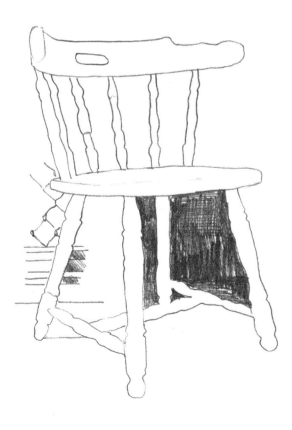

An example of an incorrect approach to negative space

Judging Proportions

Have you ever wondered what artists were doing when they peered over an outstretched pencil at a subject? This strange-looking practice is a very useful method of measuring the sizes and angles of the subject by using your pencil as a ruler, and establishes a more accurate drawing. These aren't absolute measurements—rather you are looking at the relative proportions. For example, if you view your model's head from where you are sitting and use your pencil to measure the proportions, it might appear to be around an inch tall, but your actual drawing might be four inches tall. So, in this example, one inch is your "base unit" of measure, and everything that you measure as one inch with your pencil will be four inches in your drawing.

Measuring Sizes

To measure sizes using your pencil, grip the pencil in your fist and place your thumb near the top of the pencil. Stretch out your arm from the shoulder, elbow straight, and line up the pencil with your chosen "base unit" of measurement (in the previous example, the model's head). Line up the top end of your pencil with the top of the chosen object and slide your thumb down the pencil until it lines up with the bottom of the object. The distance between your thumb and the end of the pencil establishes the base unit of measurement. When taking other measurements, be sure to stretch out your arm to the same degree and stand in the same place. Frequently return to check your base measurement, as slight changes in position can substantially alter the apparent size.

Measuring Figures

In figure drawing, the base unit is usually the distance between the top of the head and the chin. Line up the top of the pencil with the top of the head. Slide your thumb down the pencil until the tip of the thumbnail lines up with the bottom of the chin. This is one head-unit. Keeping the arm extended, you can then drop the pencil so the top lines up with the chin. Where your thumb lines up on the subject is now one head-unit down from the chin. Once the head is sketched in, for reference, make a small mark one head-unit below the chin you've drawn. This should be the middle of the breastbone. Continue in this manner down the figure, marking in each measured point.

Measuring Distances

You can use the same method to judge other distances—widths, spaces between objects, and diagonal measurements. This is especially useful when you have already sketched some elements, which you can then use as base measurements. Once you've taken the base measurement from an object, be careful not to move your thumb. If the thing you are measuring is smaller or larger, guess how much the difference is and make your mark correspondingly smaller or larger on your drawing. If the difference is too big to guess, choose a different reference point. In portrait drawing, smaller details, such as the eyes, can be used as references. You can use any clear, suitably sized element in drawing, whether landscape or still life, as a reference point.

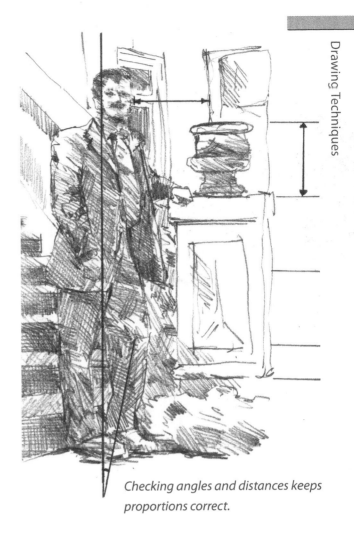

Checking angles and distances keeps proportions correct.

Measuring Angles

A simple way of measuring angles is to use two pencils, holding them in an outstretched hand. First, line up one of the pencils with any established vertical or horizontal in or near your subject (a door frame, a chair, or other prop), then rotate the other pencil to line up with the limb or other element of the subject that you need to locate.

Once the angle is established, carefully move the pencils to your paper, line up your horizontal or vertical, and transfer the angle to the drawing. This needn't be an actual line—finding several angles from known points to a questionable point can help you locate it accurately: sketch in each line, and they should intersect at the point's location.

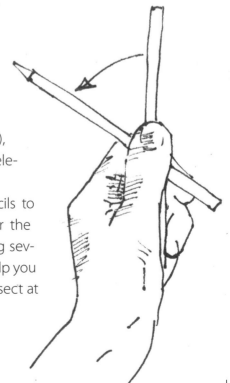

35

Getting It All In Perspective

Linear perspective sounds like something complex and mathematical, but in fact, it can be quite simple. Linear perspective drawing is simply a method of representing the way objects seem to get smaller and closer together as they get further away. Imagine driving along a straight road. Picture the road narrowing to a point in the distance, getting smaller and smaller, and the telephone poles alongside the road getting closer and closer together as they shrink toward the horizon. If you can imagine that, you can understand linear perspective.

When drawing you only need to understand basic perspective. For general drawing, you'll need to get comfortable with basic one- and two-point perspective so that you can judge whether you have correctly drawn an object from life. If can also be lots of fun constructing three-dimensional imaginary worlds, so play with ideas and see what you can create.

First, here are a few important words and abbreviations that are sometimes used that you might want to get familiar with:

> **Horizon Line (HL):** The horizon line represents the horizon you see out in the countryside. It also happens to represent the viewer's eye level, and is used even if you can't actually see the horizon. A high horizon gives the feeling of looking down on the subject, while a low horizon line gives the feeling of looking up from a low viewpoint.

> **Vanishing Point (VP):** The vanishing point is a spot on the horizon that receding lines vanish toward. When constructing perspective, one- and two-point perspective is the most usual, though you can also use three-point perspective when drawing tall buildings or cliffs.

> **Orthogonal:** An orthogonal is the "vanishing line" drawn from the points of your object to the vanishing point. It is worth remembering, as it is a concise and accurate description of the line.

> **Picture Plane:** The easiest way to understand the picture plane is to look through a window, and to draw what you can see (or imagine what you might see) on the windowpane. The window is then your picture plane, just as your drawing on paper is a virtual picture plane.

Essential

If you want to draw a natural-looking human's-eye view of a building, remember that the horizon is eye level—so draw your building with about three-quarters of the lower-floor doors below the horizon, and draw the figures' heads around horizon level.

One-Point Perspective

In one-point perspective, objects are drawn so that one plane is square to the picture plane. This just means that horizontal lines are parallel with the top and bottom of your page, and vertical lines are straight up and down. Only lines that are moving away from you, such as the sides of the road, converge on the vanishing point. One of the major mistakes that people make when learning perspective drawing is to draw lines that should be parallel with the picture plane at an incorrect angle.

Drawing a Box in One-Point Perspective

Aim: To learn simple one-point perspective construction

Materials: Paper, pencil, ruler

Time: 10 minutes

Start Drawing: Follow these steps to draw a simple box in one-point perspective. For your first attempt, copy the example exactly, so that the lines are drawn in the right order.

1 Draw a horizon line, indicate a vanishing point as shown, and draw a square, below and well to the left of the vanishing point.

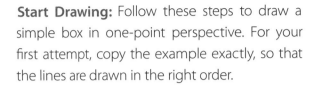

4 Where it meets the top orthogonal, draw a horizontal line to represent the other visible edge on the back of the box.

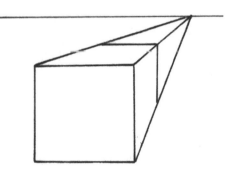

2 Draw the orthogonals (remember, vanishing lines) to the vanishing point.

3 Draw a vertical line between two orthogonals as shown (make sure it is vertical—at right angles to the horizon, not sloping) to define one edge of the back of the box.

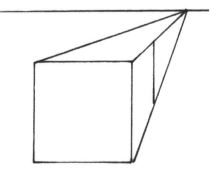

5 Erase the excess vanishing lines, and you have a box in one-point perspective.

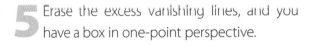

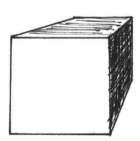

Note that in one-point perspective, the front plane is always drawn first; then the orthogonals are drawn to the vanishing point. Finally, the back of the box is drawn, and the spot where it meets the middle orthogonal is the start of the other side. You can draw the rest of the box by adding more lines, to make it transparent like a fish tank. This is useful if you need to locate the back of the box for further construction.

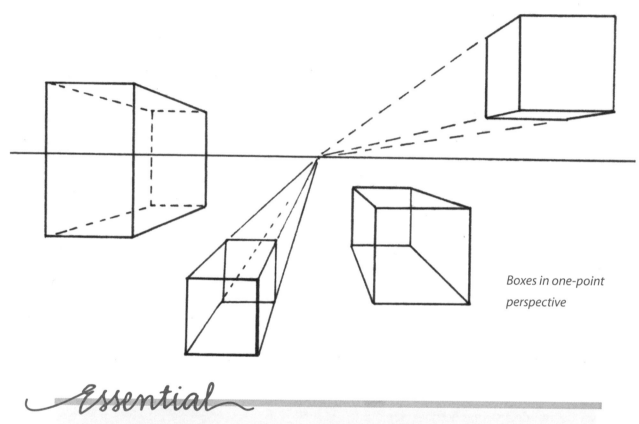

Boxes in one-point perspective

Essential

Use a T-square (if you haven't got one, use the corner of a piece of paper as a guide) to ensure your verticals and horizontals are true. Even a slight error can make your drawing look out of kilter. In complex drawings, keep your VP visible by lining up your ruler precisely, but don't take the orthogonal all the way to the point.

Dividing Planes in One-Point Perspective

When you have drawn a plane (that is, any rectangular shape) in perspective, there are several techniques you can use to divide it evenly. This is useful when you want to draw a door or other features on a building: divide up a floor into boards or tiles, space fence posts, power poles, railway sleepers, and other repeated features. Like most new techniques, these might sound complicated to read about, but if you practice and experiment with them, you'll quickly learn to use them with confidence.

Finding the Center of a Plane

To find the center of any rectangular face, whether parallel to the picture plane (for example, square-on, not diminishing) or in perspective, simply draw a diagonal intersecting line through each pair of opposing corners. Where they meet is the center. You can then use horizontal, vertical, or orthogonal lines, depending on the orientation of the plane, to locate the center of each side.

Diagonal-Line Method

Measure the front edge of your plane—whether a horizontal (floor) or vertical one (a wall, or row of poles)—and lightly mark equal divisions along it. Draw an orthogonal from each division to the vanishing point. Draw a diagonal line from one front corner of your plane to the opposite back corner. Where the diagonal line crosses each orthogonal, draw a horizontal line (or vertical line, for a vertical plane).

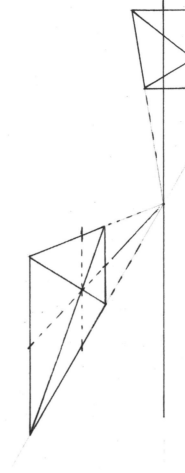

Intersecting diagonals locate the center of a plane.

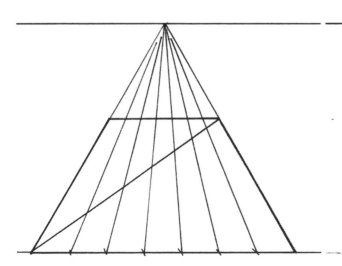

Divide the front edge of the plane and draw a diagonal between its corners.

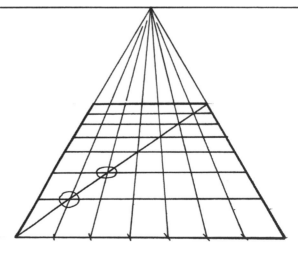

The intersecting lines locate the horizontals, giving an evenly divided plane.

Spacing Lines

If you want to draw a row of evenly spaced trees, fence posts, or poles, draw your first one, measuring it so that you can mark a point exactly halfway along it. Draw a vanishing line from the halfway point to the VP. Draw your next wherever you think it ought to go. Draw a diagonal line from the top of your first pole, through the spot where the second pole crosses the orthogonal from the halfway mark. Where this diagonal line hits the bottom orthogonal is the starting point for your next pole. Draw the next pole, then draw a diagonal line through the top of the second pole, through where the third one intersects the middle orthogonal, and so on. This works for horizontal poles (railway sleepers, carpet squares, ends of road markings) as well. It's a sort of reversal of using intersecting diagonals to find the middle of rectangles.

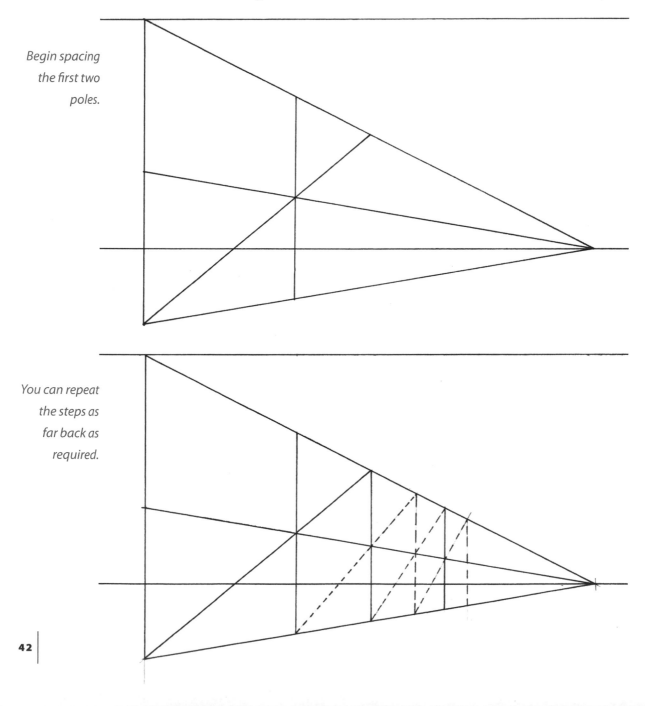

Begin spacing the first two poles.

You can repeat the steps as far back as required.

Drawing Circles in One-Point Perspective

To draw a circle in perspective, first you need to draw a square plane to contain it. Imagine you have a square piece of paper you are going to cut the circle out of: draw that in perspective. Then use the diagonal-line method to find the center of the square. Project lines through the center of the square, parallel with each pair of edges. These will be horizontal or vertical for edges parallel with the picture plane. For edges in perspective, draw a line through the center from the vanishing point. The center point of each side of the square is the point where the circle touches the square. The circle, which in perspective will look like an ellipse, can now be sketched freehand.

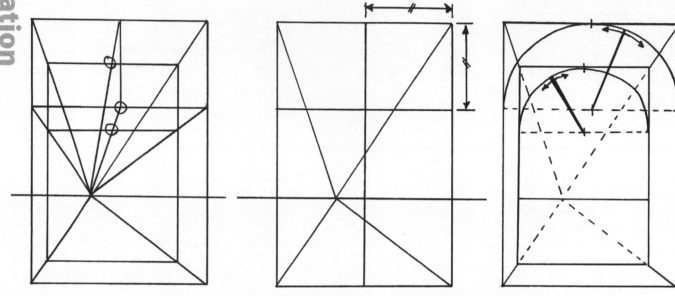

Drawing an Arched Window in One-Point Perspective

1 Draw your horizon line roughly across the middle of your page. Measure a tall box in the middle of the page, which should be around two inches wide by about four inches tall. Mark a line down the middle of your box, and draw an additional horizontal across the top of your box, as far down as half the width. (If your box is two inches wide, the line will be one inch down.) This gives you the center point for drawing the semicircle of the arch. Mark a vanishing point on your horizon—slightly offset looks the most interesting, though you can make it central if you wish. Draw the orthogonals from each corner.

2 Draw one side of the back of the window and use this line to locate the remaining sides, as when constructing a box. Draw orthogonals from the ends of the additional horizontal line to construct a corresponding horizontal across the back of the box. Draw an orthogonal from the center point marked on that line to find the corresponding center of the back horizontal. Draw an orthogonal from the top center to find the center of the back of the box.

3 Now you need to draw in the window's curves. Place your compass point on the marked center point of the front arch, and adjust it so that your pencil touches the top center. Draw the curve of the arch. Do the same with the back arch, using the corresponding center marks.

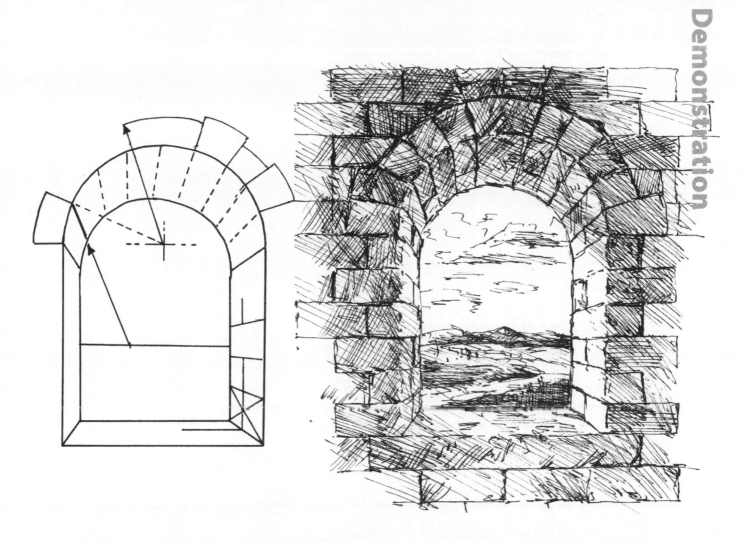

4 Erase your working lines, and smooth any mismatch between the curves so you have a nice, continuous window shape. Use your vanishing point to draw evenly spaced lines around the inside of your window to indicate the stonework.

5 Have fun adding some rough stonework and a landscape through the window. If you are drawing a brick pattern around the top of the arch, remember to make the external bricks (the lines on the front of the window) radiate from the center of the arch, not the vanishing point. The mortar lines running along the inside of the arch are in perspective and diminish to the vanishing point. If you want to have bricks inside the window, measure them and use the intersecting-diagonal method to find the middle point where the bricks overlap.

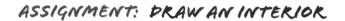

ASSIGNMENT: DRAW AN INTERIOR

Remember that the horizon line is equivalent to your eye level, so place your ceiling at an appropriate height—about one-third of the total wall height above the horizon line. Line your room with a picture rail, a table, and doors. If you like, try constructing a tiled floor using a method of dividing space.

You can place an object at an angle within a one-point perspective composition by placing two additional vanishing points and drawing it in two-point perspective. Sketch the object freehand first to help estimate the approximate placement of the vanishing point on your horizon line.

Two-Point Perspective

Two-point perspective works just like one-point, except that instead of having one set of parallel lines (the front of the box) and one set of receding lines (the sides of the box), the box is turned at an angle so that there is one edge. There are two sets of parallel lines receding toward different vanishing points, with the edge of the box at the center point of these two sets of lines.

Dividing Spaces in Two-Point Perspective

Any of the methods used in single-point perspective can be used in two-point perspective drawing. The measuring-line method is modified by using a measured distance along the ground line, rather than measuring along the front of the object, since this is now in perspective rather than parallel to the picture plane. The object sits upon the ground line, and its measurements are projected through the edge of the plane to the vanishing point.

As in one-point perspective, to find the center of rectangular face, use a pair of diagonals drawn through opposing corners of the plane. This is useful when dividing planes or constructing architectural features or placing details.

The measuring-line method in two-point perspective

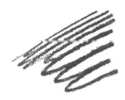

Drawing a Box in Two-Point Perspective

Aim: To learn simple two-point perspective construction

Materials: Paper, pencil, ruler

Time: 10 minutes

Start Drawing: Follow these steps to draw a box in two-point perspective. Copy the example exactly, so that the lines are drawn in the right order, and you can see if you have made any errors.

1 Begin by drawing your horizon line and placing two vanishing points as far apart as possible. Near the middle of the paper, below your horizon line, draw a vertical line for the front edge of your box. Draw orthogonals to each vanishing point from the top and bottom of the vertical line.

2 Draw a vertical line representing the left back corner of the box, between the orthogonals on the left. From the top and bottom of that line, draw orthogonals to the right VP.

3 Now draw a vertical line for the right back corner of the box, then draw orthogonals from the top and bottom of that line to the left VP. The center point where the two sets of orthogonals intersect is the far edge of the box.

4 Erase the construction lines, making your box look solid by erasing the additional interior lines.

Review: Does your box look convincingly three-dimensional? Common errors include verticals which aren't vertical, sloping horizon lines, and lines which do not accurately meet corners or vanishing points (a slight error can significantly alter the appearance of your drawing).

Explore Further: Try constructing boxes at different locations in relation to your horizon line, and experiment with placing your vanishing points closer and farther apart. You might even want to try turning your box into a fish tank (a transparent box) by drawing in additional lines.

Drawing a Roof in Two-Point Perspective

To draw a roof, find the center of the front and back plane of a box. Draw vertical lines extending up through the centers. On the front vertical, mark a point indicating how high the roof is to be, and draw the orthogonal back to the opposite vanishing point. The point where it intersects the back vertical is the top of the back of the roof. Draw lines linking these two top points to the top corners of the box, and there you have your roof in perspective.

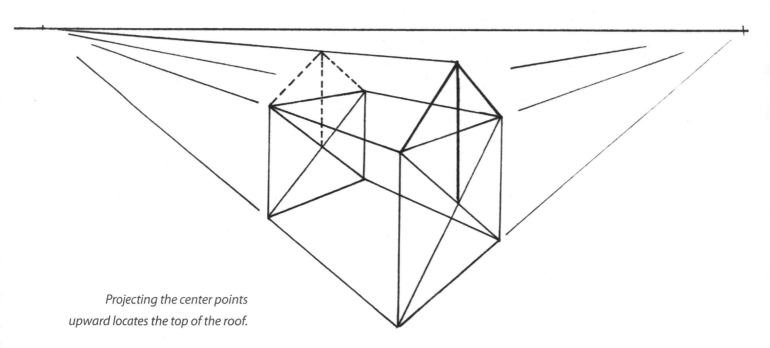

Projecting the center points upward locates the top of the roof.

Drawing a Pyramid in Two-Point Perspective

To draw a pyramid, draw a horizontal plane in perspective and use the intersecting diagonals to find its center. Draw a vertical line straight up from the center. Pick a point along that line for the height, then draw a line from that point to each corner of the plane.

Projecting lines from an imaginary light
source to draw cast shadows

Drawing Cast Shadows in Two-Point Perspective

First, draw your object in two-point perspective. Position the light source, and draw a perpendicular line to find a point on the ground plane. This establishes its position in relation to the object. (Notice that a shorter line makes it seem closer to the horizon, while a longer line brings it closer to the viewer.) Project rays through the corners of the object from the ground point and the light source. Where these intersect gives you the corners of your shadow.

It's All Relative

Perspective drawing isn't just about buildings—you can add objects and populate your drawings with people and animals. It's important to make sure that these additions make sense and are in proportion relative to the structures and each other. To draw people, animals, and objects to scale, use an established reference point in your drawing for a starting point. If you've drawn a building in perspective, draw a short line right next to it to indicate the height of a person—you'll have to judge this by eye. You can then draw orthogonals through the top and bottom of the line to project their height forward or backward in the picture. Use horizontal lines to translate the proportion across the picture. Do the same to establish the height of objects or animals. To draw an animal or object in perspective, imagine that it is encased in a close-fitting box, and draw that in perspective. Add guidelines to place important forms, such as the belly and chest of a horse or the wheels of a car, estimating how far up the box they are and drawing orthogonals through them. You can then sketch your object or animal freehand.

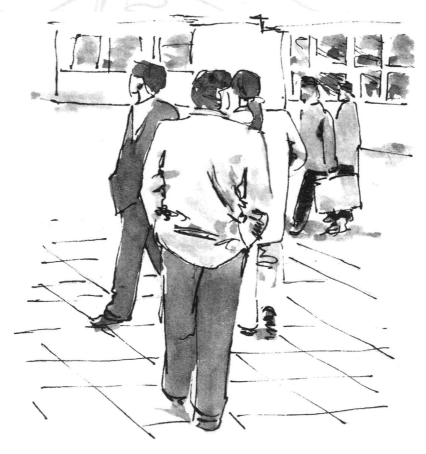

People in perspective

Note that whether the figures are close or further back in the picture, their heads are all at roughly the same height—this is the height of the horizon line and the eye level of the viewer.

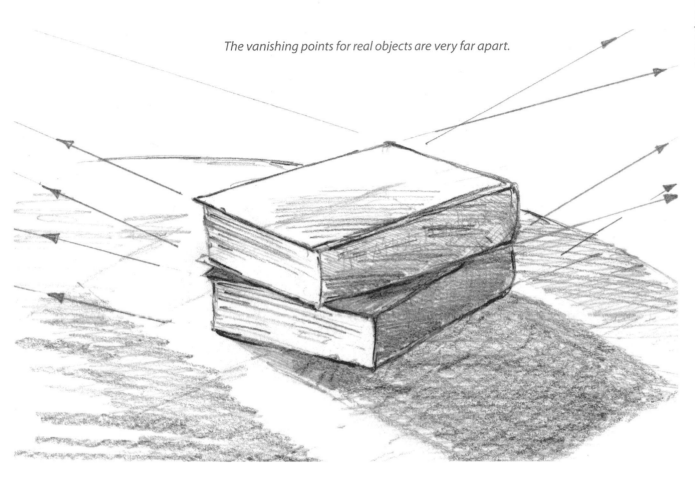

The vanishing points for real objects are very far apart.

Practical Perspective

Now, you're probably thinking that perspective drawings look like cold technical drawings rather than art. However, if you enjoy constructing perspective, once you've built your structure, you can have fun adding details and shading to make it look more lifelike. You can also try freehand perspective sketching, which is great practice for when you are drawing from life. Even if you don't enjoy constructing perspective, but like to work from life, you'll soon notice that you actually use the principles of linear perspective all the time. Try drawing a still life while ignoring perspective! Actually, modern artists spent a great deal of energy exploring alternative means of representing space and form, but for the time being, linear perspective is the accepted means of depicting three-dimensional space on a two-dimensional surface.

Practice Perspective Drawing from Life

Aim: To sketch using linear perspective

Materials: Paper, pencil, ruler, eraser, some boxes or books

Time: 30 minutes

Set Up: Create a simple arrangement of books or boxes, placing several in a loose pile, being sure that they are aligned in slightly different directions, as in the example.

Start Drawing: Using whatever approach you prefer—building the structure first, or doing a direct contour drawing—create a sketch of your books or boxes, lightly at first to allow for corrections. Observe carefully and be sure that your proportions are correct. You might like to use the thumb and pencil method to check sizes, using a background vertical (such as a door frame) to check angles. This isn't a work of art, so you don't need to get involved in detail, but simply draw the shapes as accurately as possible. Try to draw the invisible edges lightly and visualize the three-dimensional shapes.

Once you are happy with your drawing, take your ruler and align it with the edge of each book or box in your drawing, lightly sketching a line back through the page. You should find that the parallel lines in each set go back to their own vanishing points, or close enough.

Review: Did you try to force nonaligned edges to go to the same vanishing point when drawing? That will make some of the shapes look odd. If the back of the box looks too big, seeming to lift up off the page, you might not have made the lines diminish enough (making them parallel). While the vanishing points might be well off the page, they still exist, and parallel lines look even odder if you've just been drawing in perspective.

Chapter 4

Shades of Gray: Value Drawing

Linear drawing uses line to indicate an outline or a change of plane within the subject, sometimes using cross-contours to help describe the three-dimensional form. With value drawing, lines are not used except in the initial layout to place the drawing on the page. Areas of light and dark describe forms, shaded to match the fall of light and shadow across the subject. You need to be aware of your perception of the object in front of you. You know it to be a certain color or value, but we can see many variations of shade because of the fall of light. Being keenly aware of this difference between the innate surface quality and your perception of it will enable you to make the jump into realism.

Materials Matter

To draw values accurately, you'll need to use a range of pencils. Which ones you choose will depend on your natural way of working and the type of paper you have. The B pencil is good for middle values and is hard enough so that you can draw fine darker values without the point wearing down too quickly. For lighter values use a 2H, and use 2B for the darker values. For very deep values, use a 4B, and sometimes a 6B, though the softer pencil blunts very quickly. Start off with these, and move up or down on the hardness scale as you need to. If using a soft pencil, you can shade over it with a harder pencil to blend and smooth the coarser particles, giving the different pencils a more uniform quality.

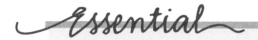

Keep your pencils sharp, with a good, long point. A sharp point allows the graphite to get right into the surface of the paper, producing solid lines and shading. A blunt pencil sits up on the surface, squashing the fibers and skipping over pits, resulting in patchy, light lines and shading. For detailed work, a sharp point is essential, as you'll want to be able to capture tiny variations in value.

You can use any paper for value drawing, but the quality, texture, and depth of tone will vary depending on its surface attributes. A firm, smooth paper will give a finer, lighter texture, while a coarser paper will drag more particles from the pencil, giving a darker, grainy surface. If you are sketching in a book and find that the paper underneath makes the surface too spongy, try placing a piece of card under the paper you are working on, with one extra sheet for padding.

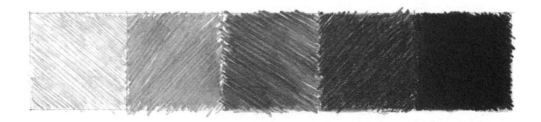

Draw gray scales in five, seven, and nine steps.

ASSIGNMENT: EXPLORING VALUE

Make a strip of hatched values using each of your pencils. Keep the strokes close and even. Try one using close strokes, and another using wider spacing. Try using hatching, crosshatching, and various angles overlaid. Note how letting a little white paper show through the hatching keeps light and energy in the work.

Using whatever pencils you have available, make a graded value-scale in one-inch squares using pencil shading. Try doing five, seven, and nine steps. Try making a dark value using overlaid charcoal and pencil, blending them so that the surface quality isn't too different from the pure graphite. Practice doing patches of continuously graded shading, from darkest to lightest with a single pencil.

Do a strip of continuously graded shading from the darkest value possible to the lightest, using your range of pencils, employing graduated layering to create a smooth, even change.

Practice continuous graded shading.

Explore Value with Newspaper Shading

Aim: To practice value drawing, matching shaded values to a printed image

Materials: Size A4 or bigger paper, HB, B, 2B, and 4B pencils, large black-and-white newspaper images, a glue stick

Time: 40 minutes, depending on image

Set Up: This exercise looks best with large newspaper images. You can use a print-out of your own photograph. Choose a large image with plenty of shades of gray. Tear or cut off a section (usually half vertically, though you might choose to remove a different section, depending on the image), and glue the remaining piece onto a sheet of sketch paper.

Start Drawing: Using the torn-off section as a guide, complete the image, beginning with the areas closest to the newspaper first. You might like to lightly outline the shapes to begin with, but don't get sidetracked into line drawing—it is important to use shading and think in terms of areas of value, rather than line. Look at the shapes and values in the torn-off section and copy these to your drawing, using the HB for very light values and your 2B or 4B for darker ones. A sharp pencil is usually best for value drawing, but for this exercise you might find a blunt pencil works well for matching the grainy look of newsprint.

Review: Check that your values really match those of the picture. When you squint your eyes, it should look like a single piece of paper. Most people make their values too light when they start out. Make sure you are using a soft enough pencil (4B or 6B) for the really dark areas.

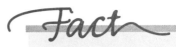

Fact

The most common mistake that beginners make is to be far too tentative with their value drawing, making things much lighter than they actually are. Try using a softer pencil than you think you need. Most drawings should have at least some very dark shades and black. If your drawing doesn't, take another look at your drawing and your subject, and consider whether you are working with too light of a touch.

Seeing Values

Seeing value seems to be a common concern for beginner artists. Perhaps they've been given the impression that there is some sort of trick to it. Rest assured that there is no magic involved: provided you have something like twenty-twenty vision, at least with your glasses on, you can see value very well. It's just something we aren't in the habit of observing.

Try to separate, for a moment, *seeing* from *drawing*. Seeing is something that you do independently of placing marks on the paper. By seeing accurately, you can then make informed judgments about the shapes and values that you need to apply to your drawing. The key is to look at details on the surface object rather than the object as a whole. Sometimes, asking yourself questions can help you assess what you are seeing. Choose a simple, matte (not shiny) object to study. A ball or an egg is ideal. Place it near a light source and take a look at it step-by-step:

Highlights: Highlights will be the white of your paper, and it's essential to reserve these. Where are the very brightest spots on your object? Where does the light hit it directly?

Body Tone: This is the main area of value on your object. If you squint your eyes a little, what sort of tonal value does the object mostly seem to have?

Core Shadow: This is the darkest part of the shadow on an object, near the shadow's edge. At times it can be tricky to spot. Can you see a darker value through the middle of the object, just before the light starts to hit the surface?

Reflected light: Light travels past the object and is reflected back to the shadowed side. Sometimes the effect can be surprisingly strong, especially if the object is on a bright or colored surface. Does the shadowed part of your object look lighter in places?

Cast Shadow: Look for cast shadows across the object—sometimes cast by one part of it shading another—and look at the object's shadow on the background or table. Where is the darkest part of the cast shadow? Are there multiple shadows, from different light sources?

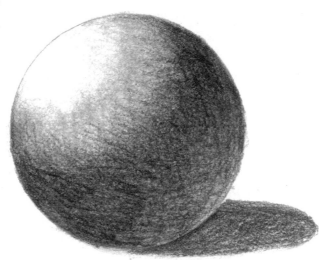

Key areas of light and shade are easy to identify on simple objects.

During the drawing process, you tend to work back and forth through this cycle of observation. Often the process is simply a matter of reserving the lights, looking for the darks, and shading the tones between.

Essential

Remember that value is relative; that is, values appear to change depending on what is around them. Placed against an empty sheet of white paper, values seem much darker than they really are.

Judging Values

Sometimes deciding on the appropriate value for an area can be difficult. Establishing the darks first gives you a starting place to develop your value scale. Colored pencil artist and teacher Bet Borgeson, author of *The Colored Pencil* and *Colored Pencil for the Serious Beginner*, suggests pinning a square of black to your drawing paper, as a reminder of just how dark black really is. This is an excellent idea. You could take it a step further by placing a value scale on the side of your paper. If you feel your own shaded value scale doesn't have enough steps, you can create one on a computer with very precise shades of gray.

Sometimes holding your value scale against the subject and squinting your eyes can help in deciding the appropriate value to select. A value viewer—a hole punched in a piece of card—is also useful for isolating areas of your subject.

Essential

The whitest paper can't match the intense white of real light. When drawing, you need to use the white of your paper for the brightest light in your subject, and move the rest of your tonal values in the drawing a notch down the scale, drawing them darker than they really are.

Colors can pose a problem when deciding on values, especially pure primaries. Red is technically a dark color (as you will see if you convert a color photograph to gray scale using a computer or photocopier), but it is intensely stimulating to the retina, so it seems bright. Yellow paint tends to overstimulate the retina and looks duller than it really is. Don't feel you need to be a slave to photographic interpretation of color. In drawing, you are representing the effect of the color on the eye, so make your own judgment as to the brightness you consider appropriate for a particular color.

Notice how the darker background illuminates the brightness of the mug.

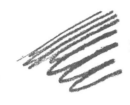

Shadow Box Value Drawing

Aim: To use controlled lighting to create maximum value variation

Materials: Paper, HB, B, 2B, 4B pencils, eraser, white objects

Time: 30 minutes to 1 hour

Set Up: The shadow box used in traditional drawing training is simply a base with a back wall and one side wall. You can make one by cutting off the top, front, and one side from a cardboard box. Often the inside of the box is painted black or gray to minimize reflected light.

Create your white still life by painting some small objects white. You could use small off-cuts of wood or an old vase. You could also use undecorated white crockery, an egg, and scraps of fabric. Keep it fairly simple, but make sure you have a good range of tonal values and interesting lines to draw.

Shine a desk lamp from the open side of the box, adjusting its distance and angle until you are happy with the range of highlights and shadows that it casts. Minimize the rest of the lighting in the room so that the shadows are quite dark.

Start Drawing: When beginning your still life, draw its outline lightly, and then quickly build up good dark values. Work up the background as you go—don't leave it until last, as the darks on the white surfaces will seem too strong if the background is left white. Choose an approach—either shading or hatching—and use it consistently.

Review: You should end up with a pretty convincing three-dimensional form if you've shaded this drawing correctly. Did you resist the temptation to outline? Hard outlines flatten your drawing. If you found it too challenging, perhaps your subject was too complex—try something simpler.

Explore Further: Try doing this exercise at night, with minimal ambient light and a single-point light source, such as a desk lamp, a flashlight, or candle, to illuminate your still life. You may need a shielded lamp or candle to draw by. (If using candles, please do take appropriate safety precautions!)

Starting in the Middle

Aim: To develop use of middle values in drawing

Materials: Paper, HB, 2B, 4B, 6B graphite pencils, eraser, a simple object

Time: 30 minutes to 1 hour

Set Up: Choose a simple subject, such as a piece of fruit. Remember to use directional lighting and minimize ambient light in the room.

Start Drawing: Begin by shading with a 2B pencil over your whole page, leaving a border if you wish. Don't be tempted to use a blunt pencil—this will make the shading rough and patchy. Use a sharp pencil, and take your time, gradually building up a smooth, even layer of graphite. Add a layer using an HB pencil, working at right angles to the previous layer. If it still looks patchy, you may need to add another layer.

With a 6B pencil, lightly sketch in the overall shape of your object, then look for the darkest shadow areas and shade these in. With a 4B, work in the next-darkest values. Now you will need to add some highlights. Stretch and fold your kneaded eraser to make a clean patch, and roll it to a point. Carefully observing the shape of the highlights on your subject, erase the pencil in these areas. You might need to renew the clean spot on your eraser several times. Then lightly erase the lighter areas, working back over them with an HB pencil if you take off too much.

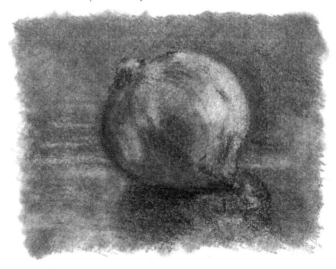

Review: If you had difficulty erasing, you might need to try a smoother paper—try using some cheap A4 office paper—as some sketch papers are difficult to erase. Your drawing should look fairly simple but solid, with soft edges. Did you start off with a mid-value that was really in the middle, or was it too light or too dark?

ASSIGNMENT: CRUMPLED PAPER DRAWING

Draw a piece of crumpled white or brown paper in graphite pencil. Use directional lighting to enhance the value range. If drawing the outlines first, do so very lightly.

A drawing of crumpled paper in progress

Creating Texture

Creating realistic textures in drawing is a matter of closely observing every detail of your subject's surface, and using the appropriate medium and technique to create an illusion of that surface on paper. Now we'll look at some common textures that you will come across in drawing and ways to draw them.

It's helpful to remember that you are trying to create an illusion. You will never exactly match the look of a surface—especially in black and white—though I have to admit, the masters of realism in graphite, like J. D. Hillberry and Mike Sibley, achieve astounding results. Extreme realism is achieved by very close observation of high-quality reference sources, combined with patient, detailed rendering and supplemented by a range of techniques to make the job easier and to facilitate creative expression. When sketching, you need to communicate this information to the viewer in a minimal fashion, but you still need to observe it accurately. The mind is good at putting clues together to understand what is going on in a picture, but the clues must be useful ones in order to create a convincing illusion.

Remember that highlights are highly reflected light and will always be much brighter than the light bouncing off your paper. You can heighten the visual illusion by deepening the mid and dark tones of the drawing.

Essential Elements in Texture Drawing

Paper surface is particularly important when creating textures. A velvety paper can help you create a soft, fuzzy look, while a smooth surface enables you to create the crisp highlights needed for reflective surfaces. For the varied textures required for a complete drawing, you might need to employ techniques such as lifting, incising, or rubbing to create the surface you need. Most realist artists prefer a smooth, durable surface such as Bristol board, but particular subjects—such as landscapes or teddy bears—might be well suited to a rougher surface.

Place several different types of paper together, and you'll notice a significant variation in color temperature. Some are pure white, some look cool—faintly blue— while others may have a warm cream tint. Grays tend to be cool or neutral. Pure white paper is important in any drawing where bright sunlight or intense highlights are going to be a feature. In other drawings, a slight tint can add warmth or character.

Choice of medium is another key element. Soft pencil used lightly skips over the surface, with light reflecting through dull, textured particles. Firmly used, sharp, soft pencil can create a dark, solid surface with a slight gloss. Harder pencils leave a smoother, finer particle. The increased amount of clay in harder pencils also makes a more matte, lighter gray particle. The addition of charcoal or carbon pencil adds a richer, darker black.

Something else to consider when creating texture is how you apply the pencil to the paper. When sketching, it is easy to fall into the habit of shading away without much thought. When creating fine textures, each pencil stroke becomes important. There are numerous techniques you can employ: place the pencil on the paper and lift it off in flicking strokes; "feather" the pencil, gradually applying it and lifting off in a somewhat circular action; place the pencil down, make the mark, and lift the pencil straight off; or stipple with a straight up-and-down dotting action. To make a dot with a harder pencil, use a twisting motion.

Basic pencil strokes

The graphite can be manipulated in various ways to create textural effects. Layering soft-over-hard or hard-over-soft pencil changes the appearance of shaded areas. "Burnishing" layers of pencil until the paper texture is filled polishes the graphite particles and creates a dense area of tonal value with a smooth sheen. Lifting the top layer of burnished graphite reduces the shine. Use of a blending stump (tortillon) creates soft blended effects and dulls the surface by reducing the light reflected through the particles.

Masking tape and Blu-Tack can be used to lift areas of graphite to create interesting, subtle textures.

Frottage is French for "rubbing." The rubbing effect is created by placing a textured object underneath the paper and rubbing with the side of a pencil or charcoal. Fairly thin paper and a moderately firm medium are required for the best results. Thick paper will not allow the texture to be picked up, while a soft medium tends to push into the surface and fill in the pattern.

Scraping into an area of graphite creates coarse, ragged lines. Incising—cutting out a section with a scalpel—creates crisp white lines, but should only be attempted on heavy paper or board. Both these effects are dramatic and irreversible, and must be tested before being used in a major piece.

Impressed line and stipple effects are created by using a fine, rounded point—such as a large darning needle or plastic knitting needle—to squash a fine line or dot into the surface of the paper. The point should not be so fine as to cut the paper. When shading is applied over the surface of the paper, the impressed lines stay clear.

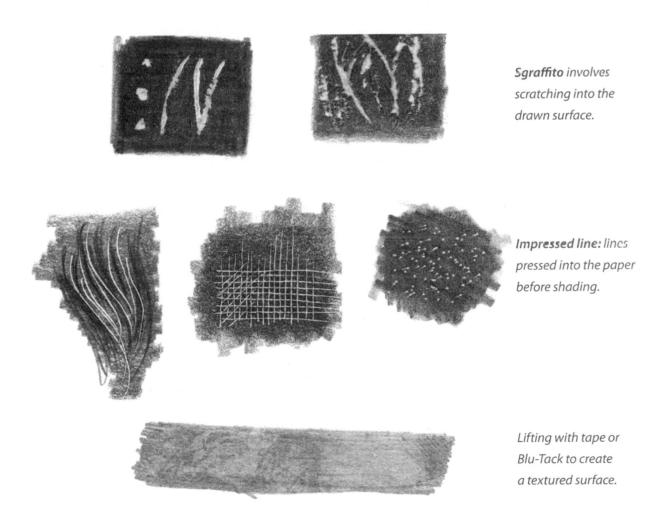

Sgraffito *involves scratching into the drawn surface.*

Impressed line: *lines pressed into the paper before shading.*

Lifting with tape or Blu-Tack to create a textured surface.

ASSIGNMENT: EXPLORING TEXTURE

Read through the previous paragraphs on applying and manipulating the pencil, with paper and pencils in hand. Experiment with each of the techniques mentioned.

Global Versus Local Tone

Global tone, or *global value*, is the approach to value drawing that you'll generally use when sketching. Basically, artists use value to describe form by allocating planes around an object at certain values and getting progressively darker around the object. Usually the actual fall of light is the reference point for this shading, with the colors, highlights, and shadows based on actual observation. However, small variations in surface quality are not really taken into account.

Local tone, or *local value*, is an approach to value drawing that involves observing value variations on an extremely fine level. Rather than being concerned with using shading to model the form, the artist seeks to accurately reproduce perceived values in a small, accurately drawn area, which come together to form a highly realistic representation of the object. Generally, local tone is used in conjunction with reference photographs, which enable the artist to focus on very fine details, but this approach can be used when drawing from life.

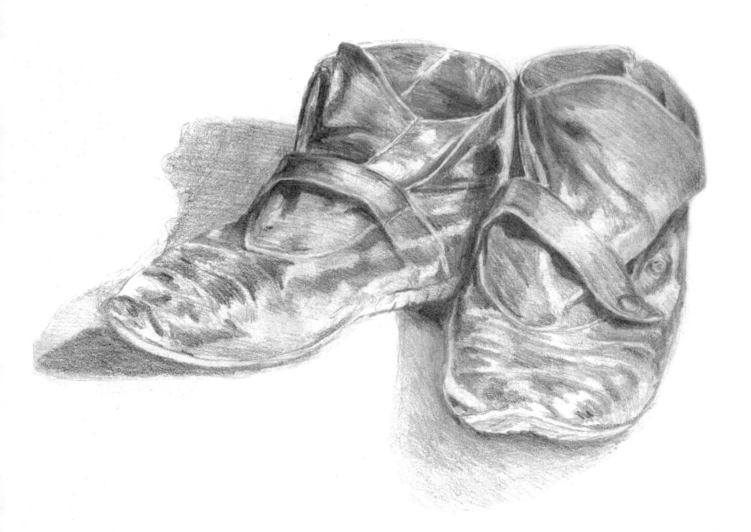

Drawing Specific Textures

When looking for a high level of realism from a photographic reference, some artists prefer to work on a small area at a time, carefully rendering each area of value. This approach can be successful with any texture, as you are observing small areas and rendering them minutely. If using this method, do a working drawing first to check your composition, and do the contour drawing lightly but precisely. You can also obtain a high level of realism when working from life, particularly if you take a very methodical approach to building a precise structure and contour drawing.

Shiny Surfaces

Most shiny surfaces have several complex elements. These include reflection, surface quality—including cast light and shadow—and in the case of glass, the background elements observed through the transparent areas. A general impression can be conveyed when sketching by implying these qualities with carefully chosen abbreviations of the visual effects. You know that wiggly line that cartoonists always do across windows, or the little curving four-square shape on balloons? They are suggested reflections.

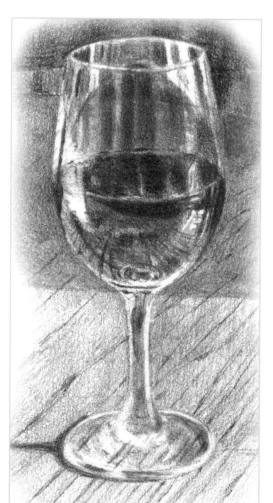

Highlights are probably the most important feature of drawing shiny surfaces, as these tell viewers that they are looking at a highly reflective surface. Observe these closely and reserve them carefully. If possible, choose a smooth surface for any drawing that involves a shiny surface. Coarse sketching paper won't allow you to get the smooth, even values you need, and it can be a little resistant to erasing; you need to be sure that your highlights are crisp and bright.

Glass has transparent and semitransparent areas where background elements show through, sometimes with refraction (bending of light). Also look for reflections of the surroundings. The distortions in these reflections can tell the viewer a great deal about the shape of the glass. You may also observe surface detail if there are any painted details, tints in the glass, fingerprints, or other marks.

Glass is a complex surface, transmitting and reflecting light.

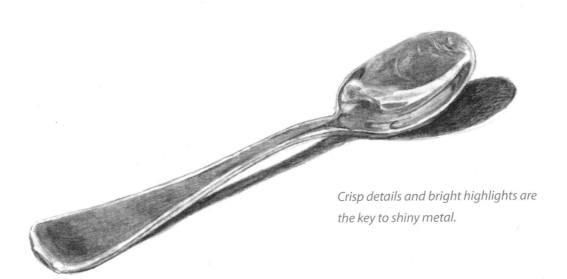

Crisp details and bright highlights are the key to shiny metal.

The degree of reflection from a metal surface depends on the type of metal and how highly finished it is. Highly polished metal is probably the easiest to draw; it is simply a case of closely observing the reflections on the surface. Rather than worrying about the color of the metal (gold, brass, copper), focus on the local tone and draw a small portion at a time, being sure to reserve highlights carefully. Colored metals will impart a hue to the reflections, but so long as you accurately observe each small area, the overall effect will be accurate.

Metal that has been scuffed, such as a spoon from the cutlery drawer, is the most difficult to draw, as the small scratches create a faint, dark indent with a light edge.

Jewelry can have very bright highlights or more muted ones, depending on the degree of polish and wear. Usually a jewel will have clearer highlights than the surrounding metal. Use a sharp pencil to carefully delineate precise facets. Pearls have a soft sheen, with a reflective surface, so use a blending stump very lightly to soften the modeling without filling the grain of the paper. Deepen dark values around jewelry to intensify the lights.

Notice the soft sheen and reflective surface of these pearls.

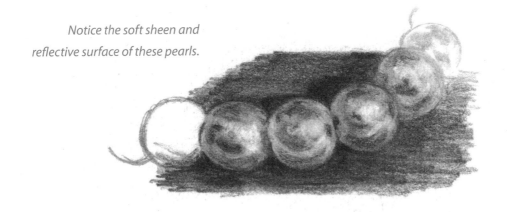

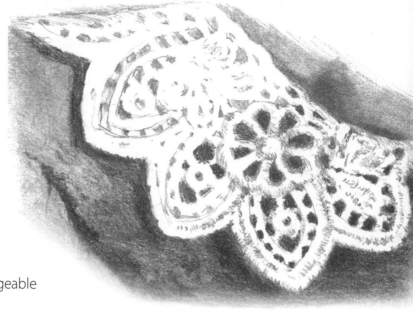

Fabrics

Fabric is a ridiculously broad term when speaking about texture. From velvet to watered silk taffeta, from an ethereal ballet skirt to a luxuriously embroidered gown—fabrics offer a mind-boggling array of colors and textures. So how do you approach drawing the stuff?

Let's break it up into some manageable components:

Structure: How does the fabric hang and fold? Does it have stiffness, or does it flow? Does it cling to the surface beneath, or does it drape loosely off projecting points?

Surface quality: Does the fabric have a velvety surface, an obvious weave, or a smooth surface? Is the pattern printed or woven?

Light: How much light is reflected from the highlights? Smooth cotton might have a faint sheen, while velvet has muted highlights. Very sheer fabrics can be highly reflective, while some will be transparent enough that you can see right through them.

By observing these qualities in your subject, you're already halfway to drawing them.

For smooth, reflective fabrics, use an approach similar to drawing metal: Create a smoothly shaded surface using medium-grade pencils, accurately represent crisp lights and shadows, and use a blending stump or hard-grade pencil to soften obvious paper grain. Use an eraser to lift out lighter areas.

For transparent fabrics, draw what you can see through it—sometimes drawing it a little stronger than needed and even drawing what you can't quite see under the fabric. Use your imagination to fill in the blanks, then use an eraser to "draw" the fabric, adding shading where there is a shadow on the surface. An eraser is also useful for lifting out lace patterns.

For coarse weaves, light shading with a soft pencil or stippling can be used to draw the dark gaps in the weave. This can then be shaded over to create the surface value.

Drawing printed patterns is largely a matter of patience. When sketching, try to avoid becoming too involved in patterns, handling them in a similar manner to other surface elements in your drawing.

Essential

When drawing any continuous feature—such as a tree branch, wood grain, a linear pattern, or any straight edge—that is broken by a surface detail or a small foreground object, continue drawing the line straight through, very lightly, before placing the interrupting detail. That way you'll avoid having any awkward-looking discontinuity in the line.

Timber

Timber is probably one of the most difficult textures to draw, and like fabric, comes in myriad types. Natural wood finishes are easier to draw than cheap laminates or stained pine, as the manufactured surface already looks artificial, which makes it look even more artificial when rendered in pencil. You'll need to consider the grain and color of the timber you are drawing, as well as any surface shine and surface patina (marks, dirt, or finger smudges). Correct perspective is essential when drawing timber, because its linear grain highlights any errors. Sketch the perspective elements first, doing a contour drawing and indicating any joins between strips of timber. Once you are happy with these, lightly draw the dark grain of the timber. Take your time and observe all the elements carefully.

Shade the body color of the timber surface, lightly blending with a stump as needed and working up the grain pattern. Use an eraser to lift out any surface highlights or light marks, then draw any dark marks and cast shadows across the surface. These may be crisp or blurred depending on the level of polish.

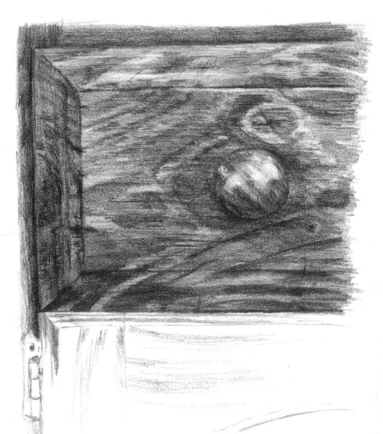

A drawing of a timber surface

Composition

Composition in drawing is the arrangement of shapes and lines within the picture. The basic principles of composition are simple ones, most of which you use intuitively. Art historians often get a bit overenthusiastic about this, drawing elaborate diagrams all over paintings, which often seem to bear little resemblance to the actual dynamics of the picture. Sometimes the elements are obvious, but composition shouldn't be forced. Look at the drawing and be sensitive to the way your eye naturally moves around it. By being aware of the principles involved, you can manipulate a composition to better express your creative aims and make the most of your pictorial space.

Using a Viewfinder

When taking photographs, people habitually aim at their subject's head, the center of interest. This results in a mile of sky above the subject's head, with their feet cut off! You'll find you tend to do the same thing when sketching, drawing the object of interest in the middle of the page. However when you start creating drawings as works of art, you need to consider how the subject sits within the frame, and create a fully composed picture.

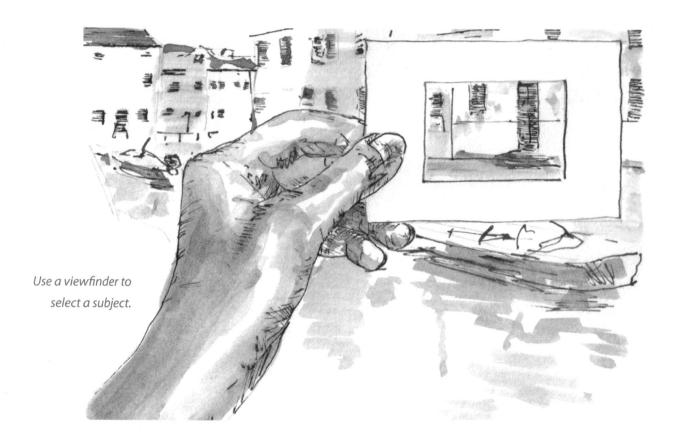

Use a viewfinder to select a subject.

Selecting a subject from a broad view, or trying to imagine how a subject might look when set on paper and defined by a frame, can sometimes be rather difficult. Prominent points of interest will always catch your attention, or lines will wander beyond your field of view. To better visualize your potential composition, try using a viewfinder. For landscapes in the photographic format of three by two, an empty 35mm slide frame is ideal. You can also cut small windows in pieces of card. To view closer subjects, you'll need a larger frame. Two L-shaped pieces of card are useful, as you can vary the proportions to suit the subject. Keep a piece of adhesive putty such as Blu-Tack in the overlapping corners to keep them in place should you wish to refer to the framed subject when drawing. Elaborate versions are available in art shops, but you'll find the homemade version works just as well!

The sketch pictured here takes in the whole scene. As a composition it is quite pleasing, and has potential to be developed into a complete drawing. Using the viewfinder reveals many more subjects and interesting details that are lost in a broad view.

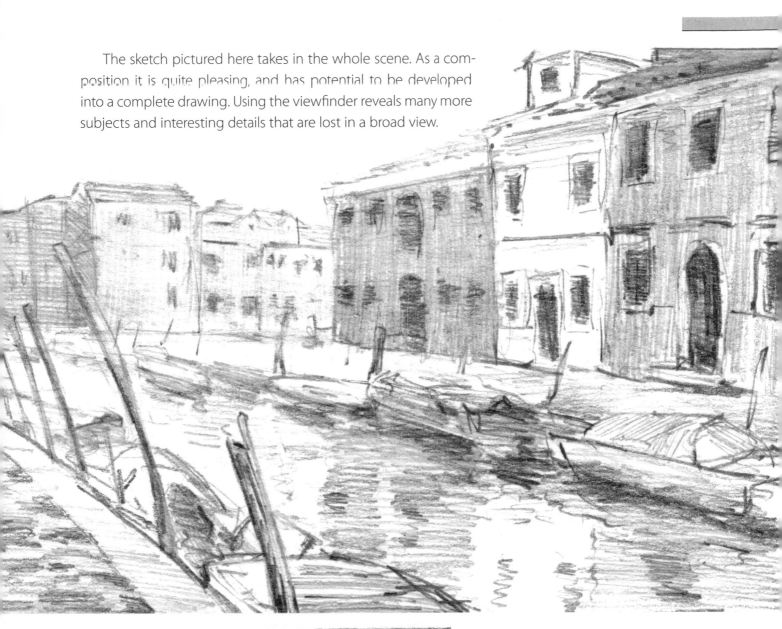

Every scene offers many creative possibilities.

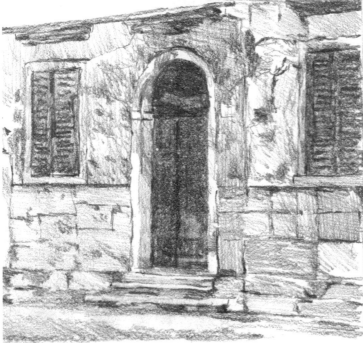

This view focuses on a detail to explore the interesting textures of the old building.

A narrower view completely changes the look of the scene, giving a tighter, urban feel. Adding a figure gives a human scale, while use of a different medium (in this case, pen and ink with diluted washes) dramatically changes the atmosphere of the picture.

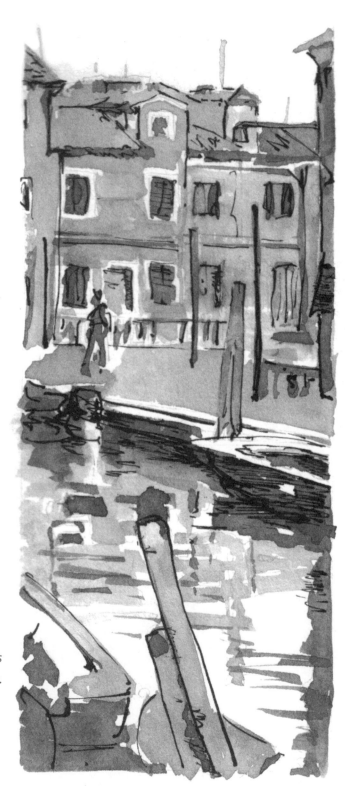

The portrait format works well in this example.

Picture Format

There are two formats traditionally used in Western painting, landscape and portrait. When format is spoken of, it is simply describing the size and shape of the picture, and does not mean that the subject is either landscape or portrait.

Portrait

Landscape

Portrait and landscape describe the orientation of the rectangular frame.

In landscape format, the horizontal edges of the picture are longer than the vertical sides. In portrait format, the horizontal edges are shorter than the vertical sides. Just remember that tall is equivalent to portrait, and wide is equivalent to landscape.

Essential

When taking photographs for reference material, take extra close-up and wide shots to give you the detail you'll need should you want to try different compositions later on. Bracketed exposures (shots taken faster and slower—or at wider and smaller apertures—than the optimum) may be needed to capture the detail in shadows and highlights.

From time to time you might find that a certain subject will warrant a less conventional format. A landscape might suit an elongated panoramic view, something similar to a wide-screen TV format or even wider. Similarly, a tall format would be required for a full-length portrait, a Chinese-style ink drawing, or some other tall subject, such as a waterfall.

The square is not a common format for pictures, as it offers particular problems in creating an interesting composition. However, there are occasions when it is useful (for example, when a square composition is needed for framing or display), so you might like to try experimenting with it.

Circular and other formats are uncommon and difficult to pull off successfully. You will notice images in art history incorporating archways and unusual shapes, particularly on the top edge of the image, usually produced as designs for fresco, altar pieces, or for a particular architectural setting. Later images sometimes employ these formats as an allusion to a historical image. These shapes can be fun to experiment with, but they are really of limited use and should be used with caution. Unusual formats often look contrived and generally create a load of compositional problems in themselves.

When you have set up or located your subject, use a viewfinder to place it within a frame. You may have a format in mind, or you may adjust your proportions until you find a pleasing arrangement. Use your two thumbs at right angles to make a rough frame if you don't have a viewfinder. Once you're in the habit of framing images, you'll find yourself doing it mentally without the need for a viewfinder.

Essential

Try asking questions to assess your composition. Does it seem dynamic, encouraging the eye to explore the piece, or is it static, quickly directing the eye to settle on the center of interest? Perhaps you can add or move a small detail to add balance or create energy and movement. Does your viewpoint show what you want to convey about your subject? Is the scale appropriate? Perhaps you might try zooming in or out.

Ideally, you will already have visualized your composition while viewing the subject. Once you have drawn an indication of the main lines and forms, you will begin to get a better idea of how well your composition is working. Consider how your eye enters and moves around the picture. Look at the relationship between the point of interest (your object or landscape feature) and the edges of the picture. Check that there is sufficient space below the subject, so that it doesn't seem to fall off the page.

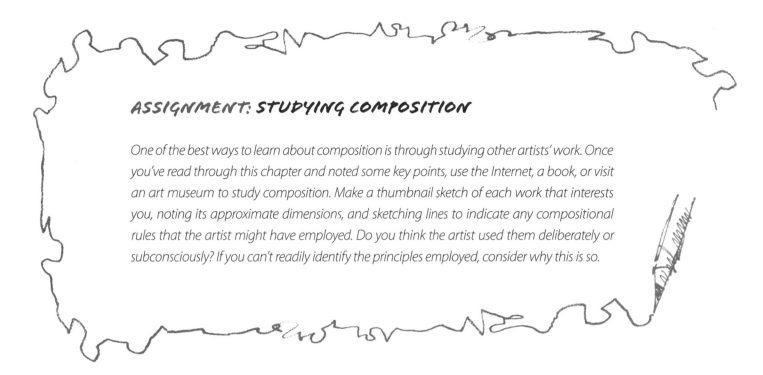

ASSIGNMENT: STUDYING COMPOSITION

One of the best ways to learn about composition is through studying other artists' work. Once you've read through this chapter and noted some key points, use the Internet, a book, or visit an art museum to study composition. Make a thumbnail sketch of each work that interests you, noting its approximate dimensions, and sketching lines to indicate any compositional rules that the artist might have employed. Do you think the artist used them deliberately or subconsciously? If you can't readily identify the principles employed, consider why this is so.

Constructing a Composition

While rules of composition are often artificial, they are nonetheless useful tools, especially when you are first learning to construct a composition. If you habitually shove your subject in the middle of the frame, deliberately employing these rules can be a great help. Remember that they aren't really rules; rather, they are guidelines to follow.

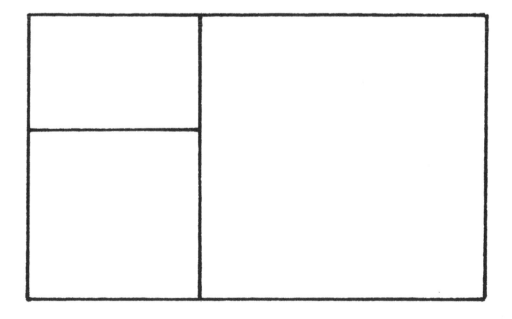

A rectangle divided according to "the golden section."

The Golden Section

The golden section (also called the golden ratio or golden mean) has fascinated those in the arts and sciences since classical times, when the presence of mathematical relationships in nature was considered evidence of the divine order of the universe. Strict rules were derived from mathematics and geometry that were applied to architecture, painting, and music. The golden section describes the relationship between two sides of a triangle. In a right-angled triangle with the sides designated as ABC, where AB is the short side, and BC is the long side, $AB : BC = BC : AC$. To use a "golden rectangle" with these proportions you have sides 5×3, 8×5, 21×13, and so on, with a perfect ratio of approximately 1.618:1, symbolized by the Greek letter phi. The larger the numbers in the equation, the closer their ratio gets to phi. These numbers can also be found in the Fibonacci sequence of 0, 1, 1, 2, 3, 5, 8, 13 (a number sequence in which the first two numbers equal the following number, and so on throughout the sequence).

Because these proportions were regarded as representing divinely ordained measures of beauty, artists used them as the basis for proportions in painting, sculpture, and architecture. You can use these proportions to determine the size of your frame, as well as divisions within that frame.

The Rule of Thirds

To avoid central compositions, especially the fault of a horizon cutting halfway across the picture, the frame is divided into thirds, like a tic-tac-toe board. The horizon should ideally be along one of the horizontals, with a center of interest at either one-third or two-thirds across the picture. The rule of thirds is more of a guide than a rule; it is helpful in that it gets you thinking along the right lines, but it needn't be strictly adhered to. Often you'll want a higher horizon for dramatic effect or will need to move the point of interest to balance other elements in the scene.

The rule of thirds is a simplified version of the golden section that photographers often employ to assist in framing their shots.

Dynamic Composition

Dynamic composition uses a diagonal drawn from the bottom left to the top right of the picture, with a right-angled line drawn from that diagonal to the bottom right corner. (To draw this, just slide a T-square along your diagonal until it touches the corner.) These lines give you the key directions of movement in your composition.

The rule of thirds is easy to visualize.

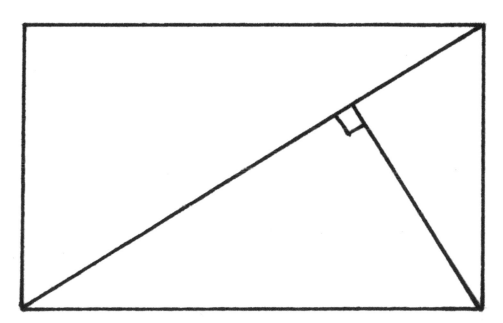

Dynamic composition

Symmetry

Symmetrical compositions usually have a static feel, drawing the eye quickly to the center of the composition and lacking interest. An asymmetrical arrangement creates interest and encourages the viewer's eye to explore the picture plane. Often mass and volume are used to counterbalance the visual power of line and form.

Line and Direction in Composition

Line is the most fundamental element in drawing. It can be expressed, as in a contour line, or it can be implied, where several elements are visually connected in some way.

A key role of line in a composition is to lead the viewer's eye through the picture. Beware of lines that shoot off out of a picture: you need to direct the lines back toward the center of interest, which will draw the viewer's eye back as well.

Because we read left-to-right, a diagonal moving toward the top-right corner tends to create the feeling of upward movement, a diagonal toward the top-left corner may suggest leaning backward or restraint, and a diagonal moving toward the bottom right suggests falling away.

Lines can also function as spatial dividers. Strong horizontals and verticals create a visual punctuation mark that separates space. Sometimes these work well to balance a piece and create a harmonious composition, but the effect can also be jarring and unpleasant. Often a strong line needs to be headed off before it reaches the edge of the composition by another line or form cutting cross it.

Strong composition pushes the viewer's eye along directional lines.

Curves are powerful compositional elements. The arc creates a flow that gently swings the viewer's gaze around the picture, dividing space less severely than a straight line, and often suggesting harmony and rhythm. The S-curve is particularly effective, and you'll find it in any number of pictures. You'll find it in landscapes, such as in the curve of a river or footpath weaving through a forest or mountainside; in figure drawings, maybe in the flowing robes draped over the subject; in depictions of animals, such as in the arc of a horse's neck; and in the curve of a bottle or bowl in a still life.

Lines dividing space

You'll find triangles are often featured in composition, with groups of three providing balance and dynamic tension. Base-heavy triangular composition can suggest stability, with a broad base giving a solid support to the mass. This is often used in portraiture. This type of arrangement sometimes needs to be balanced with a visual element across the upper part of the composition. Making one element higher or more offset creates asymmetry in triangular arrangements.

Triangular composition, with a balancing shape added to the corner

A typical S-curve

Mass and Volume

Mass and volume are suggested by modeling and placement. Tonal value can often imply weight: a small, dense, dark form can seem to have a similar feeling of mass to a larger, more open or lighter form. Don't confuse the actual weight of an object with its visual mass in drawing. It is up to you to express that real mass in visual terms.

Creating a darker, more solid rendering, placing the object lower on the picture plane, making it larger than other objects, and emphasizing volume are some approaches to achieving this. Mass is independent of size, however. Think of a primitive clay sculpture or the maquettes of British sculptor Henry Moore, which, while tiny, seem to possess an immense presence and solidity.

Balancing mass and volume

Relationship, Space, and Proximity

The arrangement of forms on a surface immediately suggests a relationship between them. Overlap implies that one form is in front of another. This is useful in constructing still life, where creating a slight overlap rather than leaving a gap helps to establish depth.

Close proximity suggests a close relationship in actual space, and can imply an emotional connection. Isolation of a single object from a group draws attention and suggests emotional separation, and can be used to single out a particular element of the composition.

The space between objects is relative; that is, if a certain spacing is used between some elements in a picture, that space will have a bearing on the interpretation of other spaces in the picture. Establishing patterns of spacing and breaking them, as in the placing of landscape elements such as trees, heightens the significance of the variation. The relationship of the object to the edges of the frame is also significant. The interaction of forms is so complex that clear rules can't always be defined. Try to sense the implications of the composition and the relationships between the various elements by studying the drawing. You will get better at this with practice.

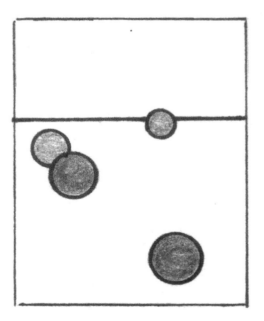

Proximity implies relationship.

Contrast

Contrast generally refers to contrast in value, describing big jumps from light to dark. Contrast is a powerful tool in composition. Areas of strong variation in tonal value attract the eye and have great energy, dominating the rest of the picture. Strong contrast across an image can create a feeling of visual "busyness," and carefully controlled contrast can creates a sense of rhythm or pattern. Limiting the degree of contrast within an image can be an effective tool.

Contrast in texture and pattern can be used to emphasize elements of the composition, whether these are realistically rendered or created by interesting mark-making. Contrasting scale can be used to create drama and heighten perspective.

High-contrast images catch the eye.

Framing

Framing can be a useful tool in leading the eye back into the picture. Elements that move around the top and sides of an image "contain" the image and send the viewer's eye back toward the center. In a landscape, for example, this might consist of a branch arcing out across the top of the scene.

Strong architectural elements—doorways, arches, or windows—can create a powerful feeling of looking out from an enclosed space. This can dramatically change the atmosphere of an otherwise open picture. Note that framing doesn't need to be as obvious as the example. Branches or subtle background elements can also be used to create a less-intrusive framing effect.

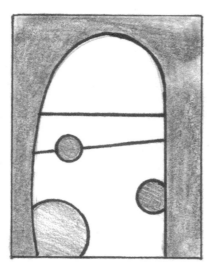

Framing closes in the view.

Keeping It Simple

When setting up a still life or looking for a scene to draw, you'll tend to want to include a million elements. There is the old barn, the broken tractor, the horse in the paddock, and the interesting fence, and . . . Before you know it, the picture is crowded and you don't know quite where to look. On the other hand, you need to have enough interest to keep the viewer intrigued.

You can simplify and unify compositions with a great many elements, such as a still life with lots of fruit, by using strong compositional lines, grouping the objects, and perhaps containing them. Elements should have some sort of logical relationship with each other as well. Choose a few points of interest, and eliminate superfluous elements—these can become subjects of other drawings.

Essential

Simple, strong compositions are usually the most powerful. Like music, which needs to have a clear melody or rhythm holding it together, a sense of direction or pattern gives the viewer something to latch on to; chaotic, unfocused compositions lose the viewer's interest quickly.

If things are looking a little bare—say, you have a house on a hill—try cropping the composition to focus attention and allow small details to become separate points of interest, such as areas of vegetation or the pattern of windows. Alternatively, introduce an element from outside the composition, such as drawing a tree a little closer to other objects than it really is.

Thumbnail Sketches and Working Drawings

Thumbnails are little sketches that establish the key features of a composition, as reminder notes about a subject, or to test a layout before commencing a larger drawing. They are usually not much bigger than a couple of inches, depending on the scale of the subject. When drawing a thumbnail sketch, look for the big areas of dark and light and key directions moving through the composition. These will indicate the strength or weakness of your overall composition, and can indicate which elements are likely to dominate the composition.

Thumbnail drawings are useful for testing potential compositions.

Working drawings are more detailed sketches that are completed once the basic composition is established. In a working drawing, the contours are reasonably accurate and tonal values are included. If you are going to spend many hours working on a highly realistic drawing, it is well worth taking the time to do a more detailed working-drawing first, before you set out on the real thing. Once you've spent hours on painstaking rendering, you really don't want to discover fundamental flaws in your composition. This type of drawing does not always lend itself well to correction, with "ghost" images persisting (faint traces of the erased image) despite your best efforts. Problems such as overpowering or clashing patterns, strong values in background areas that jump forward, or perspective distortions are more readily observed in a completed working drawing. This is particularly relevant if you use multiple photographic references.

Thumbnail Drawing

Aim: To explore compositional possibilities using thumbnail drawings

Materials: Paper, pencils

Time: 20 minutes

Set Up: Set up a still life or interior view, select a landscape view, have someone pose for you, or use a photographic reference. If using a photograph, choose something with a wide enough view to allow for a selection of various detailed views. Landscape photographs and interior scenes are ideal, offering the best range of possibilities.

Start Drawing: Do a midsized sketch—between sizes A5 and A4—of your overall scene, taking as broad a view as possible. Then fill a page with small (a couple of inches) thumbnail sketches, finding at least two different portrait format views and two landscape format views of the subject. Include reasonably broad views of the subject, a closely cropped view, and a close-up, detailed view.

Explore Further: Create some detailed drawings using your best thumbnails as a guide, or try creating some unconventional formats, such as circular or square compositions.

Review: Were you tempted to get very involved, trying to squeeze a lot of detail into your drawings? Try to look for the key elements. If you can't find at least four well-composed, differing views, try drawing a different subject.

Chapter 6

Sketchbook Drawing

Sketchbooks serve many functions for an artist. On the most basic level, they are a great way to keep all your drawings in one place, and the binding keeps them safe from damage. A sketchbook is also a wonderful way to record your progress, and looking back over old work enables you to clearly see how your drawing has developed and helps you to identify areas that need work. Once you are in the habit of keeping a sketchbook, you'll find that it becomes your constant companion, and the way you use it will become highly personal.

Choosing a Sketchbook

Selecting a sketchbook is largely a matter of taste, and you'll probably have a few different ones before you settle on a type that suits you best. Your choice will depend your budget, the different mediums you use, your subject matter, and your approach to keeping a sketchbook.

Binding

A spiral-bound sketchbook is useful when you want to be able to remove pages, and you have the advantage of being able to lay the book flat or fold it back. A bulky wire spiral can be a bit of an inconvenience when storing books. Hardback sketchbooks are probably the most popular choice, and have the advantage of allowing you to work across the gutter (middle) if you want to sketch a large scene. They are durable and look very attractive. Do beware of fancy varieties with paper that is unsuitable for drawing, however.

Quality

Inexpensive diary-type sketchbooks are good for everyday use, and the reasonable cost encourages experimentation and informal sketching, which is the purpose of an everyday sketchbook. A better-quality art-paper sketchbook suits an artist who wants to use it for more developed drawings, or one who does a lot of value drawing and find the less-expensive paper too coarse. Luxury artist's sketchbooks are a pleasure to use and an excellent investment for a serious artist, so long as you aren't going to be put off by the risk of wasting a page of beautiful paper. Watercolor paper sketchbooks are ideal if you like to use ink washes or watercolor. You can use watercolor pencils to make on-location color notes for later completion.

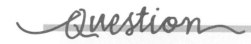

When starting out, how many sketchbooks should I keep? One? At least two? What makes sense?
Don't be obsessive about your sketchbook. If you keep one for display, keep another everyday sketchbook. Perhaps you will decide not to show your sketchbook to people—that way you won't censor your work as you go. You need freedom to experiment without worrying about the results, so that you can cart around a sketchbook and use it in any environment.

Sketchbook Size

Size A4 is the most useful everyday sketchbook. If you prefer to make large sketches, you might prefer an A3 sketchbook. A5 is really too small for useful drawing, though it can be handy for field notes when a larger sketchbook isn't an option.

An alternative to keeping a bound sketchbook is to use loose paper in a folder. This is a convenient alternative that many artists prefer, and would be a good choice if you like to use a variety of papers or want to be able to discard or use the drawings without spoiling a book. If you use this option, be sure to date the corner of each page so that you have a record of when the drawing was done.

Caring for Your Sketchbook Drawings

Most sketchbooks get tossed into a bag and dragged around the countryside without too much care and survive very well. To give your sketchbook a little extra protection when traveling, try keeping it in a large plastic bag—a simple way to save it from disaster should you have a misadventure with an ink bottle or soda can. Store it out of the bag to keep it from getting moldy. If using pen and ink, make sure your drawing is fully dry before closing the book. Keep a couple of sheets of blotting paper to place between pages just in case. Charcoal can be a bit of a problem with sketchbooks, as the coarse particles seem to get everywhere. You can spray fixative on sketchbook drawings just as you do larger pieces, being sure to allow it to dry well before closing the book. Use a large brush to flick away loose particles. If you work on both sides of the page with soft graphite pencil or charcoal, keep some pieces of jewelers' tissue trimmed to size to place between the pages. (Jeweler's tissue is a crisp, extremely lightweight paper, something like baking paper. Most art stores should stock something similar.)

Alert

Put together a portable sketch kit with an A5 sketchbook, pencils, eraser, and a sharpener with a shavings' container, and keep it handy in your car's glove compartment or in a backpack for unexpected sketching opportunities. Add a disposable camera, and you'll be ready to capture any subject that comes your way.

Approaches to Sketchbooking

Some artists keep a sketchbook that is more like a journal, full of written notes and newspaper clippings, interspersed with thumbnail sketches and ideas. Other artists use a sketchbook purely for drawing, filling it with almost-finished drawings that are works of art in their own right. Sketchbooks can be a wonderful resource when you are stuck in the creative doldrums, as you can look back through old sketchbooks and find unfinished ideas to work on, or revisit a favorite subject that worked well. They are also helpful whenever you doubt your own ability, as you can see how much you've improved and find good drawings that remind you that you really can draw. A sketchbook can also be a great place to keep together all those experiments when you tested different techniques and mediums.

Relaxed ink sketches.

Finding Time to Draw

Like any skill, drawing ability develops best when practiced daily, or at least on a regular basis. An everyday sketchbook is perfect for this frequent practice, and becomes almost like a daily diary. Making time to draw can be a challenge when you have a busy life, and fitting a new habit into your routine takes time. Try to schedule a time where you can fit a half-hour into your day to sketch. If you work outside your home, lunchtimes can be ideal, and if you commute to work, the time you spend on the bus or train is also a good time to draw. Be aware that some people might feel uncomfortable with being sketched, and always ask first if you want to draw your workmates or even strangers—don't assume they'll be flattered. Often your environment will provide a subject—even a simple coffee cup or a satchel slung on a chair, can serve as a good subject so that you can get in some useful practice. Tape an envelope inside the front cover of your sketchbook to carry reference photos for times when you can't find a subject.

Alert

Overenthusiasm soon fizzles out, and the four-pages-a-day soon becomes one a week, maybe. Settle on a realistic aim—whether it's one page daily or twice weekly. Remember, a new habit takes time to form; you'll need to schedule sketching sessions to start with.

Drawing often needs to be treated as a bit of a luxury, taking the place of other activities such as watching television.

Beware of the tendency to wait until you feel inspired in order to work. Inspiration is unreliable at the best of times, and it is easily overpowered by the demands of everyday life. Nurture your drawing skills diligently, and when inspiration strikes, you'll be able to take advantage of it. A tonal value study or contour drawing doesn't require inspiration to be of value, so even if you are feeling uncreative, try to spend some time working anyway.

Working with a favorite theme can encourage creativity, and it can be rewarding to explore possibilities and rework compositions with familiar subjects. It is also important to look for ways to break out and try something different from time to time. Remember too that a new technique can take time to learn, so be prepared for failures and keep trying. If you can get in the habit of sketching often, you might find that you create some unexpected keepsakes.

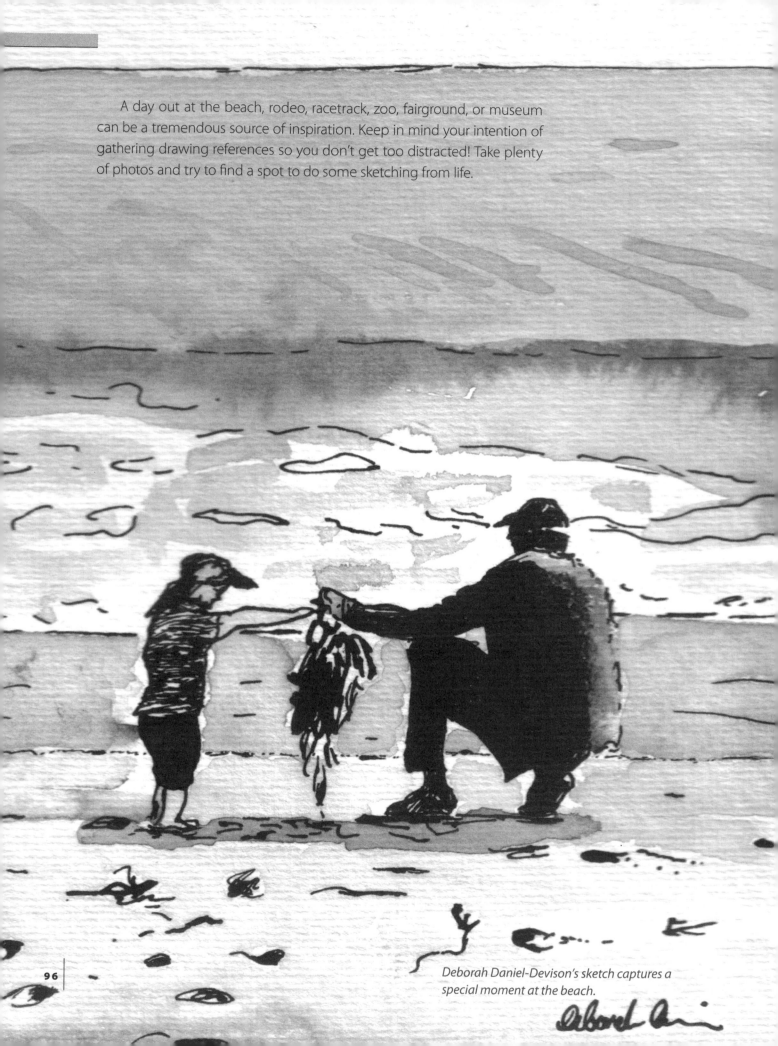

A day out at the beach, rodeo, racetrack, zoo, fairground, or museum can be a tremendous source of inspiration. Keep in mind your intention of gathering drawing references so you don't get too distracted! Take plenty of photos and try to find a spot to do some sketching from life.

Deborah Daniel-Devison's sketch captures a special moment at the beach.

Sketchbook Projects

Some people seem blessed with a natural creative urge that can barely be contained and are forever coming up with original ideas and finding constant inspiration in daily life. For the rest of us, there are often times when we feel like drawing, but we are at a loss regarding a subject. Here are some projects to get your sketchbook started. You might not want to do them all at once, but come back to them when you get stuck for ideas.

Finding a friend who shares your creative urge can be a great way to develop the drawing habit, especially if you are able to schedule a regular time to meet and work. Community art groups get together often and are an excellent way to meet other artists in your area.

Sketching action is a great practice
for your visual memory.

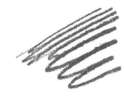

Sketchbook Project 1: From Object to Subject

An ink drawing of binoculars

Aim: To explore different aspects of a single object

Materials: Sketchbook, range of pencils, eraser

Time: Varies for each drawing

Set Up: Choose a favorite object, something that you feel some sort of affection for or connection to. This might be a favorite mug, an item of clothing, or your old boots. If you aren't confident enough to tackle something complex, choose a piece of fruit or a vegetable.

Start Drawing:

Day 1: Do a blind contour drawing of the object. Do a regular contour drawing of the object. Write why you chose the object. What attributes make it a good subject?

Day 2: Do two structural drawings of the same object, one with line only, and one with hatching to help define the form. Write a note about what attributes of the object make viewing its structure easy or difficult.

Day 3: Create a detailed value drawing of your object. Remember to use lighting to help model the form. Write a few lines about the drawing. What do you like about it? What could be better?

Day 4: Create a two-dimensional, decorative design based on your object. Use a pure contour (silhouette) and an elaborate background. Use contrasting shapes, patterns, and textures to create visual interest. Try to relate your choices to the object in some way. Write about your choice of design elements, and why they do or don't relate to the object.

Day 5: Use the library or Internet to find out about the early Cubist paintings of Picasso and Juan Gris. Create a cubist-style composition based around your object, using segments viewed from different angles. If you find it difficult, try drawing several contour drawings from dramatically different angles, then cut them out and cut them into pieces. Use the pieces to create a picture. Write about your feelings about the abstract composition. Did you enjoy the freedom, or did you feel a bit lost?

Sketchbook Project 2: Changing Light

Aim: To explore how different lighting affects a scene

Materials: Sketchbook, range of pencils, eraser

Time: 30 to 45 minutes per drawing

Set Up: Choose a scene around your home that you will be able to observe at different times of the day. A corner of a garden is ideal, or it might be the view from a window. These drawings will be best done in autumn or spring when the light changes dramatically during the day. Choose a comfortable vantage spot that you can easily return to at various times.

If you can't find a suitable outdoor location or view, try this exercise with a still life set up in a window.

Start Drawing:

Day 1: Draw your scene at midday. For your first drawing, allow plenty of time for careful observation, recording every detail. Try to pay particular attention to accurate tonal values.

Day 2: Get up very early, and draw your scene first thing in the morning. Note the direction of light and length of shadows. Look for dewdrops on plants or early morning mist. Urban scenes might have glints of sunshine or wet roads.

Day 3: Draw your scene in the late afternoon or evening. Does the air have balmy warmth or is it cool? Consider using a touch of color to cool or warm your drawing. Look for strong contrasts, direction of light, and the quality of the air.

Day 4: You might like to try drawing your scene at night. Remember that the sky isn't necessarily black—there are still sources of light at night. Squint your eyes and carefully consider the tonal values in your scene. Use directional mark-making to help distinguish areas of similar value. Try using charcoal highlighted with white chalk.

ASSIGNMENT: THE DAILY NEWS

Artists often create art in response to the events around them. The aim of this project is not to illustrate an event—though your drawing may take this form—but to express how you feel and think about something. You might like to take an image from the news as a starting point, or you may find that simply reading the description of an event might suggest a visual image. Think about the many means you have at your disposal to express your feelings: strong or restrained mark-making, balanced or asymmetrical composition, subtle or dramatic contrast. You could take the viewpoint of a bystander or a participant in the action. You might want to tell your story through a series of pictures.

Chances are you'll have a strong response to current events in the world, with war and natural disasters too often in the headlines. Try looking for a positive message—a human-interest story or bit of good news.

ASSIGNMENT: INSPIRED BY SCIENCE

Science and nature are full of amazing patterns. Think of the DNA spiral, the Fibonacci sequence, molecular structures, microorganisms, and subatomic particles. Take a look through any science book or magazine and you'll find all kinds of unusual diagrams and photographs. Find some that interest you, and use them to create a series of abstract drawings. Look for interesting lines, and consider compositional issues—balance, movement, and direction.

Sketching for Painting

Sketching on location is a useful way of recording your immediate response to a subject, and it can capture feelings and thoughts far better than any camera. A sketch enables you to focus on the essential features, and it records the energy of a subject that you might want to develop more fully in a painting. Painters also use sketching as an information-gathering exercise.

While photography is an efficient and useful tool, a sketch has certain advantages. You are using your two eyes to observe the subject, so the information you record in a drawing conveys the sense of three dimensions, while a camera, depending on lighting and a host of other factors, can often make things look flat. Later in the studio, with only a photographic reference, it can be difficult to recapture the sense of depth that you felt in the original scene. A drawing of a carefully observed scene can help you rediscover the scene's many characteristics. Carelessly used zoom lenses can result in distortion, and it can be very frustrating trying to draw from a photograph that puts vertical buildings in acute perspective. An on-the-spot drawing is a valuable resource that can give you a great deal of useful information.

If you are a painter, you probably want to include a small set of color or watercolor pencils, or a field watercolor box, in your sketching kit. This will enable you to record at least an approximation of the colors for later painting. Alternatively, you can simply note brief descriptions of color. Some painters even develop their own code of abbreviations for longer color names. You might like to paint a color key with a range of hues for common mixes, with some sky blues, greens, grays, and browns, depending on your favorite subject. This will help you identify which specific shade to use. Simply number them and indicate the number on your sketch.

The added bonus of using sketches as the basis for painting is that, for some reason, a sketch encourages you to use the information creatively, while a photograph can often be very binding. Its assertion of realism seems to demand that you are faithful in representing every surface detail, while a sketch serves as a reminder of something seen, but leaves you free to continue to reinvent and interpret it.

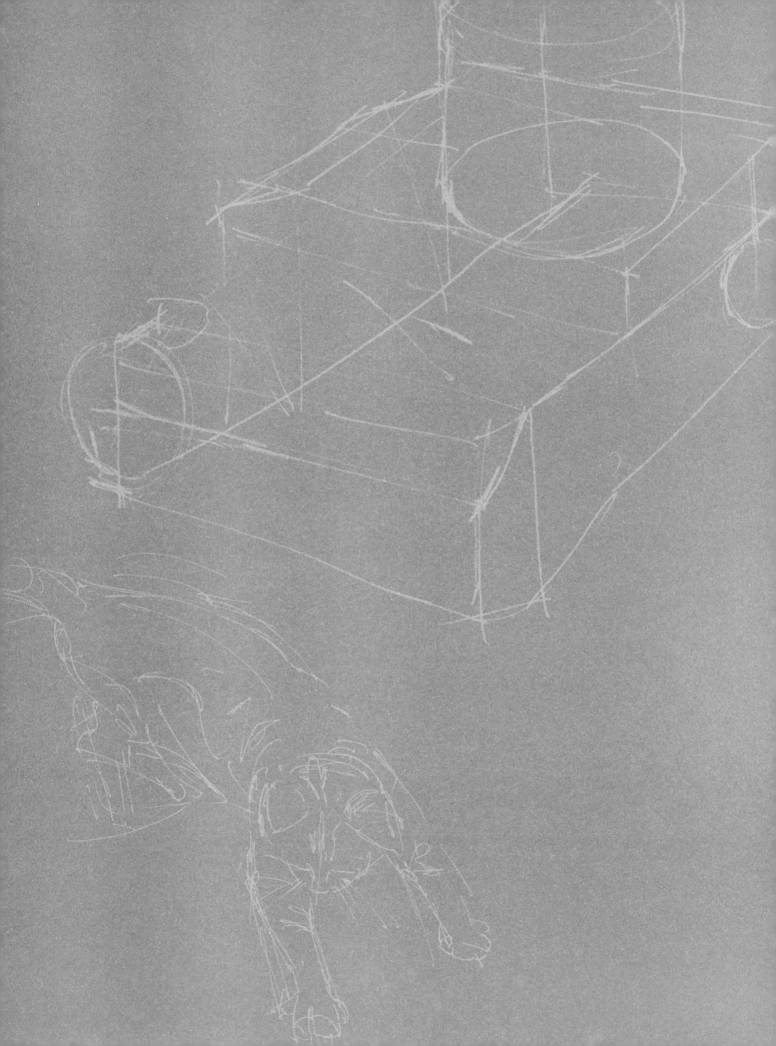

Chapter 7
Studio Tips

Artist have always relied on good craftsmanship and the effective use of tools and technology. Whether a traditional artist's aid such as a grid or the latest computer graphics program, the right tools and techniques can help you develop skills, and speed up the process of getting your creative vision down on paper.

Tools Instead of Rules: Aids to Drawing

For centuries, artists have been using various aids for drawing, with Albrecht Durer's perspective machine—a complex device for translating points from the subject onto a drawing plane—one of the most famous. But for some reason, traditionalists insist that artists should stick to using only the naked eye and a pencil—that anything else is "cheating." David Hockney's book *Secret Knowledge: Rediscovering the Lost Techniques of the Old Masters* created a storm of controversy over his claim that many of the old masters used optical devices to assist in their drawing. The debate still flares up here and there, but ultimately, it doesn't matter; artists make the marks, and as the renowned illustrator Glen Vilppu says, "There are no rules, only tools." To say that a "real artist" doesn't use technology to aid in her artwork, one might as well claim that a "real chef" doesn't use a nonstick pan or a "real musician" doesn't use metal guitar strings. Technology might make the artist's job a little easier, but it doesn't replace creativity or craftsmanship. The following is a list of some of the tools available to artists:

> **Artists' glass:** This tool is essentially a framed glass panel on which the artist sketches the scene beyond, enabling the accurate representation of perspective. An attached viewfinder helps the artist maintain a constant viewpoint, to eliminate error. You can make your own by securely taping the glass into an old picture frame and using an easel to hold it in place. A grid of squares is drawn on the glass to provide reference points when drawing. You can use a loop of wire to make a viewfinder: a quarter-inch circle, on a 6-inch stem of wire—like a bubble-blowing wand—taped to the top of the frame. Line up the center of the loop with the middle of the glass. (Be careful with the glass, and your eye!) You can see an authentic artist's glass in the Peter Greenaway movie *The Draughtsman's Contract*.

> **Camera lucida:** The camera lucida is basically a glass prism, through which the artist peers to see an image of the subject superimposed upon the paper surface. David Hockney's claim that Ingres used a camera lucida generated a great deal of interest in the device, but they are awkward to set up and use. At best they might be of some assistance to the still-life or portrait artist, used along with an easel, when a digital camera is not available. Otherwise, they are of little real value to the artist.

Being an artist isn't about age, fashion, or social standing. Creativity is not about following some set of rules; it is about producing artwork. The essence of being an artist is simply spending time making art, drawing, painting, or sculpting, in some form or other.

> **Opaque projectors:** A great timesaver, opaque projectors are used to project reference images or artwork—especially a detailed layout sketch—onto a drawing surface. These are particularly useful when using Bristol board or heavyweight watercolor paper, which is not suitable for tracing or image enlarging.

> **Pantograph:** This tool is used for copying an outline, either at directly, or at a smaller or larger scale; most are not particularly adjustable. It has two hinged V-shaped pieces of plastic or timber, one inverted and placed so that the legs overlap. One end is fixed to the table, and the drawing is placed under the stylus at the point of one V. The paper under the pencil is fixed in the top of the other. These instruments are almost as cumbersome to use as they are to describe.

> **Light box:** These are immensely useful for tracing drawings to lightweight paper. A light box is simply a box containing light bulbs, with a frosted glass lid. If you don't have one, a window does the same job. Just tape your drawing to a sunny window, and tape your paper over it. Don't try to just hold it—you'll invariably move the paper! If you work at night, use a piece of Perspex held up to the light.

Alert

While drawing aids are useful tools, don't let any of these methods become a crutch, or you'll end up artistically crippled. Always practice drawing and sketching from life, even if it is only a small exercise, to keep your eye, hand, and mind in top form.

Squaring Off: Using a Grid

Perhaps the simplest of all drawing aids is the humble grid. You'll find them under fancy names, such as the Durer Grid available from art stores. These are nice, but you can easily make your own. If you are trying to train your eye and develop confidence in your own ability, using a grid is a good transition from tracing to free contour drawing.

While you are learning, make your grid the same size on both your photo and on your drawing paper. Really, it doesn't matter; you are not measuring actual distances when drawing the lines, but approximate positions (for instance, this line is one-third of the way across the square). So, you can actually make the grid any size you like. But to begin with, stick with the same size for both. When you first do a grid drawing, choose a very simple subject, with a fairly small picture, and just do a few squares—something that fits inside a grid of four by three, one-inch squares is ideal.

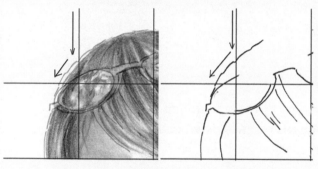

Gridding up the photograph

Drawing a Portrait with a Grid

To successfully use a grid to copy a photograph, your photo needs to be quite large and clear. You can't draw what you can't see, so select your photo with care. You may wish to enlarge it using a photocopier or computer.

1 Draw a grid on your photograph. One-inch squares are a good starting point. If you don't want to spoil your photo, use a photocopy, or put the photo in a plastic document sleeve. Count how many squares up and down you need, and draw a grid of the same size on your paper. Draw as lightly as possible, as you will need to erase any pencil marks later.

2 Follow along the first grid line that crosses part of the image. Find the corresponding place on the drawing grid, and begin drawing. Follow the outline of the photograph, matching the shape and observing where it crosses the next line to mark the line on your paper in the same spot. If you find this difficult, begin by doing a few squares at a time.

3 Continue drawing until you have enough visual information to begin shading your drawing. Include indications of important areas of highlight and shadow. Before you start shading, you will have to carefully erase all your grid lines, repairing any erased contour lines as you go.

Draw a square at a time.

The completed line drawing places
the important details.

Using a Grid in Still Life

Just as grids can be used when copying photographs, they can also be of assistance with still-life drawing. Draw a fairly large grid—with two- or three-inch squares—on a piece of card, and prop it behind your still life. It's important to remember that the grid does not need to be the exact same size on your paper! Because you are standing back, it looks smaller, and you are not measuring distances; you are judging their relative proportions.

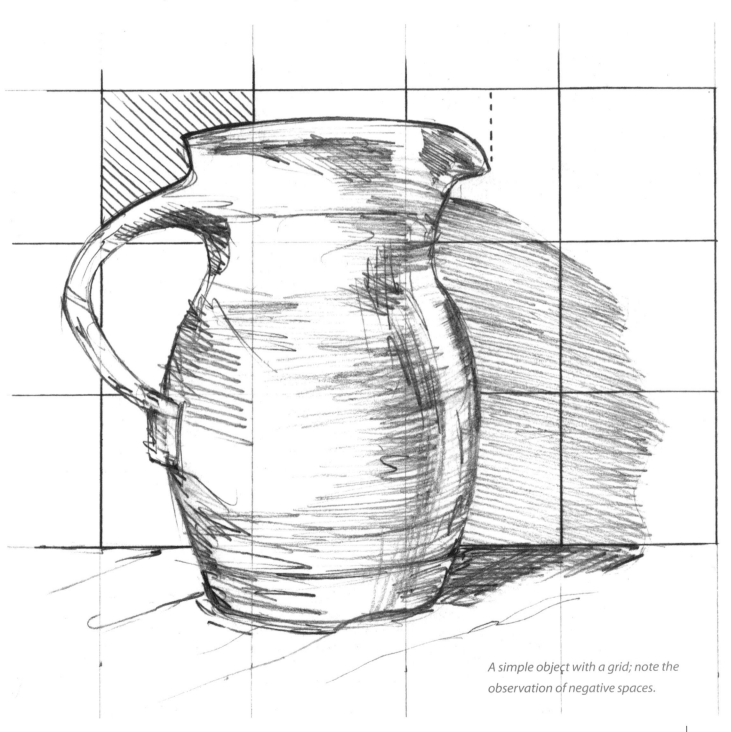

A simple object with a grid; note the observation of negative spaces.

When drawing, be sure to keep your head in the same spot, and try closing your non-dominant eye when looking at the subject to minimize movement. You'll notice that if you move your head slightly sideways, the object seems to move in relation to the background. This isn't helpful when you are using the background to place your object! Essentially, the grid lines are fixed reference points. Observe where each line and curve of the object appears on the grid you've placed behind it, and simply make similar marks in the corresponding grids on your paper.

Essential

The dominant eye is the one that you naturally use to look through a camera viewfinder or telescope. To check which eye is your dominant eye, line up two vertical objects, one near and one far—two doorframes are ideal. View each frame with both eyes, then shut one and view each doorframe with just one eye. With one eye, the distant object should shift markedly in relation to the near object. This in your nondominant eye. With your dominant eye, the object only seems to move a little, if at all.

Once you've finished the outline drawing, erase the grid carefully, and continue with your drawing. You can still use this method if you want to include background detail in your drawing, using the grid to accurately place your foreground, then using the foreground elements as reference points when drawing the rest of the picture.

The Durer Grid is a grid made of elastic supported on a free-standing frame. You can make your own out of an old picture frame, using elastic or string to make the grid. You can prop it up with a book, or make some legs out of scraps of timber. You place the grid in front of your subject and use it in the same way as the drawn grid.

Using Computers

Experimenting with computers can be quite fun. A lot of creative people have an aversion to reading instructions and are daunted by computers, but you'll find that most computer programs are really very user-friendly. Browse through the instruction manual or the built-in help files and you'll soon be navigating the menus like a pro. Rather than trying to learn everything at once, set yourself a task at a time to learn. For example, learn how to scan an image; how to change the size and resolution of the image; how these changes affect the appearance onscreen and when printed; what the different file formats are (especially .tif, .jpg, and .gif), and what each type is best used for; how to crop an image; and how to adjust tonal values, brightness, and contrast. Once you've mastered these basics, you can take off and experiment with manipulating images. There are also many Internet sites, such as *http://graphicssoft.about.com*, that offer helpful tutorials.

Essential

Use your computer to experiment with composition. Try your portrait with different backgrounds, add a more interesting sky to your landscape, or add some flowers to your still life. It is easy to manipulate tonal values onscreen, and the crop tool allows you to experiment with different formats. Use the freehand select tool to cut details out of one picture and paste them into another.

Computer printouts or photocopies are also useful for experimenting with composition, if you prefer to work offscreen. You can also use a copy or printout to try techniques or make major changes. When ink drawing, try scanning your line drawing by using a print to try out ink washes before working on your good drawing.

Using a computer printout of an outline to experiment with ink washes

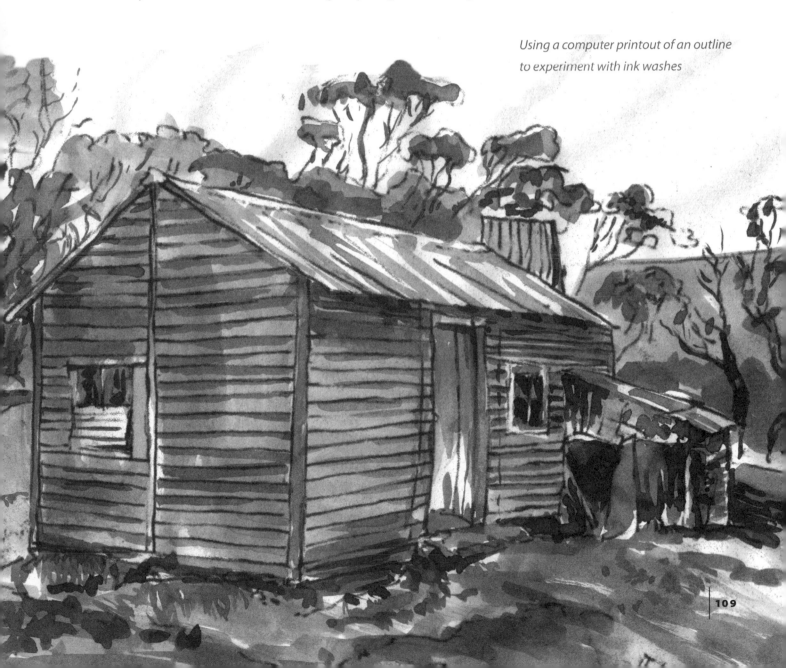

Getting Detail from Photographs

A surprising amount of detail can be hidden in the shadows of 35mm photographic prints. Scan your photographs at high resolution and use a tone adjustment function to lighten the darks, revealing detail. A good-quality photograph can also be enlarged considerably without much loss of detail, depending on your scanner. This can be very useful when your resource image has small details that you want to enlarge for use as reference material, whether to draw fine detail or to pick out a subject from a larger composition. Use crop and resize functions to create larger images from small features.

Scanning Drawings

Regular desktop scanners do a reasonable job of scanning drawings. It's a good idea to scan your drawing at the highest resolution possible, and save an unedited copy in your graphics program's native file format. Keep an archive of your unedited scans as read-only files for future reference, especially if your drawing is on fragile paper or in a fugitive (fading) medium such as a Bic pen or cheap watercolor. For screen display and printing, you'll probably want to edit your image a little. The dispersion of the scanner's light from the bright white paper and the shiny surface of the graphite makes graphite pencil drawings look less substantial than they are, so they generally need the darker tones boosted a little The graphics program scans your drawing as lots of tiny dots; higher resolution means more dots, and more detail. Resolution is measured in dots per inch (dpi). High resolution, around 300 dpi or higher, is needed for fine printing, especially photo-quality prints, but for onscreen viewing, you only need 72 dpi. Smaller resolution also makes the file size smaller, which is important for Internet use, should you want to place your image on a Web site or e-mail them to someone. Use the "resize" or "resample" function in your graphics editor to select the resolution of your image.

The Internet

The Internet has many online art galleries, which offer you the opportunity to study great works of art without leaving home. Do be aware of the limitations of digital information—file size restrictions can significantly reduce the size of the image, with a corresponding loss of detail. There are also many drawing galleries and instructional Web sites that offer ideas and tips, and often forums where you can swap ideas with other artists. You might like to visit my Web site at *http://drawsketch.about.com.*

There are also many sources of copyright-free images. The Library of Congress Web site (*www.loc.gov*) has an extensive online collection including historical images and drawings, many of which are in the public domain. You can print these and use them as reference material for your drawing, or simply study them online (be sure to read the terms and conditions for the particular collection you are browsing).

Using Photography

Drawing from life has many advantages, not the least of which is the ability of our eyes to perceive three-dimensional space, judging depth. Because of this, and the slightly different information that our eyes gather, drawings done from life always look a little different and usually more solid than those done from a photograph. However, you do not always have the advantage of a patient model or fine weather, and photographs offer many advantages of their own, such as recording fine detail and making it easier to reproduce complex surfaces. Most of us enjoy creating drawings from favorite photographs, and it is excellent practice in observing detail and matching values accurately.

When using photographs—if the aim is to achieve an accurate final result rather than to practice observation—it is perfectly okay to trace, at least to mark the placement of the main features. If the proportions of your drawing are off by even a fraction of an inch, it can mean the difference between creating a "likeness" and an image that in no way resembles the subject. You don't have to trace if you prefer not to, but you should feel free to make the process easier by tracing or transferring (with graphite carbon paper) as much information as you need, or at least the major "landmarks" of the subject; then you can use the time you've saved to add greater detail to the drawing. Using a grid is a good compromise for those who really prefer not to trace, or if you want to develop your hand-eye coordination.

When choosing a photograph to draw from, look for a clear, well-composed picture, with plenty of detail in the shadows. If you can't see something, you can't draw it, so when taking photographs for a drawing, be sure to take extra reference photos using bracketed exposures and zooming in on complex details.

Be Aware of Copyright

Most of the images accessible in books, magazines, and on the Internet are under copyright, meaning they belong to the photographer or publisher. There are many myths about the laws governing the use of copyrighted images. One such myth is that it is okay to reproduce a copyrighted image as long as you "change it 10 percent." Well, it's not okay. The 10 percent idea probably comes from the fact that in most countries it is legal to copy up to 10 percent of a publication for "fair use," generally meaning for educational purposes. It is not legal to do so for commercial purposes! If you make a copy (a drawing) of a photograph and display it in a gallery (even without a price attached), this is deemed advertising and is therefore considered commercial use. If you ever draw from other people's photographs, make sure you find out about copyright laws.

The safest bet is to avoid using commercially produced images and take your own photographs. Not only does this protect you from possible infringement of copyright, but it gives you an image that is your own complete creation from start to finish, since much of the composition of an image occurs in the camera viewfinder.

Portraits from Photographs

Drawing a lifelike portrait is challenging enough without making it more difficult for yourself. Some subjects, especially the delicate facial features of children, are particularly difficult to draw convincingly unless you take steps to arrange your model to your best advantage. Lighting makes a huge difference to any picture, and it is one of the important keys to drawing that is the most neglected. Choose your time of day, or use artificial lighting to create favorable shadows and highlights and to model the form of your sitter.

Photographs need to be taken with a drawing in mind. Snapshots tend to be taken with the subject holding an exaggerated smile, which, however charming, can look artificial in a drawing. A person's natural demeanor will be revealed in a more relaxed pose, where the set of the jaw, the lines of the face, and the expression of the eyes are those that we see in everyday conversation. Teeth are also very difficult to draw, so it is much easier if you draw a closed mouth. If you have a favorite picture of someone's bright smile, by all means use it to create a drawing if you wish—but while you are learning, consider taking some reference photographs with the sitter focused on some activity, such as reading, knitting, or simply gazing into space.

Typical Snapshot Photograph

A look through a set of snapshots quickly reveals some common faults that make many of them unsuitable for drawing. Watch out for these faults and select a suitable source photograph:

- Subject too far away; lack of detail
- Bright flash lighting from the front
- No detail in shadows; highlights washed out
- Subject smiling broadly
- Subject wearing heavy makeup

Ideal Portrait Photograph

As you take a photograph or choose one to use as a source image, look for qualities that will contribute to your drawing and make your job as an artist easier:

- Natural, angled lighting
- Detail in highlight areas and shadows
- Subject relaxed or with a natural smile
- Groomed hair and natural or no makeup

Spend some time looking at good photographic portraits. Try not to be seduced by the beauty of the sitter, but look at the elements the photographer has employed to create a successful image. Try asking these key questions:

- How far away is the sitter from the camera?
- Is the camera viewpoint low, medium, or high?
- What is the camera angle—looking up, straight, or down?
- Where is the primary light source?
- Is the light source natural or artificial?
- Is there a secondary light source?
- Where is the sitter looking?
- What are the key compositional features?

Combining Multiple References

Very often, especially if you are interested in fantasy or surreal art, you'll find that you need to combine more than one photographic reference into a single drawing. This can be quite successful, depending on your approach and requirements. There is just one caveat to be aware of: perspective. With buildings and roads, perspective effects are obvious, but with natural landforms and animals, perspective is often quite subtle. However, it still exists, and it must be taken into account when drawing from photographs. Remember that the horizon line is at the eye level of the viewer. The relationship of your subject to the horizon changes the effect of perspective, sometimes quite dramatically. A horse photographed with a zoom lens at some distance from the viewer may have an effectively low horizon line, with the effect heightened by the compression of the telephoto lens. (Telephoto lenses tend to flatten a scene, diminishing the sense of perspective). A landscape with distant hills may have a relatively high horizon line. Combining the two images—the horse and the landscape—may result in an awkward-looking subject. Counter this by trying to identify the position of the horizon line on both source images and ensuring that you place the subject into the background with the horizon line at the same level.

Organizing Your Reference Material

If you use photographic reference sources in your drawing, you'll soon find that you have an enormous pile of photographs that you are shuffling through on a regular basis. You can save a great deal of time by organizing your photographs right away. Choose a system that best suits your preferred storage methods.

Whatever system you prefer, you'll need to divide the contents according to your favorite subjects. These might be: family portraits, figures, dogs, cats, landscapes, and still life. Broad categories that have many images can be broken up into subcategories. Photos of people might be grouped as particular people, nude models, clothed figures, hands, feet, and so on. Animals might be grouped according to breed, while landscapes could be divided by season, location, or a particular feature, such as sky, mountains, trees, and flowers.

Loose-Leaf Folder

An binder with plastic sleeves is useful for storing computer printouts and keeping them clean and ready to use. You might also place the original photograph in the sleeve, along with traced outlines or other notes. Use tabbed dividers to separate categories. Holders for negatives are available from photography shops to suit this type of folder.

Photograph Album

Slipping your photographs into albums as they are printed is a quick and convenient way to keep them tidy. Write any relevant notes on the back of the photographs as you store them so that you can easily replace them in the correct album after use. This method is most suited to material organized by date, though you might also keep an album for each theme. For flexibility, choose expandable albums.

Photo Storage Box

For large amounts of reference material, indexed photograph storage boxes are the most cost-efficient. They also make it easy to flip through your photographs to find the right image quickly. Office index card boxes and drawers are ideal and can often be picked up second-hand, since computers have largely replaced card files.

Digital Storage

Scanning prints or using digital photography and storing the images on a computer's hard drive or disk saves space and offers many options for convenient organization. Photo album software makes it easy to sort your images, where one image can be stored in multiple categories. This approach is particularly useful if you use computer paint programs to manipulate images, or enjoy printing a larger image to use as reference material.

Care and Storage of Paper and Artwork

Paper isn't the most durable of materials, and it requires a little extra care and attention if it is going to keep for a long time. As you learned in Chapter 1 of this book, paper can be acidic, and its acid balance will alter if stored next to something else acidic, such as a cheap cardboard folder. A folder works well for rough sketches, and most students make do with one for years. However, when you do work that you want to preserve, you'll need a plastic folio to protect your work. Art shops sell a range of these, from simple cases to elaborate leather folders with display sleeves.

Try to store your work horizontally, so that the drawings don't slide down in the folder and become buckled. Most professional artists own a set of plan drawers, which is the ideal way to store paper and drawings. You can sometimes find these for sale at reasonable prices in second-hand office furniture shops.

Prevent mold by storing your paper in a dry, well-ventilated place (not the garage or basement).

Framed artwork is not immune from damage. Do not hang works done on paper in areas of direct sunlight. Ensure there is airflow between the frame and the wall (stick small pads on the frame to create a gap if need be), and do not hang them on external walls, where the temperature fluctuates. Ensure that your framer uses archival materials, buffering the paper from any acidic backing boards with corrugated polypropylene.

If framing an important drawing, you may want to consider conservation glass, which blocks over 97 percent of UV light from reaching the image. Be cautious about choosing regular antireflective glass, which allows much more ultraviolet light to reach the image than normal glass.

Chapter 8

Get Creative

It's always interesting to discover that most artists you admire often are unhappy with at least some aspect of just about everything they produce—they might acknowledge some good qualities, but they'll always be able to point out something they would have liked to have done better. The imagination is always ahead of the hand. There is always the next challenge, the more perfect surface, the more interesting composition. As an artist, you find that you look at the world in a new way and constantly discover new subjects. As your own skills develop, you find that you are increasingly able to learn from other artists' work. Mirroring life, art becomes a journey, not a destination.

This flower sketch by Cherie Farmer captures her love of nature.

Find Your Direction

When starting out, you may already have strong ideas about the sort of art you want to create, having been inspired to draw something of particular interest to you. However, many people have a strong urge to create but are a bit vague about what they actually want to do. There are several avenues you can explore in deciding where you want your art to go next.

Look at where your other interests lie. If you have a passion—it might be anything from vintage cars to gardening—you can use that enthusiasm to fuel your creative endeavors. Your art can be about almost any subject imaginable. Visit art galleries—both online and in person—to see how other artists have explored the themes that interest you. Create a scrapbook of art that you enjoy. You can find art online, in books and art magazines, on postcards, and in the newspaper.

Once you have been drawing for a while, you can often discover a muse's footprint on your own artwork. You might find a theme or composition that consistently recurs, a subject that you continually return to, or even a feeling or quality that is present in your drawings. Consider which drawings gave you the most satisfaction to create. These might not have been the easiest to create or the most successful pictures, but they may have provided a challenge that you want to revisit.

This ink sketch of a Wayang puppet focuses on shape and pattern.

Exploring Realism

As you have discovered, there is no trick to realism, simply the patient, accurate recording of very fine detail, correctly re-creating shape and value. Heightened realism involves very acute observation of tiny variations of value. Advanced realist techniques sometimes involve shortcuts for creating fine texture, or ways of combining media for more accurate representation of value and surface quality. If you are interested in photo-realism, or at least using photographs as source material, it can be worthwhile to take a photography course to ensure that you are using the best resources available. A great deal of the composition of an image occurs in the camera viewfinder, so having a good understanding of photography will give you much more control of your whole creative process.

Simplifying a landscape to explore composition

Modern realist artists often use an element of the surreal to add a contemporary flavor to their work, though this can look awkward in the wrong hands. Often quite traditional pieces take on a contemporary quality by virtue of large scale, creative use of paper, or intelligent composition. You might like to explore very traditional forms of art, looking back to classical and romantic models for inspiration. Proponents of "old master" styles often advise immersing oneself in the culture of the appropriate period, listening to its music, eschewing contemporary entertainment, and even favoring a more subdued décor. There is something to be said for this approach: remember that impressionism, which is conservative to our eyes, was considered shocking when it was first exhibited.

You might like to:

- Choose a single artist that you love, and methodically research their drawings. Try copying small details and consider their line work.

- Choose a painting by an old master and create a drawing based on all or part of it.

- Try staining paper with tea or coffee and drawing with red chalk to create a drawing in the style of the old masters.

- Choose a single theme that interests you, and explore how realist artists have represented that theme throughout art history.

Going Abstract

If you are interested in abstract art in one of its many forms, the possibilities are endless. Abstract artists often explore composition in a very pure form: mark-making, texture, and pattern. These are called "formal" concerns, when the artist is interested in design for its own sake.

You might like to:

- Make a series of small paper-cut pictures, cutting shapes out of colored paper and arranging them to create compositions.

- Explore using paper in a three-dimensional way. Crumple, fold, and cut and glue your drawing. Tear off pieces and reconstruct a composition.

- Choose an abstract artist, like the Russian constructivists, Kasimir Malevich or Ivan Kliun, and create some drawings based on his or her work. Try to take some of the artist's compositions and develop them in your own direction.

You might be interested in using art to convey emotions and ideas. Modern art history is rich in this type of art, and you'll easily find many contemporary artists you can relate to.

Expressing your feelings in art can be very therapeutic. Much of this type of artwork is deeply emotional and sometimes disturbing, but remember that making pictures can also be an outlet for positive emotion.

You might like to:

- Create your own interpretation of an expressionist masterpiece.

- Draw a self-portrait that expresses your usual emotional state.

- Get a big roll of drawing paper and stick some sheets together to create a large, physical drawing. Work on the wall or floor.

- Make a drawing that expresses a significant event in your life. Try to communicate your feelings to the viewer without actually illustrating the event.

- Choose an interesting philosopher, such as Ludwig Wittgenstein, and create a series of drawings incorporating quotes from his or her work.

Do you habitually use the same sort of marks? Are they smooth and flowing? Sharp and angular? Do you have a heavy hand or a tentative, uncertain one? Have a look at the drawings you have done so far, and consider the quality of line. Make a note of these qualities, and draw something that breaks away from your usual style—choosing a suitable object (spiky pinecones or soft roses?) that encourages this.

Loosening Up

When you've been focusing on realistic, perspective, and value drawing for a while, you can easily become very stiff in your drawing. From time to time, it is helpful to break out and draw some loose, relaxed pieces and make marks without concern for realism. This allows you to get back in touch with your natural expressive self.

Now that you've been working on realistic, observational drawing for a while, try to include some "loosening up" exercises in your drawing routine.

Blind Contour Revisited

Aim: To consider personal mark-making style

Materials: Paper, B pencil or pen

Time: 30 minutes

Set Up: Select a reasonably complex object to draw, preferably something meaningful to you, such as an ornament, favorite piece of clothing, a plant, or a person.

Start Drawing: Working in whatever way you normally do—whether slowly and carefully or more briskly—create a blind contour drawing of your object. Make sure you take enough time to do plenty of line work. If you finish the object quickly, continue the drawing into the background or do an additional object.

Review: Look at your blind contour drawing as an abstract work of art, done by an unfamiliar artist. What are the qualities of the line? What does this drawing tell you about the person who drew it? Was it done carefully, even obsessively? Is it busy, rushed, or energetic? Is it graceful, strong, or well defined? Make a list of these qualities, and take a look at some of your other drawings. Can you make similar observations about the more realistic work, or has the focus on realism changed your style?

Wrong-Hand Drawing

Aim: To loosen up drawing style

Materials: Paper, B pencil or pen

Time: 30 minutes

Set Up: Set up a simple still life to draw, find a landscape, ask someone to sit for you, or do a self-portrait using a mirror.

Start Drawing: Working in your preferred style—either starting at a point and continuing on or beginning with a structural framework—create a drawing using your non-dominant hand (the one you don't normally draw with). You'll likely find it very odd and a little frustrating. Try not to tighten up, but draw as normally as you can.

Review: Notice how, despite the stray lines and mistakes, your drawing has an expressive energy that more carefully drawn images might miss. Drawing with the wrong hand also helps you break away from habits of mark-making that override otherwise correct observations, so you might find that in places your drawing is more accurate than usual.

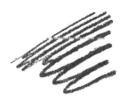

Portrait Without the Sitter

Aim: To convey the force of a person's character *without* portraying the person, or at least not the face

Materials: Paper (size and medium of your choice)

Time: Several hours

Set Up: Choose a subject to draw—it can be yourself or someone that you know very well. You may choose to use elements of still life or landscape to help express your subject, or you may make the piece completely abstract. Remember that the aim of the drawing is not only to express things that the subject likes or dislikes, but to express the individual's personality as well—to give the viewer a sense of the subject's inner life and spirit. You must do this without using an actual image of the person

Start Drawing: Work on whatever scale you feel is appropriate to your subject. Do some preparatory sketches, trying out various compositions and formats. Consider line, volume, value, balance, dynamism, texture, and pattern. Consider the symbolism and all the possible associations of any design element or object that is part of your image.

There is no example drawn here, as this would stifle your imagination. Consider what object or environment would best symbolize your subject. You may focus on some objects that you associate with the subject.

Black and White: Drawing with Pen and Ink

Pen and ink lends itself to many styles and subjects. As pure line, its simplicity and strength, is ideal for cartooning and illustration, but it can also be lyrical and expressive.

Used with hatching and stippling techniques, rich textures can be created, while washes add tonal value with watercolor-like immediacy. Some might find its unforgiving nature a little daunting, but perseverance reaps great rewards, especially for those whose drawing tends to be lightweight.

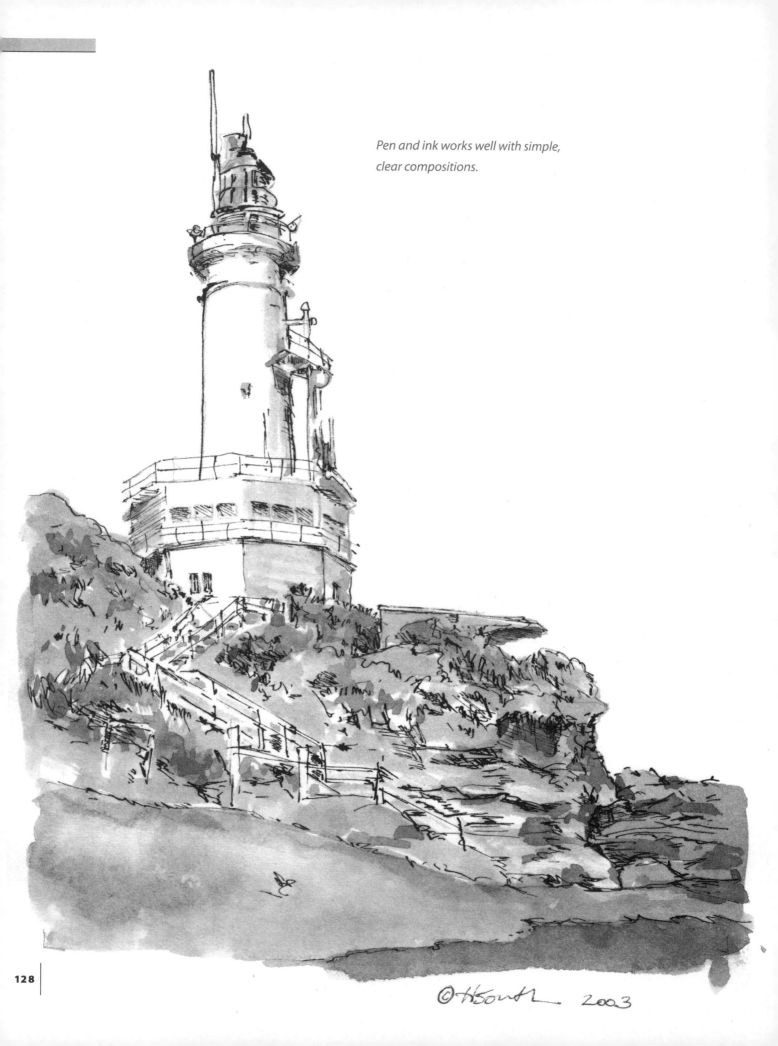

Pen and ink works well with simple,
clear compositions.

©HSouth 2003

Line Drawing with Pen and Ink

If you can, experiment with a range of pens to find what type suits you best. The old-fashioned dip pen is the most versatile and gives a beautiful line. To begin with, select a medium drawing nib—firm enough to give you a smooth even line, with just enough give for variation in line weight when required.

Getting acquainted with a dip pen can take a little time. Be prepared for ink blotches, catches and spills, ragged and uneven hatching, thin lines when your ink runs out, and fat lines when you've overfilled the pen or when dried ink is coating the nib. Do plenty of sketching on cheap paper before you tackle a major piece, and do some test pieces on a scrap of your good paper so that you know how the pen is going to behave when you work on it.

Essential

Decant just enough ink to properly load your dip pen. A small screw-top container (such as a sample-size jelly jar) works well as a container for the ink. This will help prevent messy overloading, and if you tip the jar, you won't lose all your ink. If you tend to be a bit clumsy, use tape or sticky-tack to secure your ink jar to the table to minimize spills.

Most importantly, approach your drawing with confidence. One of the most enjoyable approaches to pen drawing is a relaxed one, freely exploring line. Let errors happen, redrawing only the most errant of lines. Hesitant, scratchy line work will result in an unconvincing drawing that looks flat, while a confident, bold line has a certainty that can persuade the viewer of the accuracy of the artist's vision—however far astray it might be. If you doubt the worth of this approach, visit an art gallery and look at some modern artists, especially Picasso, who was a master of the elegant line. Even when his observations are "technically" flawed—big, meaty hands, misshapen faces, or clunky legs—there is immense beauty in the line itself, its fluidity and certainty. This doesn't mean that all your line work is to be forceful. A sensitive or delicate touch is often called for, but sensitivity is not the same as hesitation.

Line Drawing in Pen and Ink

Aim: To explore linear drawing in pen

Materials: Drawing pen and ink, two sheets of paper

Time: 10 minutes for part 1; 30 minutes or longer for part 2

Set Up: Choose a favorite subject to sketch, preferably something you have drawn before. Use something like a comfortable old chair, a jug, a plant, or an old pair of shoes.

Start Drawing: There are two parts to this exercise. The first calls for a relaxed, gesture-like approach. Observe the subject for a few moments before beginning, and decide if you want to draw "working lines" first (a framework indicating the main parts of the drawing) or if you simply want to start at one point and continue from there. Sketch the subject rapidly, keeping the pen moving.

For part 2 of the exercise, do a steady observational drawing. Do a structural sketch in pencil, then work in some further guidelines in pencil, making sure that you have located all the major elements of the drawing before commencing. Then do your pen drawing, observing detail as carefully as possible.

Review: Looking over these drawings, you might be surprised to find that in many ways your first drawing is more pleasing than the second. The relaxed, fresh lines of a gestural drawing reveal something of the artist's personality and often say more about the subject than a more detailed drawing does. With a detailed observational line drawing, there's a more "flat" look, which can often have a charming decorative quality.

Lost and Found Lines

When you want to move away from flat, linear outline drawing and create more three-dimensional drawings in pen and ink, one of the main problems is the solidity and strength of the line itself. Though you can vary the weight to some extent, pen does tend to have an "all or nothing" quality very different from the subtlety that you can obtain with pencil. The solution to this is the broken line and the "lost and found" edge. The eye is very good at making inferences from visual information, readily inferring a connection between two lines that don't quite meet or perceiving a line disappearing behind another as continuing on unseen, depending on the context.

When drawing a light line—such as the edge of a light-colored plane that you just want to suggest—you can skip the pen over the surface, leaving many little gaps, rather than drawing a black line. Similarly, a large gap can be left between two lines that lift off gradually and ease back on again, implying a continuation or connection of sorts. This is particularly useful where two linked planes round off, or where a highlight strikes an edge. For example, when drawing faces, a lost and found line such as this might be used along the bridge of the nose, or when suggesting a lip line or eyelid.

Before you commence drawing, look carefully at your subject and consider the highlights and soft edges that will need to be implied rather than stated, and be sure to break up your line work in these areas.

Simple line work and hatching gives a clean, illustrative look.

Creating Value and Texture with Pen

While pen is usually used for linear work, it can be an effective tool in value drawing. Basic hatching and cross-hatching are the most commonly used methods to suggest areas of value. This may be representational (copying observed values) or may simply differentiate planes (hatching parallel planes in the same manner). Variations on linear hatching and crosshatching can be combined with a range of mark-making approaches to create texture, pattern, and value in drawing. Most of these take a bit of time to get familiar with, so experiment with them and don't expect perfection in your first drawing.

Linear Hatching

Linear hatching is one of the most widely used techniques in pen drawing. While the basic method looks simple enough—parallel lines drawn at regular intervals—it can be surprisingly versatile. Generally, the direction of the hatching is aligned with the direction of the plane it is describing.

Crosshatching

Basic crosshatching with pen and ink is the same as that used for pencil drawing and consists of two layers of hatched lines at right angles. Further layers, drawn on diagonals, can be added for a darker tone. Very precise hatching is difficult to achieve but can look impressive, especially when used to describe manufactured objects. It can, however, look artificial, rather like a layer of screen mesh. To counter this, it is often applied in random intersecting patches to add variation and interest to large areas.

Contoured Hatching

Linear hatching following curves becomes contoured hatching, and can be used with line weight variation to effectively describe form. A modified form of crosshatching involves two or more layers of hatching at a slight angle to each other, which results in a moiré-like pattern. Moiré is when light is diffused and creates a rippled surface pattern. This pattern, combined with subtle variation of line weight, can be most effective in describing form and light. You can observe this type of hatching in many ink and chalk drawings by the old masters.

Stippling, Pointillism, or Dot Technique

Stippling is the technique of making many tiny dots to create areas of value and implied line. A crisp, on-off action is used with the pen held vertically to create a precise dot. Artists who specialize in stipple drawing usually prefer to use "tech pens" (technical drawing or drafting pens), which have durable wire tips that give a uniform dot size. Use the ink recommended by the manufacturer. Fiber-tip fine-point artist's pens are also suitable, though they are less robust. The stipple effect can be created with dip pens, though they tend to create an irregular dot size and shape, and very close dots tend to run together. Stippling applied with a more relaxed approach is very useful in creating textural effects within ink drawings.

Scumbling, Scribbling, or Brillo Pad Technique

Scumbling (also called scribbling or Brillo pad technique) is a technique using various scribbly lines to create texture and value. A figure eight or overlapping S-shape works well for rough textures and to rapidly fill an area. Calligraphic marks, with curves and dashes like an ancient script, are ideal for darks within textures, such as in foliage or fur.

Contoured hatching follows form in these first three images.

A Pen-and-Ink Sampler

Aim: To practice various approaches to creating textures and tonal values with pen

Materials: Drawing pen and ink, paper

Time: About 1 hour

Start Drawing: Using the previous examples as a guide, make a sampler page including each of the hatch patterns and textures. See if you can come up with your own combinations and variations. Repeat some of them with different pens or nibs that you have available, making a note of which one was used for future reference.

Practice drawing different styles of hatching by using different spacing and line weight.

Explore Further: Try using different types of paper for the same mark-making. Note the difference in feel and look when using sketch, cotton, and watercolor paper.

Review: Did you find it difficult to just "make marks," or do you enjoy experimenting? If you find it awkward, try looking at examples of different textures and patterns, and copying them.

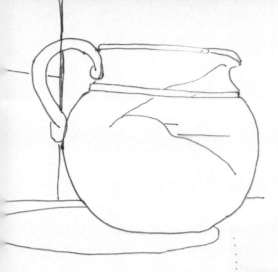

*A preliminary
contour drawing*

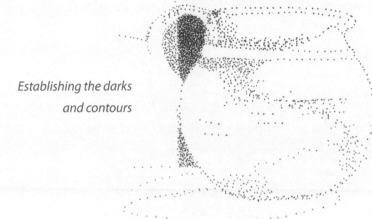

*Establishing the darks
and contours*

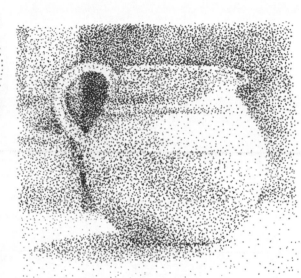

The completed drawing

Stipple Drawing

1 Make a contour drawing in pencil on a separate sheet of paper. Draw over it in pen, outlining areas of dark, midtone, and light, and looking out for any highlights, which must be preserved. Next, trace the image lightly onto your drawing paper, so that the image is barely visible and can be lifted off later without damaging the drawing.

2 Lightly dot the outlines, avoiding the highlights, and begin working on the middle and dark values. Finding a "safe," well-defined area of dark shadow to work on first helps establish the value scale. When stippling lines, be careful not to work too fast and start drawing dashes instead of dots. When working on lighter areas, pay attention to dot placement to avoid too many close or overlapped dots, which can stand out in a sparse area.

3 Stipple drawings take enormous patience to complete, so you must be really committed to finishing the project before taking another one on. Some artists seem to take pride in the hours required to complete a major piece, but the real criterion for success is whether you are happy with the end result. Don't use pens intended for stippling for any other drawing, especially if you are using fiber-tip pens. The uneven pressure and abrasion on the tip as you draw distorts its shape and will give you an uneven dot size and shape.

Defining Planes

Aim: To practice defining planes on a solid form with hatching

Materials: Drawing pen and ink, paper

Time: 30 minutes

Start Drawing: Draw some boxes in two-point perspective. Imagine the light source is at the top left of your page, and create convincing shading on your boxes using hatching and crosshatching.

Review: It can be tricky to stop hatch-lines so that they make a perfect edge—practice makes perfect. You can also try using a paper stencil. Consider the effect of perspective on your hatching too—you can use it to your advantage by "vanishing" horizontal hatches to the VP, or you can avoid perspective by hatching vertically.

Explore Further: Practice your perspective drawing and draw interesting shapes such as a cylinder, pyramid, a square window, and so on. Use varieties of hatching and crosshatching to define the planes.

To avoid a downward "hook" at the start of a hatch-line, move the pen in vertical circles (as if you were drawing circles in the air) with the bottom part of the "circle" being the hatch-line, rather than a straight back-and-forth line. This ensures that the pen is traveling in a straight line as you make the mark.

Creating Three-Dimensional Form

Aim: To practice modeling three-dimensional form in pen

Materials: Drawing pen and ink, paper, circle template, ellipse template

Time: 30 minutes

Start Drawing: Use a circle template to draw several small circles on a page. Imagine they are spheres and visualize the light source to add the cast shadow, drawing freehand or using an ellipse template. Add value to each using one or two types of hatching, stippling, or scumbling, remembering to include highlight, shadow, reflected light, and cast shadow.

Review: Did you find any of these textures hard to replicate? Was it harder to control the pen when doing vertical or horizontal lines? Practice the marks you found hardest. Getting the spacing and line weight right takes quite a bit of practice.

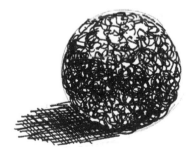

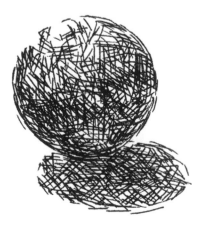

Modeling three-dimensional forms

137

ASSIGNMENT: DRAWING BUILDINGS

Buildings make excellent subjects for pen-and-ink drawing. Windows, doorways, and eaves offer plenty of opportunity to experiment with textures. Try using various techniques—pure hatching, crosshatching, and combinations of textures together. Use a pencil to sketch in your subject first, and take a reference photo in case the weather turns nasty!

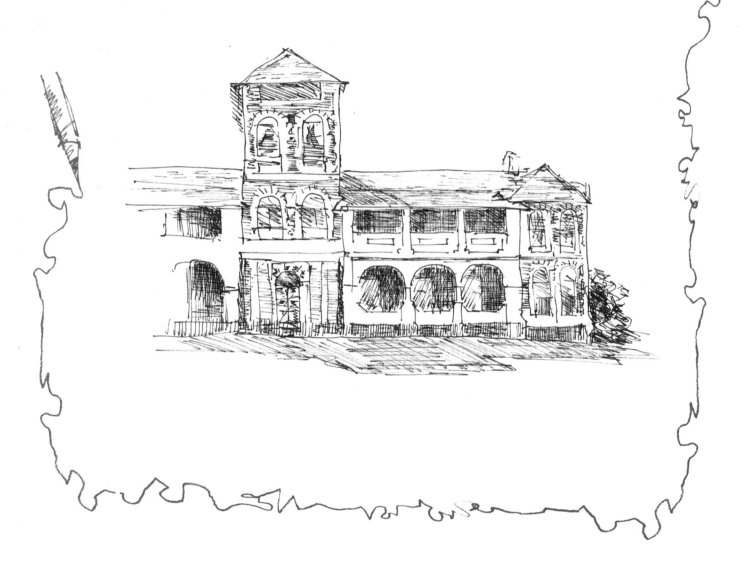

Pen and Wash

Ink or watercolor washes are used in conjunction with pen drawing to create areas of tonal value.

This may be done very simply, with only one or two strengths of wash.

Where the value is gradual, such as on the side of a curved cylinder or ball, a judgment call must be made as to where the next step of tone should begin. This simple approach can look very effective, clear and uncluttered, and helps develop your ability to see value. Alternatively, washes can be used in a painterly fashion, almost like a gray scale watercolor. While beautiful in their own right, this approach is useful for painters who want to develop their awareness of tonal value. Washes can look very effective with a nonwaterproof ink, which allows the line to bleed or feather, giving a delicate appearance.

"Resist Techniques" with Ink Wash

Watercolor techniques work well with Chinese ink and black watercolor washes. Most artists work with diluted Indian ink, though it tends to form a tougher film and behaves a little differently. Experiment on scrap paper before applying any of these to a worked drawing.

Art Masking Fluid is an ammonia-based liquid which creates a water-resistant film when dry. It can be brushed on or spattered. (Use an old brush, and clean it with window cleaner). A wash of ink or watercolor is applied over the top, and when this is dry, the masking fluid is gently rubbed off with the fingertips. For an interesting spatter effect, masking fluid can be flicked onto the paper using an old toothbrush, with a paper mask protecting the rest of the drawing. Once dry, apply a wash. You can then remove the masking fluid by gently rubbing it off, or apply a second layer of spatter and wash for a mottled pebble texture.

Another watercolor effect is salt spatter. As soon as a wash is applied, lightly scatter table salt over it. The salt particles attract the liquid and absorb some, creating a beautiful spangled effect. Brush the salt off when dry. Try using this technique for lichen and seaside rocks. Don't overdo it, as it can look rather messy in large areas.

Resist techniques are useful for creating light-toned textures. In the previous example, a white, waxy pencil (an oil-based colored pencil, not a watercolor pencil) was used under a black watercolor wash. Once dry, you can use a kneaded eraser to lift off any pigment adhering to the pencil.

When Disaster Strikes: Fixing Mistakes

Like watercolor painting, ink drawing doesn't allow much room for error. Prevention is better than cure, so plan your drawing before you begin, using pencil to rough out your design. Practice on scrap paper first, and protect any areas you aren't working on with a spare sheet of paper. Rescuing an ink drawing is a haphazard affair, especially on lightweight paper. With heavier watercolor papers and Bristol board, you have a better chance of a successful repair job. Try out some of these techniques in advance on your favorite papers, so you have an idea of the best approach to correct errors should you have a mishap.

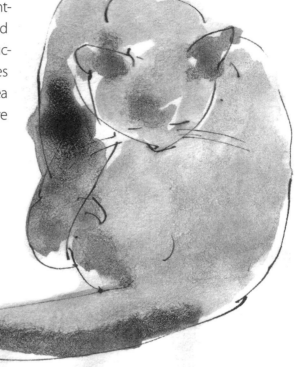

A sketch in pen and wash

Ignoring It or Working It In

You can often ignore stray lines or blotches. If you are doing a fairly relaxed piece, a sketched construction line, an incorrect outline that has been redrawn, loose washes, or a spatter of ink simply add character to the piece. If the drawing started off very clean and realistic, consider revamping it into a looser piece with the addition of some bogus working lines and rough hatching.

You can also work blotches into your design. Use a rolled-up piece of kitchen towel to blot the excess ink away, then continue drawing, adding hatching or line work as needed to make the blotch part of the drawing. You might need to reposition your light source or darken the overall key of the piece. Keep several small, rolled pieces of torn-off kitchen towel handy—the long fibers on the torn edge wick the excess ink from small areas.

Scraping or Excising

In small areas, you can use a blade to carefully scratch or lift the offending spot, then rub down the loose paper fibers with the back of a clean fingernail. Take care if you wish to draw back over the area however, as ink may bleed into the damaged fibers, especially if you are using watery Chinese or dye-based inks or fiber-tip pens. Pen-and-ink artist Joyce Ryan recommends drawing over the area with graphite pencil, adding the required pen drawing, and lifting off the excess graphite with a kneaded eraser. Hot-pressed Bristol board, made for illustrators and designers, is slightly more forgiving of this type of abuse.

Erasing

Erasing small areas with an ink eraser is possible but difficult, with the abrasive eraser lifting much of the fiber from the paper surface. An erasing shield (a small template with various shapes cut into it) is useful to protect surrounding areas. An eraser pencil is helpful, as it can easily be rotated in the hand to erase very small areas. After using an ink eraser, flick away any particles with a brush, and use a kneaded putty eraser to lift off any stray fibers.

Major Excavation

On a major piece, when you really can't face the thought of starting over, there is one last resort to try. Place the drawing over a clean sheet of the same type of paper or board on a cutting surface, then use a very sharp knife to cut out the offending area, cutting a replacement piece from the clean sheet below at the same time (you may need to precisely retrace the cut for thick boards). The trick is to make the cut along a black, solid line in the artwork, so you may need to cut a rather large section, depending on your design. You then tape the replacement piece in place at the back, being sure to align it perfectly.

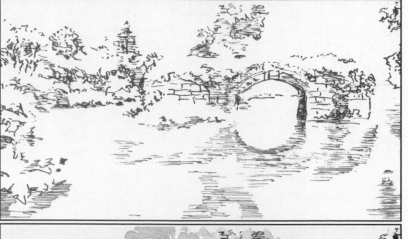

The broken-line drawing looks incomplete, but washes will fill in the gaps.

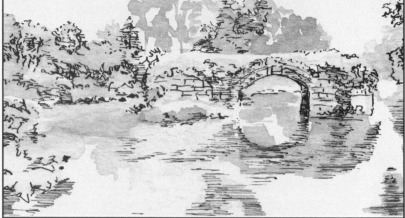

Scribbly, calligraphic marks build the texture of shadowy, dark areas of foliage and brickwork.

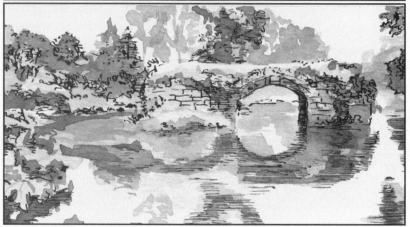

Two washes of black watercolor were used for this drawing, one fairly light and one of mid-dark value.

Landscape in Pen and Wash

1 In this example, the drawing began with a pencil contour drawing lightly traced onto the watercolor paper. Then the pen lines and textures were added. It is important to avoid overdoing the pen; look only for the darkest shadows and strong lines. A light pencil mark acts as a guide for later washes, indicating the edges of shadows and foliage forms.

2 Sketchy horizontal marks indicate the dark ripples on the water's surface. The drawing alone will look a little odd and incomplete, but resist the temptation to outline, remembering that the black pen line indicates the areas of darkest value. Allow the ink to dry thoroughly before applying washes.

3 The light wash was applied to every area of the picture that wasn't to be left white, and diluted with a watered brush for random lighter patches. Small brushstrokes build texture in the foliage. The darker wash was applied to the darkest shadow areas and helped to blend the wash and black pen marks, which were applied rather loosely and diluted for some variation in value.

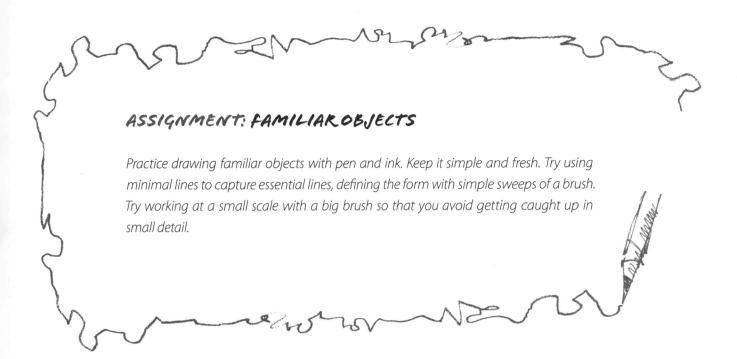

ASSIGNMENT: FAMILIAR OBJECTS

Practice drawing familiar objects with pen and ink. Keep it simple and fresh. Try using minimal lines to capture essential lines, defining the form with simple sweeps of a brush. Try working at a small scale with a big brush so that you avoid getting caught up in small detail.

Chapter 10

Charcoal Drawing

The rich, velvety darks of charcoal drawing combine with its versatile expressive power, ranging from subtle smudges to forceful energetic line work, to make charcoal an enduringly popular artistic medium. It can take time to get familiar with charcoal and to learn to exploit its unique characteristics. Willow and vine charcoal give subtle grays that you can erase with a touch, while compressed charcoal enables you to quickly develop dark values. If you are used to lightweight pencil drawing, the intensity of its line can seem unmanageable at first, but with perseverance you'll soon have this headstrong medium under control.

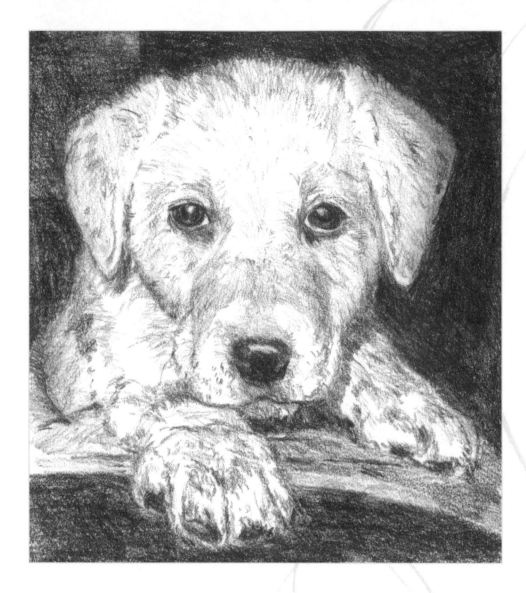

Working with Charcoal

Charcoal drawing can be incredibly messy, so be careful where you decide to work. Charcoal dust gets everywhere—all over your hands, on your paper, and on the floor. Use a soft brush to flick particles off your drawing. Disposable dust cloths (the ones with a static charge) are great for cleaning as you go. Clean up smudges around your paper with a kneadable eraser as you work.

When beginning charcoal drawing, it is a good idea to work large. Charcoal tends to be soft and crumbly, and it can be frustrating if you try to work too small before you are familiar with the medium, as you will be trying to get too much detail out of it.

Use a wall, table, or drawing board and large sheets of butcher's paper for your first drawings. When preparing your drawing surface, it's a good idea to attach several sheets at once so that the sheets underneath cushion your drawing.

If you can, stand back from your drawing with your arm nearly fully extended, with the elbow slightly bent, so that you can comfortably reach the top and bottom of the page. If your drawing is on a table, work standing, leaning on the table if need be. You want to have maximum freedom of movement.

Using Fixative

Charcoal has large, dry particles and no binding agents, so it tends to fall off the page. If charcoal drawings are stored without fixing, they will smudge and the image will gradually degrade. Spray fixative binds the particles to the paper with a thin film of resin. Generally fixative is used when a drawing is complete, but using a workable fixative enables you to fix partly completed pieces and is particularly useful when a heavily worked piece is becoming too smooth to draw on, as it gives the medium something to adhere to. Fixative does alter the appearance of drawings slightly, and it is important to test the results before using it on major pieces. Sometimes applying fixative toward the end of the drawing but before the final layer of marks enables you to keep the drawing crisp but still have the adhesive benefits of fixative.

In the past, fixatives have contained various unstable organic and synthetic resins, which tended to yellow with age and affect the acidity of the paper. Current products have much improved formulations and are recommended by conservators.

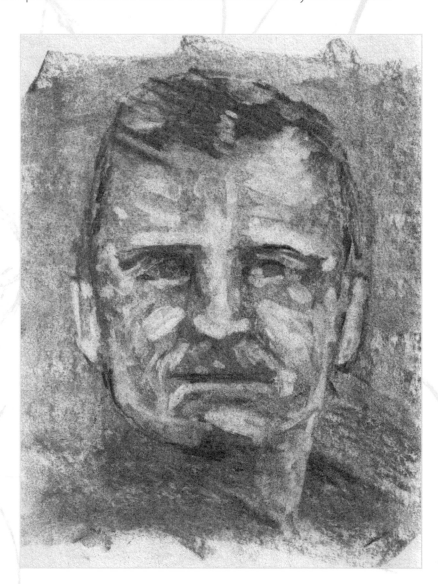

ASSIGNMENT: ACQUAINT YOURSELF WITH CHARCOAL

Use a sheet of newsprint to explore the possibilities of the medium. Experiment with making lines and scribbles, shading, smudging, erasing, and blending. Without blending or smudging, make a strip of graduated shading from light to dark. Try using hatching and crosshatching to create the values. Then make a blended strip of shading, and make a ladder of values from light to dark. Consider how each type of charcoal handles erasing, smudging, and depth of tone. Focusing on these simple qualities of the medium without worrying about a picture will help you to know which styles to choose for different types of work.

To save money, many art students are advised to use hairspray to fix their drawings. While hairspray works, it contains many ingredients that are not necessary, such as perfumes and conditioners, as well as ones that are harmful, like alcohol, which is acidic. If there is nothing else available, hairspray will do the job, and most artists have some works fixed with hairspray that have survived ten years. But if you are serious about charcoal drawings, and if you want to sell your work, pay the extra dollar or two and purchase a can of workable fixative.

Essential

If you prefer not to use fixative, you might like to try carbone pencils, which are made from greasy soot and have a sticky texture. The drawback is that they can be a little difficult to manipulate, but they adhere well to the page and deliver a beautiful, smooth, black line.

Fixative is best applied in several light coats, rather than a single heavy one. Prop large works against a wall at an angle of forty-five degrees; smaller pieces can be laid on a surface. Protect timber surfaces with a sheet of newspaper. Hold the can about six to eight inches away from the paper (check the instructions on your own brand, as they may vary) and spray in regular overlapping vertical stripes. Wait a few minutes, then apply a second coat in a horizontal pattern. The most common mistakes new artists make in fixative application are applying too much at once (which occurs if your stripes overlap too far), holding the can too close to the page, or spraying it too slowly. Allow your drawing to dry between applications.

Use fixative in a well-ventilated area, preferably outdoors. It is best to leave the work in a well-ventilated nonliving area, such as the garage or a spare room, for a half-hour or so to allow the fumes from the fixative to dissipate.

Gestural Drawing

Gestural drawing refers to capturing the essential quality of movement and form through the type of mark-making that is used. For instance, marks might be continuous, linear, and curving, or crisp, short, and straight. The detail of the subject is usually minimal, because surface details are not the focus in gestural drawing; rather, the focus is on overall shape, proportion, movement, and character.

Gestural drawing is particularly effective on a large scale. Using the whole arm and entire body—getting physically involved in the drawing process—and working on a large scale helps create dynamic and expressive works. For these drawings, use large paper on a wall or easel. Newsprint or butcher's paper has an ideal surface for charcoal drawing, and is it cheap enough that you can work impulsively without worrying about wasting expensive paper.

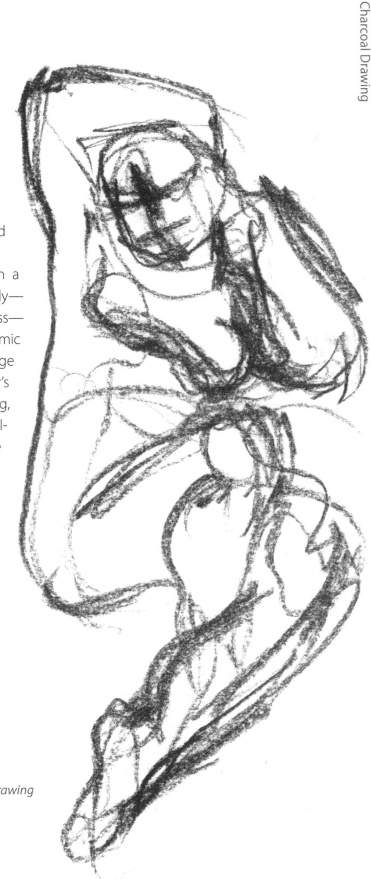

A gestural figure drawing

Gestural Drawing

Aim: To explore form and movement

Materials: Newsprint paper, charcoal, and kneadable eraser

Time: 30 minutes

Set Up: Figures are ideal for gestural drawing. Ask a friend to model for you. Loose, flowing clothing can add interest. Try playing music and ask your model to take up broad, expressive, balletlike poses with plenty of twisting and stretching. You could try posing in a mirror, then quickly sketching from memory.

Start Drawing: You'll need to work quickly, as your model won't be able to hold the pose for long. The approach to gestural drawing is something like contour drawing, rapidly exploring weight, balance, and direction. Elements of contour and cross-contour combine to express the pose of the model. Gesture drawings can take as little as twenty or thirty seconds to complete, with the model changing rapidly from one pose to the next. Try varying your approach, using bold skeletal structuring, round ovoid forms, and wandering lines to explore the poses.

Mass Drawing

Mass drawing refers to using broad strokes to simply describe the overall shape and weight of the form. In many ways it is related to gestural drawing, but because the emphasis is on volume rather than movement, mass drawings tend to have a sense of stillness. You are looking to capture the sense of a three-dimensional object occupying space and possessing weight or mass.

Charcoal is ideal for this type of drawing, as you can use a broken piece and get a graduated range of tonal value in a single stroke by applying more pressure to one end of the piece. Line is avoided in mass drawings—rather, the meeting of areas of light and dark might suggest the edge of a form.

There are two approaches to use of value in mass drawing, literal value and spatial value. With literal value, you use lighting to illuminate the model in such a way that you have good light and shadow, which you draw literally. With spatial value, anything that is closer to the viewer is light—with the closest points being the lightest—and anything further away is darker. The background must be included to provide dark values for the edges to recede into. This approach is useful if you have bland overhead lighting that does not model the figure well.

With both approaches, it is important to concentrate on areas of light and dark, rather than linear drawing. The model can be placed on the paper using willow charcoal, but from there line must be avoided. Better still, try placing your model using broad strokes with a broken piece of charcoal, placing the key darks and gradually developing the form from there.

Mass drawing has a simple, solid look.

A mass drawing of a jug

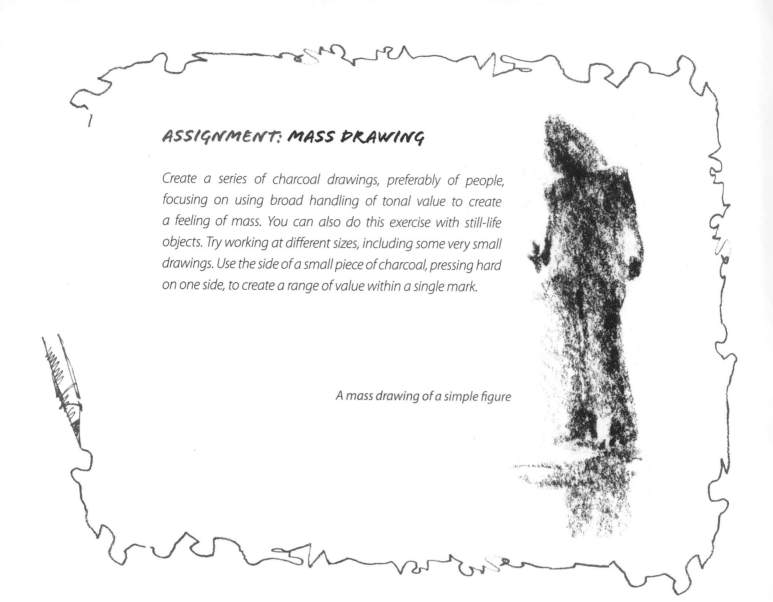

ASSIGNMENT: MASS DRAWING

Create a series of charcoal drawings, preferably of people, focusing on using broad handling of tonal value to create a feeling of mass. You can also do this exercise with still-life objects. Try working at different sizes, including some very small drawings. Use the side of a small piece of charcoal, pressing hard on one side, to create a range of value within a single mark.

A mass drawing of a simple figure

Subtractive Drawing

One of the really enjoyable aspects of working with charcoal is the full range of tone that you can obtain. The rough charcoal particle gives a matte finish that enables you to achieve very dense blacks, while careful handling gives you a full range of values. It also provides the perfect opportunity to practice observing highlights, which can be contrasted beautifully against the dark medium. Subtractive drawing sounds sophisticated, but all it means is that you start with a dark surface instead of a white one, using the eraser to draw light areas. It is an excellent exercise for observing value changes and looking at light. Since you spend most of your time looking for dark lines to draw in other types of drawing, this is particularly useful.

Subtractive Drawing

Aim: To develop use of a full range of tonal values

Materials: Newsprint paper, charcoal, kneadable eraser

Time: 30 minutes to 1 hour

Set Up: Choose a simple subject, such as a still life of fruit or a ceramic jug, with good directional lighting. Turn off overhead lights or close some curtains if need be, to ensure you have good shadows to draw. This exercise works best with a fairly smooth news-print paper or MG Litho, which facilitates easy erasing.

Start Drawing: Start off by covering your paper with a solid layer of vine or compressed charcoal. Build a smooth, even layer, blending lightly if need be, but avoid smudging with your fingers, as this will make it difficult to erase. Fold your eraser to a point, and begin lifting out areas of highlight. You can work lightly in big, broad areas first, then intensify the highlights, or draw the brightest lights first, then gradually lift the midlight values. If you erase too much, work the surface back up with some added charcoal, then erase again. Chances are you started with a fairly light layer, so shade back over the dark-est areas, working more charcoal into the background if it needs to be darker, before lift-ing out the mid values. Ideally, you shouldn't use any "positive drawing" (or drawing with dark lines) with your charcoal. If you need to strengthen a shadowed area, work over a bigger area, then lift charcoal off down to the edge of the shadow. You'll need to repeat-edly fold your eraser to a clean spot.

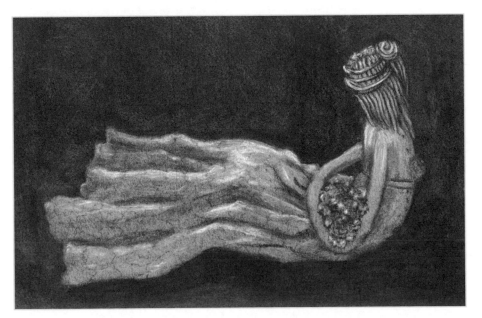

Janice O'Donnell's subtractive drawing developed into a subtle, beautifully rendered piece

Realism in Charcoal

Most art students are familiar with using charcoal for life drawing and large, expressive pieces, for which the medium is ideally suited. Charcoal can also be used for smaller drawings, especially dense, atmospheric pieces. Surprisingly, charcoal can successfully be used for highly detailed work. The key to this type of work is using a paper with a finely textured surface, with just enough fiber to grab the medium. You need to keep a sharp point or edge on your charcoal—brighten the point on a piece of rough paper frequently as you draw. Use the point of a blending stump (tortillon) for blending. Once the tortillon is well used, you can also use it to draw with; it will deposit a fine, pale layer of charcoal dust. Many artists use charcoal in combination with a graphite pencil to establish the strongest blacks and velvety textures in realistic drawings.

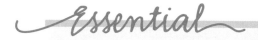

When sketching or transferring the contour drawing, use charcoal rather than graphite, as the sharp graphite tends to leave an impression in the paper, which combined with its smooth particles, rejects charcoal and results in a fine line that tends to stand out. If using a grid, draw it in willow charcoal. To transfer an image, rub the back of a photocopy with charcoal, place it on your paper, and trace carefully over the photocopy.

Drawing on Toned Paper

Tinted pastel papers usually have a strong texture on one side, with the reverse being relatively smooth. You can work on either side, depending on the effect you are looking for. Working on colored paper is another way of exploring value observation—as the midvalue is established by the paper and you work in the darks and add the highlights. For the best results, it is important to avoid overlapping the white and black, as the blended mediums look dull against the gray paper. Carefully observe and place your values, and erase errors by lifting the medium with your eraser. Avoid blending or smudging; keep the drawing fresh and direct.

It is interesting to note just how much space you leave gray when working on tinted paper in comparison to the amount of space you might leave in a similar drawing on white paper.

ASSIGNMENT: REALISM IN CHARCOAL

Use a clear, detailed photographic reference to create a small, realistic image in charcoal. Copy your image using a grid or trace it. (Rub the back of a photocopy with charcoal, place it over the drawing paper, and draw over the outlines to press the charcoal onto the paper). Make your contour drawing as precise as possible, and apply everything you have learned about value drawing to the use of the charcoal medium. If you need to use white chalk to brighten highlights, do so, but make it your very last step in the drawing to avoid dull, blended grays.

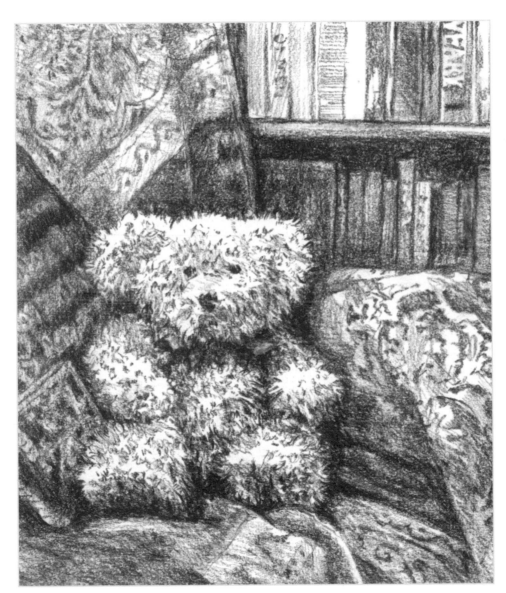

Charcoal can be used for fine detail.

ASSIGNMENT: WEIGHT AND DIRECTION ON GRAY PAPER

Set up a simple still life of several round, heavy fruits or vegetables in a clear plastic bag, knotted to a doorknob. Use a midvalue gray paper and draw with white chalk or Conté crayon (similar to a hard, white pastel) and compressed charcoal or black Conté. Try to capture the impression of weight and tension. Note highlights and straight lines to points of tension.

White chalk is used to add highlights on toned paper.

Chapter 11

Drawing Landscape and Nature

Landscape is a broad theme encompassing both natural scenery and urban cityscapes. Whether you look to capture a grand mountain vista, the changing seasons, or the minutiae of natural life, there is a lifetime of subject matter to be found in landscape. The absence of color in pencil and graphite landscape drawings places the focus on the varying forms and textures of the environment—a challenging and rewarding subject for the artist.

Sketching Outdoors

One of the bonuses of landscape drawing is the pleasure of working outdoors in the fresh air. A dedicated sketching trip is the best way to ensure you get time to draw, so you aren't under pressure to move too quickly. However, taking advantage of a few minutes for quick, on-the-spot sketches is a great way to capture the essence of a landscape. Even a five-minute sketch can be long enough to fix an impression of the view firmly in your mind, and it is a wonderful way to enhance your memories of a trip.

When time is of the essence, look for the key features. Remember to keep your line expressive; observe accurately but quickly. Simplify values down to black, dark, midtone, and light, using shading, hatching, or ink wash to rapidly place big areas of value.

Once you are accustomed to working from life, you'll find that the processes of observing and recording a scene come very naturally. You will quickly develop your own approach to contour drawing, one that reflects your own sense of design. Each subject is unique and therefore requires an individual approach.

Sketching outside is enjoyable, but you need to be well prepared. Always be aware of personal safety. Ask a trusted friend to accompany you rather than working alone, and be aware of any problems in your local area, such as dangerous wildlife or unpredictable weather. Consider contacting a local art group, since many organize day trips for their members.

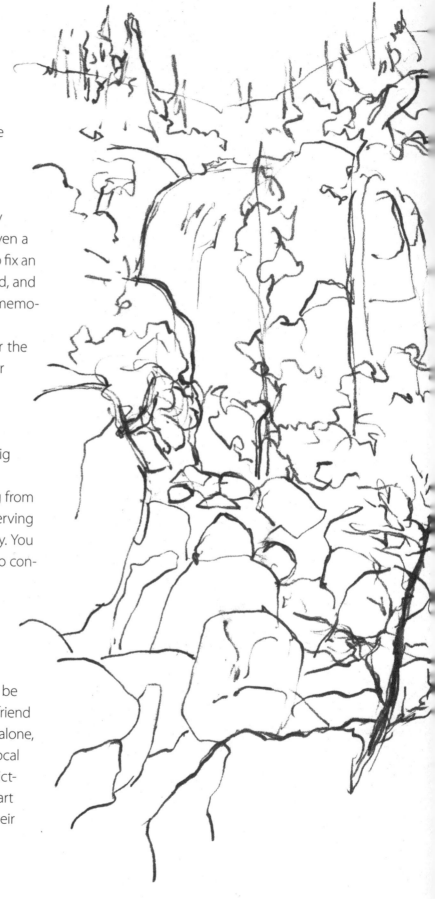

Composing Your Landscape

Remembering the principles of good composition is very important with landscape drawing, as gradual landforms and similar tonal values seem to lend themselves to vague, directionless drawings. On the other hand, there is a tendency to pick a point of interest—such as a building or large feature—and start drawing with it in the center of the page. This stems from our natural inclination to directly eyeball our point of interest, placing it in the center of our vision. Putting it in the middle of the page is automatic. While there are times when this can be successful, you can create drawings that are more interesting by remembering to frame your subject and by considering your entire composition. Use a viewfinder or your hands to help visualize the layout. Take another look at the discussion on composition in Chapter 5 to refresh your memory. You might like to make a short checklist of key points in the back of your sketchbook.

Remember that a finished drawing exists independently of any references. You don't need to make an exact copy. Keeping this in mind helps give you the freedom to manipulate elements to create a successful composition. You can alter value or texture to create an effect, or even remove or add elements, such as a tree or a bend in the road.

Once you've decided on the shape of your composition, measure a frame to estimate the appropriate proportions, leaving at least a half-inch border around the page. Leave a wide margin at the bottom of a landscape (horizontal) page to create a panoramic composition of scenery, or leave wide side margins to a portrait format for an elongated view, such as for a waterfall.

Remember that "landscape" doesn't only describe countryside vistas. You can narrow your focus to a couple of key elements—a building and a tree, a group of rocks, a small section of fence line, and so on. You can also pick out small details—a pinecone, a leaf, some pebbles—though these begin to take on the quality of a still life rather than landscape.

A Waterfall at Yosemite

Here is an approach to beginning a drawing, just to get you started. Once you've decided on your subject and visualized the composition, you need to get down some key details, especially if you are drawing a busy scene. Look for clear reference points, strong verticals or horizontals, and large forms. Placing these first helps give you solid points of reference for the rest of the sketch. Large tree trunks, rocks, any artificial features such as buildings or roads, and the line of hills or forest areas can be established at this point.

From there, you can begin to add shading. Often artists work light-to-dark so that they can make subtle adjustments to the drawing without creating hard-to-erase darks. However, for beginners, this approach often results in tentative drawings that have plenty of middle values and no black. Beginners, and more experienced artists who want to develop a sketch quickly, can benefit from attacking the darks first. Dark shadows usually have a strong visual relationship to the main contours, which make them fairly easy to place, and it is surprising how quickly shadows begin to define forms.

Sketching in the main forms

The other benefit of establishing the darks is that you begin to see the rhythms established in the picture. As you work in the remainder of the drawing, you can lift or drop the tone of midrange values to establish order, adding balance, continuity, or dynamism to a composition. As well as looking at your subject, you need to look at the drawing in its own right and consider where it is going. This is particularly important in nature drawings where there are multiple or less-obvious focal points.

Establishing some darks, modeling the rocks

Once the darks are established, shade in the rest of the drawing, reserving the highlights to create texture in clumps of foliage. Strengthen very dark shadows and enhance contours where needed.

Perspective in Landscape Drawing

Linear perspective is an essential element of landscape drawing, especially if there are buildings, roads, fences, or power lines in your scene. When drawing on location, it's a simple matter of observing carefully and recording what you see. The effects of perspective can be subtle, and you need to be careful of the tendency to flatten planes; you know the wall is flat, so your brain tries to make you draw it that way. Remember that each set of parallel lines has its own vanishing point—so if you have a building set at a slight angle to another, its vanishing points will be different. Use a known vertical to check angles.

Even if you can't see the horizon, you can infer the location of vanishing points for parallel lines in your image. This can be useful for large areas such as hills or fields, where directional shading emphasizes perspective and can help create a feeling of space and direction in your drawing.

Atmospheric perspective, which is the apparent fading and loss of detail as objects recede, also helps establish the illusion of depth in a drawing. For example, if you have a strong, dark swath of vegetation cutting through the background of your picture, this will seem to jump forward and will appear to flatten the picture. Sometimes you can manipulate other elements accordingly—making the background darker so the vegetation recedes, for example—or you can change your handling of the problem element itself.

Sketching the Landscape

Aim: To practice sketching a landscape

Materials: Paper, pencil, eraser, pen

Time: 1 hour

Set Up: Choose a suitable location for sketching or find a large, clear reference photo to work with.

Start Drawing: Create three drawings of your scene: a simple contour drawing, a value drawing, and a pen drawing using hatching and crosshatching. See if you can identify aspects of the subject that can best be brought out with each approach.

Review: Which drawing did you enjoy the most? Which most suited your subject? Think about the different qualities of each medium, and how they related to the subject.

Explore Further: See how far you can simplify your contour drawing. How can you pare down the landscape to its most essential elements? Try using a few poetic lines to express the forms.

Drawing the Sky

In 1821, the English landscape painter John Constable wrote, "It will be difficult to name a class of landscape in which the sky is not the key note, the standard of scale, and the chief organ of sentiment" (Letters of the Great Artists, from Blake to Pollock, by Richard Friedenthal, London: Thames and Hudson, 1963). In painting, with the ready use of blue and white, beginners can happily put in at least a simple sky. With drawing, and only gray graphite at one's disposal, artists often seem to cave in and opt for the "white sheet" that Constable so despised.

Because the sky is the source of light, artists tend to fear using dark values in it. But while the sky is lighter than the ground, the true source of light is the sun, and much of its rays are filtered and dispersed by the sky. Behind that expanse of blue is black night.

It can be useful to take time out and look at some black-and-white photographs of landscape to see just how dark you can safely go. Browse through any old book, search the Internet, or scan your own photos and convert them to gray scale. You'll be surprised just how dark your regular blue sky can be.

Negative space comes into play once again when sketching the sky. Whether you use ink wash or pencil hatching, observe any white clouds and reserve the whites as you go. Note that however insubstantial, clouds are three-dimensional objects: try to convey that sense of form and perspective. If perspective is a strong element in your composition, consider drawing some orthogonals to help you carry that element into the cloud structure. The use of directional hatching can help with developing the forms. Pay particular attention to the angle of the sun and its effect on the shadows. Depending on the sun, your clouds are likely casting shadows over your landscape. These can be of great help in reinforcing the sense of structure in your sky as well as modeling the landscape over which they are cast.

For fair weather **cumulus** clouds scattered softly in a bright blue sky, use light, smooth shading with a fairly hard pencil, reserving the whites of the clouds. Very lightly bring the slightest shading into the cloud here and there to soften the edge, then use a blending stump to smooth and soften the effect. You can successfully draw these without a stump if the rest of the drawing is reasonably robust, but blending gives a more painterly effect. These clouds, as well as wisps of cirrus cloud, can also be "drawn" with an eraser, again with some slight shading and blending.

Some heavier types of cloud cover, such as **altostratus** or more developed cumulus, are usually quite darkly shaded underneath, with brightly sunlit tops. Note that these clouds have a strong three-dimensional feel. Atmospheric perspective is also important here, making the distant clouds look lighter and more softly modeled.

Liquid mediums, especially pen and wash, are ideal for capturing the heavy grayness and soft edges of **rainy days**. With pencil the job is much more challenging. This thumbnail sketch uses layers of erasing and pencil strokes to suggest the sudden sheet of rain. Rain dramatically increases atmospheric perspective. After rain, look for reflections in puddles, darkened values, and brighter highlights.

Elements of Landscape

To create a convincing landscape, each element needs to be drawn so that its unique qualities of form, value, and texture are conveyed to the viewer. Sometimes you might choose to manipulate certain attributes in order to create a compositional effect—such as flattening form or simplifying tonal values.

Natural forms can often be quite forgiving; errors can easily be incorporated into the drawing. When sketching, there is no substitute for accurate observation: think simple but be precise.

Drawing Trees

The key to good foliage drawing is to identify an overall structure. First, you need to ensure that your branches make sense. Draw the trunk and branches first, as you'll need to visualize where they disappear behind foliage and when to continue the lines. This way, you'll make sure that your branches are straight and make some sort of sense, without any awkward disjointedness.

When drawing the foliage, look for groups and areas of separation. Each branch supports separate clumps of greenery, which can be defined by textured shading and highlights. Squint your eyes and look for continuous patches of shadow, midvalue, and highlight, sketching in the shadows between small clumps of foliage.

Look at the overall lighting pattern across the tree, observing the direction of the light source and noting where the leaves are in shadow. Shade the overall form of the tree to bring out its three-dimensional form. Strengthen the shadows and add little details as needed.

One of the most common mistakes in landscape drawing is scribbled "Brillo pad" foliage. The emphatic, circular shapes bear little resemblance to real foliage and sabotage all your efforts at realism in the rest of the drawing. It might be a handy method for quick sketches, but you need to find an alternative approach that allows you to imply foliage, without drawing every leaf, in a way that is consistent with the rest of your drawing.

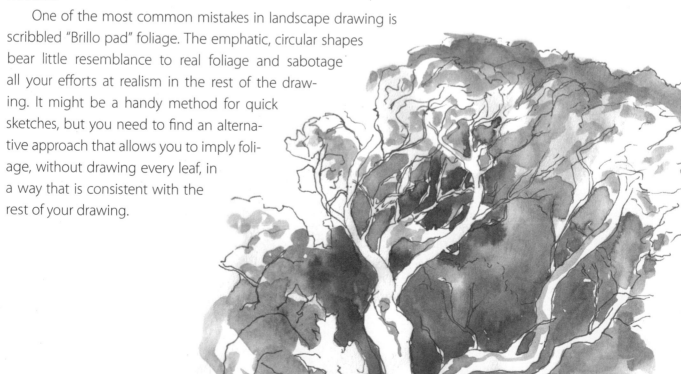

One approach to sketching foliage is to make a quick observation of the ragged areas of dark shadow behind clumps of foliage and darkly shade these, using strokes that leave reserved lights with a texture appropriate to the species. For conifers this might be spiky, outward strokes, while trees with rounded leaves will need a concave, scumble stroke.

Negative-space drawing is constantly employed when drawing trees. Sections of foliage catch the light, dramatically contrasting the shadowed foliage behind.

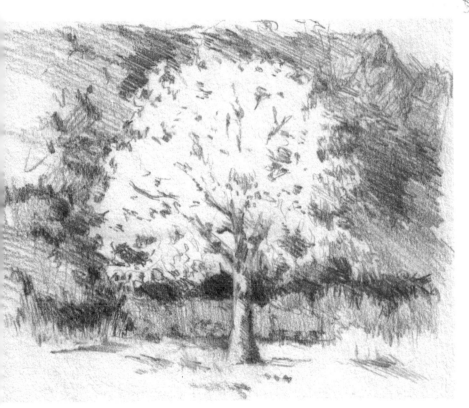

Every species of tree has its peculiar characteristics—overall form, branch structure, leaf shape. You don't need to define every tiny detail, but consider the individual qualities of the tree and reflect these in your approach to the sketch. The birch has a slightly horizontal, flaky texture, through light, silvery bark, while the cedar has deep, vertical striations in its heavily textured and deeply colored bark.

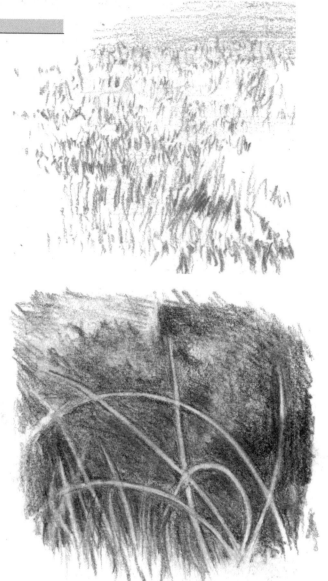

Drawing Grass

Like hair, grass often causes problems for beginners. The most common mistake is to draw every blade with a pencil stroke, resulting in an unnatural, wiry-looking texture.

Use negative-space drawing and concentrate on the darks, reserving the shapes of the light blades of grass. You can carry this to a high degree of realism by crisply defining the edges of every blade and then shading them into precise, lighter values. You can also use brisk sketch marks, "feathering" the pencil by using a circular on-and-off stroke so that the mark starts and ends gradually, to create a soft texture.

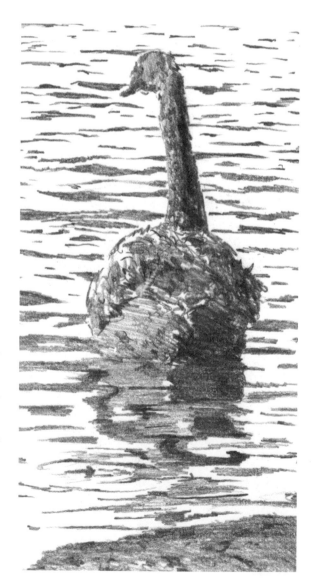

Drawing Water

Water is notoriously difficult to draw, especially when it is moving, but even when still, its qualities of transparency and reflection are a challenge. Many artists deal with this difficulty by using reference photographs and drawing water in precise detail, and this is certainly an effective approach. It is also a useful way to build up a repertoire of technique before sketching outdoors. Do spend some time browsing through some images of landscapes—drawings, paintings, and photographs—and consider different approaches to recording water in the environment.

Working in black and white will keep you from falling into the common beginner's trap of painting water blue. Water is not blue, but colorless. Where it reflects the sky it looks blue, but elsewhere it reflects the colors of whatever else is nearby. Water can look amazingly dark when in shadows, especially in tree-lined creeks and ponds. As always, observation is the key to determining how to handle any particular stretch of water. Check for:

- Water clarity (clear or muddy)
- Surface (still or rippled, foam)
- Reflection clarity (smooth, broken, or blurred)
- Transparency (visible river bottom)

A fairly smooth paper is helpful when drawing water, so as to avoid too strong a grain, which fights against the reflective surface expected of water. Note that reflections are always directly below the object being reflected. Sometimes these can be mirrorlike, and other times they can be broken by ripples.

Painters have the advantage of using opaque white paint to create spray and foam. With graphite pencil, the whites must be reserved. (White Conté pencil can be used, but it can be difficult to combine with graphite.) Use an eraser in a dabbing motion to lift off clouds of spray or foam.

As always, observation is the key. For really convincing results, a photographic reference and a patient, photo-realist rendering of fine detail is called for.

ASSIGNMENT: TONAL AND TEXTURAL QUALITIES

Find a pond or fountain that you can see reflections in from a comfortable vantage point. Only use a photo reference if there is no alternative. You could even try placing a large pan of water in the garden and drawing the reflections in that. Compare the reflections to the view that is reflected. How do the tonal and textural qualities change?

Waterway in Pen and Wash

Pen and wash is an ideal medium for sketching waterways. The liquid medium allows you to quickly define large areas of value, giving a smooth, even tone that suggests the water surface far better than grainy pencil. The crisp pen line gives texture and definition to contours and shadows. The following drawing of a mill on the River Wear in Durham, England, shows you the basic steps to approaching the subject.

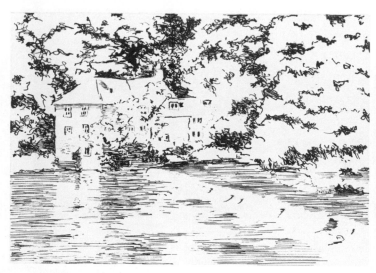

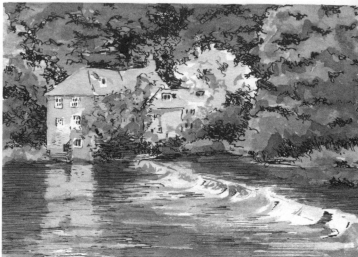

1 Lightly sketch a contour drawing in pencil, and use a pen with waterproof ink to complete the drawing. Rather than using a solid outline, leave lighter edges clear in some places to be defined by the use of wash or suggested with broken lines. Draw the darkest shadows with a scumble texture in the foliage. Use light horizontal strokes to suggest the ripples on the surface, being careful not to overdo them.

2 Add two main washes. First, use a light wash to cover almost all of the picture, reserving only the lightest sunlight areas, the white paint on the house, and the white water falling over the weir. Once the first wash is dry, apply a second, slightly darker wash, with the brush touched in some darker wash to strengthen the darkest areas of the picture.

Chapter 12
Drawing Animals

Animals are delightful subjects, even if they aren't always the most cooperative. You can guarantee that kitty will suddenly wake up or wander off halfway through a sketch, while your affectionate pooch thinks investigating the zoom lens is much more important than posing. The best pet portraits avoid sentimentality, capturing the character of the subject in the way that the best human portraits do.

Sketching

Having a pet at home is a perfect opportunity for plenty of sketching practice. Fill your sketchbook pages with drawings of your pets in various poses as they eat, play, and sleep. Pen is great for sketching, as it encourages you to commit to an image and avoid hesitant, lightweight pencil lines.

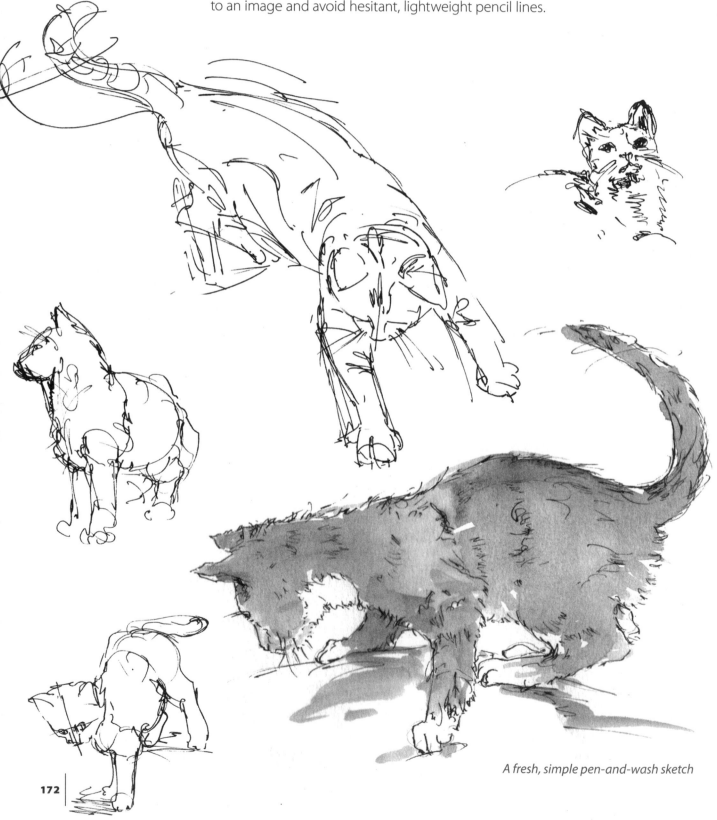

A fresh, simple pen-and-wash sketch

Remember to give equal attention to the whole sketch, unless you are trying to focus on a specific feature. Use abbreviated strokes to suggest details, practicing on rough paper first if you aren't sure of how to handle the area. This is especially important for the paws on a cat or dog, which can look clumsy if heavily worked.

Pen and wash is the ideal medium for capturing the fluid movement of a cat. In a few brisk strokes you can indicate the essential lines, then fill out the form with a stroke of a brush. A loose, circular stroke seems to best reflect the lines of a cat—they rarely form hard edges. Look for the curve of the ribcage, the flow of the spine through the hindquarters along the tail, the oval forms of the haunches and shoulders. Quick lines indicate the plane of the face along the nose and across the eyes and ears, and curving lines for the cheeks and chin complete the head. Note the S-curve of chin to chest, and the direction of the limbs.

When sketching dogs, use brisk, energetic lines to note the main form of the torso, the position of the head, and the direction of the limbs and tail. For long-nosed breeds, the head can be abbreviated into a wedge shape. Look for the simplest way to express the form of your dog; try drawing the head with as few lines as possible.

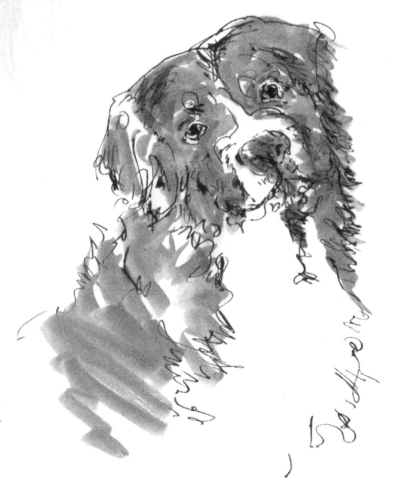

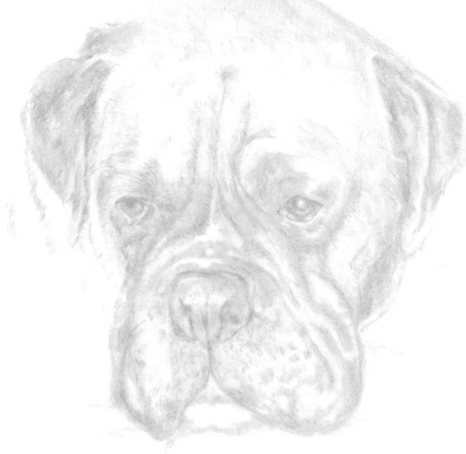

Drawing Animals in Detail

There are two major components to creating a detailed animal drawing: structure and surface. The fur of longhaired cats and dogs can obscure their musculature, but it is still necessary to understand the form underneath the fuzz if you are going to create a convincing drawing, rather than a formless fur ball. Observing similar shorthaired breeds is a useful source of information. Modeling the form of shorthairs is comparatively straightforward, as the shadow wraps around the form quite cleanly, but with long hair, clumps of hair often stick out in contrary directions and break up the form. If the fur is correctly modeled, with accurate highlights and direction of growth indicated, this problem can be minimized.

Anatomy

Studying anatomy is certainly worthwhile, but much of the skeleton is disguised under layers of muscle and fur, so in the first instance your time will be best spent observing visible structure and form. Careful observation is your key to correctly drawing the specific breed and individual animal; examples can be a guide, but then you have to trust your own eyes. With some animals, the variation between breeds is relatively subtle—a horse's head is always the same fundamental shape. Some animals, particularly dogs and cats, exhibit extreme differences in face shape and body type.

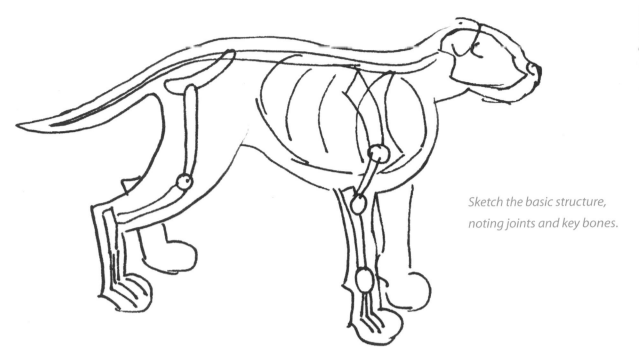

Sketch the basic structure, noting joints and key bones.

If you are interested in drawing animals, you'll want to obtain a reference source and spend some time studying their anatomy. You don't need to learn the names of bones or muscles unless it helps you remember how to draw them—what's most important is to remember how animals look and move. Simplified sketches of the skeleton can help you make sense of the way a creature changes form.

You'll easily be able to locate anatomical diagrams on the Internet (veterinary sites often have helpful diagrams) or at your local library. Your vet might have a skeleton you can look at, or observing the three-dimensional skeleton at a science museum is excellent drawing practice.

ASSIGNMENT: ANATOMICAL STUDY

Create a basic structural sketch and a detailed value drawing of the skull from several angles. Create detailed studies of the paws, hooves, or claws, and do a sketch of the full skeleton. Pay particular attention to the joints and any bone that is close to the surface of the skin. Do a sketch showing the main muscle groups and tendons.

Feathered strokes (top)
compared to straight strokes (bottom)

Drawing Eyes

Bright, crisp highlights are the key to sparkling eyes. The light shining through a window gives a clear, curve-edged highlight on the surface of the eyeball that helps define the three-dimensional shape of the eye. From there, depending on the scale of the drawing and whether you are working from life or a photo, the shading and detail in the eyes will give a degree of realism. Suggesting or fully drawing the detail in the iris, including any reflections on the surface of the eye, is a matter of time and patience. Working from life is a matter of quick observation.

Drawing Fur

The value-based approach for detailed pencil drawings can be used in an abbreviated form when sketching. This is particularly useful for longhaired cats and dogs, as trying to draw all the hairs with pencil strokes results in an unnatural, wiry-looking beast.

The trick is to make a quick observation of the darkest areas of fur and work them in with brisk pencil strokes, first in the direction of growth, then backward toward the lighter fur. Lift the pencil as you go to create a feathery edge. Carry dark lines randomly into the lighter fur. Whether drawing dark fur and leaving areas of highlight or drawing a shadowed area in light fur, a convincing fur texture can be achieved using a "curved" pencil stroke, lightly on and lightly off again, so that the pencil is lifted at the start and finish of each stroke. Remember that highlights and shadows help model form and travel across areas of fur, so observe them carefully. Carrying occasional darker lines through the highlight is enough to suggest the long fur texture that has been broken by the highlighted area.

Where there are areas of white hair, work in the opposite direction of hair growth to "reserve'" the lighter hairs in the front, or use an eraser to lift them out. Use short, flicking marks where there are patches of longer, softer fur, such as on the chest.

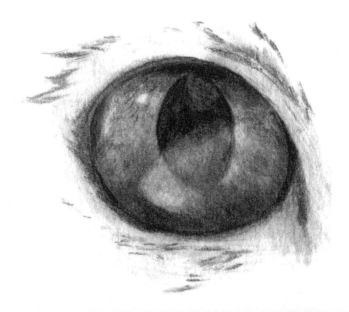

Drawing Dogs

Dogs come in the most astonishing variations in size and type—from tiny toy dogs to massive shepherd breeds, from hairless dogs to walking hairballs—and the approach to drawing them depends on each breed's unique combination of canine qualities.

Begin drawing a dog's head by building a simple structure. Establish the angle of the head with a line down its center. At right angles to this (in perspective if the head is turned) place a series of parallel lines to indicate the back of the skull, forehead, plane of the eyes, nose, and mouth. Place the eyes. Sketch the shape of the jowls; with some breeds, such as a boxer or mastiff, the jowls are much looser and you have folds of extra skin to deal with. With this type of face, sketch in the darkest line of the fold first to get a smooth line, then add the shadow. Make sure you position them carefully, and while the drawing might look odd in progress, the completed drawing will appear correct. Add the ears, being careful to observe their placement on the head.

The structural approach works well with medium-haired dogs, such as golden retrievers, where you begin with observing the basic structure of the body and add in the "shag pile" coat. Dogs with very thick coats can often be difficult to draw in this way. Visualize the skeletal structure, using whatever visual clues you have. Ensure that you place the paws and head correctly in relation to each other, then sketch in the coat. Be aware of shifts in direction of the fur, as these often hint at the structure beneath.

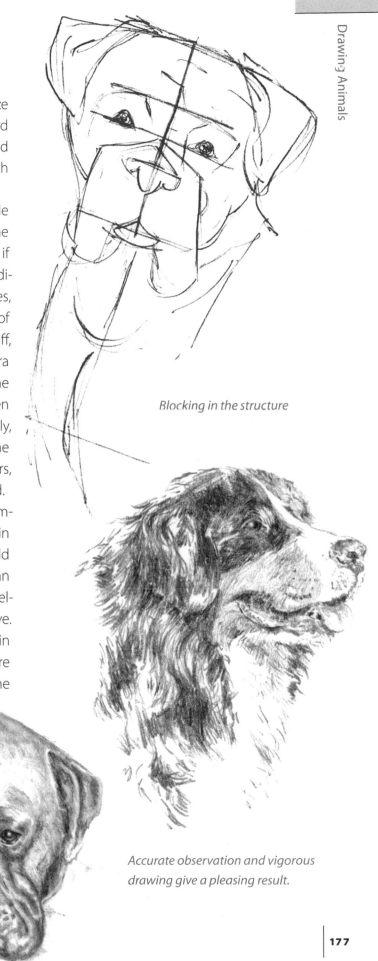

Blocking in the structure

Accurate observation and vigorous drawing give a pleasing result.

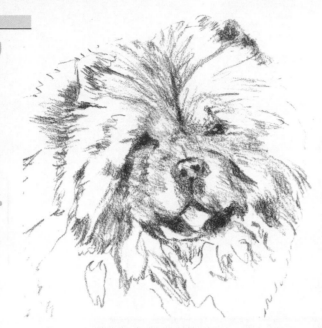

Drawing from a Photograph

Unless you have an amazingly well-trained pooch that will sit for an hour, photographs are often the best way to draw your dog. The following drawing of Chan, a luxuriously coated Chow, was done from a digital photograph. First, the outlines of his features are drawn, and the shapes of the dark and light areas of hair are sketched in with loose directional marks. Then any excess graphite is lifted off with a kneaded eraser, leaving only a hint of line. The edges of Chan's thick coat are shaggy and not hard, so straight lines are avoided.

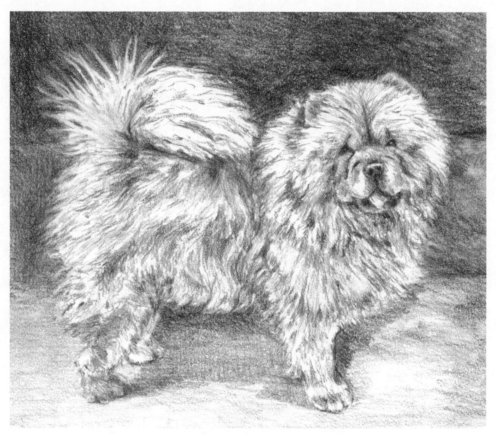

Details of the face are added using a sharp 4B pencil to quickly work in the dark values, and **highlights are left in the eyes.** As the pencil blunts a little, you can use it to add texture and value around the face and begin working in the darks in the fur. In this drawing, the soft pencil, used lightly, has a slightly grainy texture on Arches paper, which is ideal for the fuzzy fur texture.

A 2B pencil is used to build up the midtone values, in a **feather-on feather-off stroke to create the patches of light and dark hair.** The 4B is then used again to darken the shadowed areas.

Drawing Cats

Build the structure of the cat's head, beginning with a line through the middle of the head along the nose. Look for the main forms of the head, building the shape of the nose and muzzle with simple shapes. Note that the forehead, mouth, and the line through the eyes are parallel and at right angles (when the head is facing forward) to the center axis, and observe any foreshortening.

Note that the ears are three-dimensional, and the base is fixed quite firmly on the head. Foreshortening can be particularly tricky when drawing the eyes, as a sharp angle can make the far eye seem quite small in relation to the near one. Make sure both eyes are looking in the same direction,

Draw your structural sketch as lightly as possible. You can then begin adding surface detail, using short strokes to suggest fur texture and adding detail to the eyes and nose.

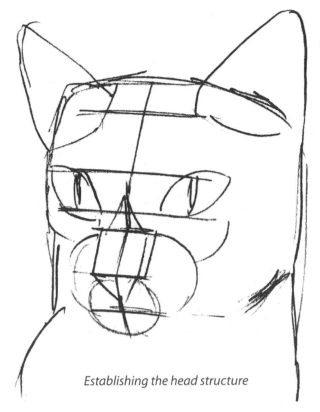

Establishing the head structure

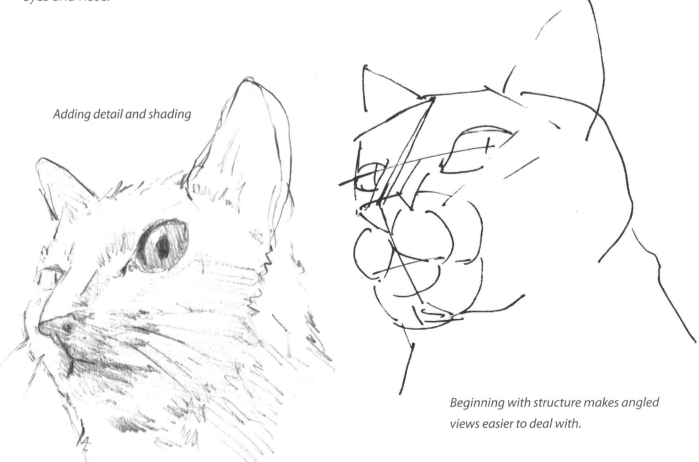

Adding detail and shading

Beginning with structure makes angled views easier to deal with.

Achieving Realism

Depending on the scale of your drawing, you can achieve a great deal of realism using pencil. Working on a reasonably large scale allows you to become quite detailed; you can show fine detail like the individual hairs on the animal (or at least implying them with a shorthand technique) and create fine textures. Larger pieces allow you to reserve the whites and add tone quite easily. When working on smaller drawings, it can be more of a challenge to create textures, as it is difficult to reserve small areas of white. This is where many artists turn to impressed-line techniques (see Chapter 4).

Whiskers, eyebrow hairs, and white ear-hairs are one of the most difficult areas to draw successfully. For a quick sketch, it is acceptable to indicate these with a pencil-line, but when you are looking for realism, the whites must be reserved.

Cat's eyes are often very darkly outlined. Be sure to draw this area dark enough, using a soft pencil overlaid with a harder one to smooth out any texture. Often the top lid-line is hidden by long hairs above the eye. Use controlled short strokes to draw any areas of black visible through the hairs.

Take care not to overdefine the nose, especially in a quick drawing. Otherwise, it will look stuck-on. For a detailed pencil drawing, careful rendering is appropriate, but for a sketch, the light suggestion of form and indication of the darkest lines will be more successful. Note the crease through the middle of the nose (see first image on next page), the dark curl of the nostrils, and the three-dimensional structure of the nose, which rises slightly from the face and flattens out a little between the eyes.

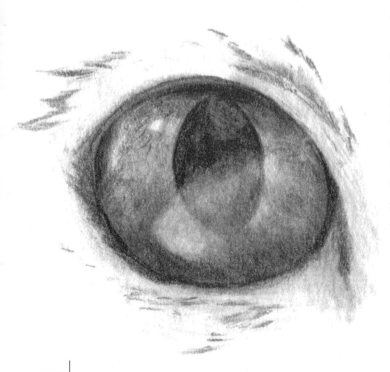

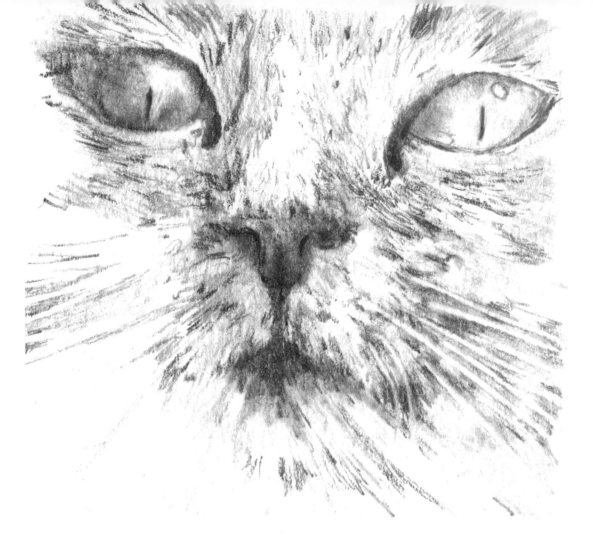

The hairs along the bridge of the nose are very short, giving a velvety texture. This can be drawn using very tiny strokes that look almost like dots. Use a sharp pencil, drawing the darks between the hairs and carefully reserving any highlights. You can lightly smooth over the sketch with a blending stump to add the base tone to the area, and again reserve the highlights or lift them out with an eraser and rework the darks along the highlighted area with a sharp pencil.

For more fully worked drawings, the leathery texture will require a subtle pattern, working in tiny circular strokes leaving spot highlights and adding dark dots where needed. Use a blending stump to smooth the texture, bringing up any more defined areas with a harder pencil.

Note that sometimes the mouth is not clearly defined; rather, it is suggested by the shadow of the hairs from the top lip over the bottom. Use short, upward strokes to suggest this hair growth.

Use short strokes and reserved whites to develop detail in the face.

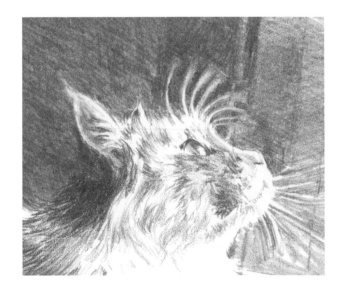

Amelia in Graphite Pencil

The drawing on page 183 was done from a fairly small digital photograph, so with limited detail available, a reasonably relaxed approach was called for. The drawing is on a rather rough paper, so it was best to avoid using a blending stump, as the paper's fibrous surface was unsuitable for excessive blending. You can create a similar drawing from your own photograph. Don't work too small—enlarge photographs up to around size A4, and make your drawing the same size.

The following steps describe how this sketch was created.

 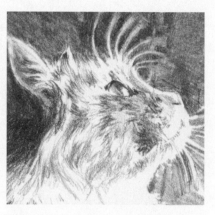

1 The main landmarks of the drawing—especially the facial features—are heightened with black pen on a computer printout and lightly traced onto the paper. Using a B and HB pencil, the background darks and some dark patches of fur are roughed in.

2 Using a B pencil to shade lightly and overlaying in various directions, the background is built up, avoiding the whiskers and feathering off toward the fur. The shading is still much lighter than the final drawing will be, but begins to establish the value range. Next, details around the face are established, the shape of the ear refined, and shading added, using light strokes lifting off to reserve the white ear-hairs. A patch of shading is erased near the eye, where some eyebrow hairs have been omitted in the initial drawing. The frame of whiskers and hairs around the cat's face is an important part of her character, and help create a soft halo—she'd look strange without them.

3 Now is the time to get serious about building value and texture. Going straight for a 6B, the darkest values of the drawing are established in the fur behind the ear. A "feather-on-feather-off" pencil stroke is used to keep a feeling of fur texture. A slightly lighter pencil is chosen for the face—the values are still quite dark, but a 6B will be a little too strong. The pencil is kept sharp, rotated frequently in the hand and resharpened as needed. The grainy texture achieved by a light touch with 6B and 4B pencils is ideal for the softer, fluffier hairs, while a harder pencil is used for more clearly defined hairs. Graphite is lifted from the background with an eraser, and the eyebrow hairs redrawn. First they are placed with a line on each side, then the background values are built up, leaving the white hairs.

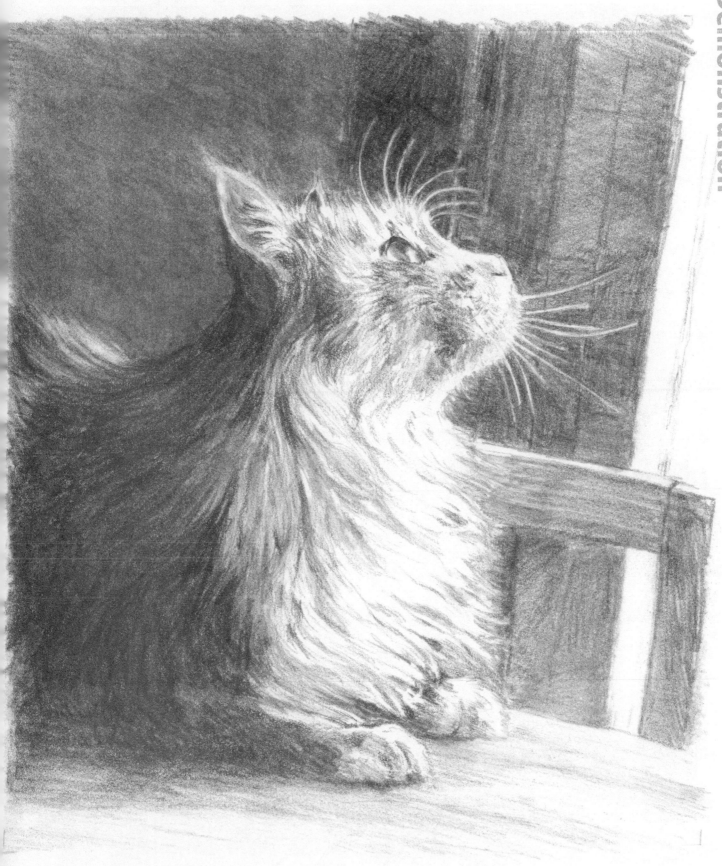

Exercise

Sketching Cats

A casual brush-pen sketch

Aim: To draw a cat in a variety of poses

Materials: Sketch paper and pen

Time: 20 minutes

Start Drawing: Try to capture your cat in a variety of poses. Sleeping, grooming, eating and playing are all times that offer interesting poses. Try sketching from life as well as using photographic references, but keep your drawings fresh and lively—avoid overworking. Using pen prevents fussy rubbing-out. Keep sketching if you make a mistake and let the stray lines become part of the design. Look for ways to convey movement.

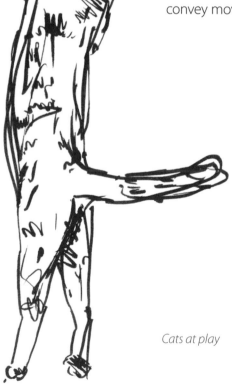

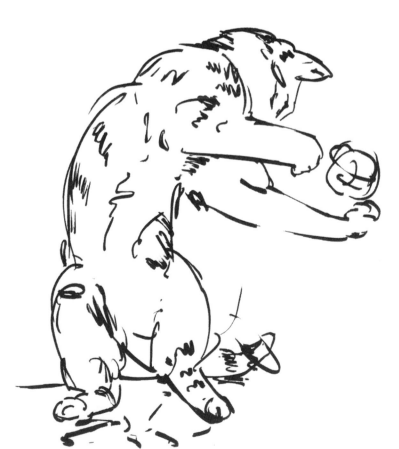

Cats at play

Drawing Horses

While the anatomy of all horses is fundamentally the same, proportions can vary considerably from breed to breed, and each has characteristic features. A tubby pony and an elegant Arabian might have the same basic gait, but each has a quality of movement all its own. Be sure to spend some time observing horses both at rest and in motion, paying attention to their natural range of movement. In this way, you will avoid drawing unnatural poses and you will develop an understanding of your subject. Most of the time, you will probably want to use photographs to draw from, as horses rarely stand still, though you should try to draw from life if you can—even if they are only quick sketches.

Midmorning and the afternoon are the best times to photograph your horse, when the sun is high enough to give definition but not harsh shadows and highlights. As a general guide, stand so that you can comfortably see your subject in its entirety (whether head and neck or whole horse), in a single glance. This will minimize distortions at the edges (from too wide an angle) or compression of perspective (from too long a zoom); this approach is particularly useful with point-and-shoot cameras when one tends not to think about focal length. Take plenty of pictures—most animals are a bit uncooperative and will look dopey, move, snuffle the camera, and so on, until you've given up and put the lens cap back on.

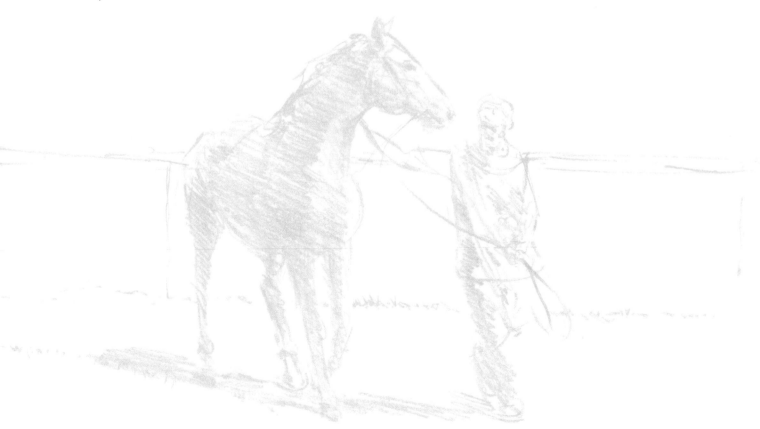

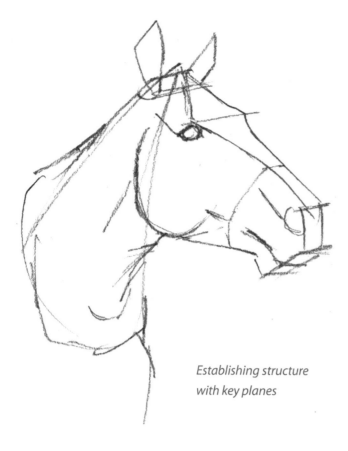

Establishing structure with key planes

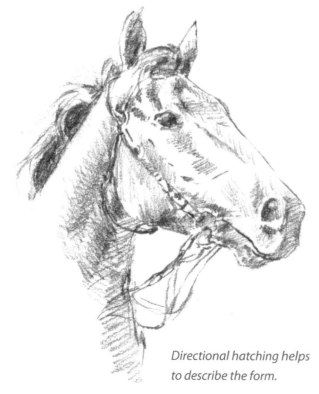

Directional hatching helps to describe the form.

The Horse's Head

Sketching a simplified structure is a useful way to begin drawing the complex forms of a horse. In profile, the head is a fairly rectangular shape and the neck is triangular. Make sure you observe the angle formed by the head and neck correctly. Some people see the head in profile as an ice-cream-cone shape. Build on the cheekbones and chin, and place the eyes, ears, mouth, and nostrils. The eye at this angle is essentially a bowl shape with a triangular hat. Remember that this formulaic approach, like the proportions of the human head, are only a ballpark guide to establish the basics. Observe your subject and make sure the proportions are relevant to the individual.

The three-quarter view can be a bit tricky, but the horse's beautifully angular head shape makes it a bit easier, forming a sort of kite-shape from poll (between the ears) to nose. Draw a line all the way down the face, then draw lines through the eyes and across the nose. Note the shape of the eyes at this angle, with the far eye being partly visible. When sketching the head in a three-quarter view, break it down to basic shapes first, keeping perspective in mind, and build up the details from there.

Eyes

Note that the horse's eyes do not show white except when rolled back in anger or fear. The pupil is a rectangular shape across the middle of the eye, though it is usually difficult to see it against the dark brown of the iris. A curved highlight helps to add form to the eye. Note the way the upper edge of the heavy lower lid catches the light. Some horses have quite long lashes.

Nostrlls

Note the overlapping curves of the nostrils. The nostrils express the horse's attitude and may be flared when the horse is fearful, angry, or running hard. Avoid hard outlining.

Mouth

The horse's mouth, with its thick lips, can be a bit of a challenge to draw. The best results are with a simple, single line between the lips, and a slightly broken line suggesting the lower edge of the lower lip. A bit may create a crease in the upper lip or corners of the lips. The droop of a horse's mouth can seem a little awkward to draw, even sad, but drawn correctly it should look fine—trust your eyes and observe your subject carefully.

Body

Horses have large, barrel-shaped chests and powerful hindquarters. Note the sloping shoulders.

The hind legs are rather tricky to draw, often looking awkward. Use negative spaces and check the angles of each part of the limbs against the vertical or existing lines.

Hooves

Many people find drawing the horse's hoof difficult. Looking for familiar shapes makes things much easier. If you begin by drawing a triangle, then cropping one corner, you'll get a pretty good hoof shape. Often, nature doesn't always look as elegant as we think it should—practice drawing from life until you are familiar with the hoof from every angle.

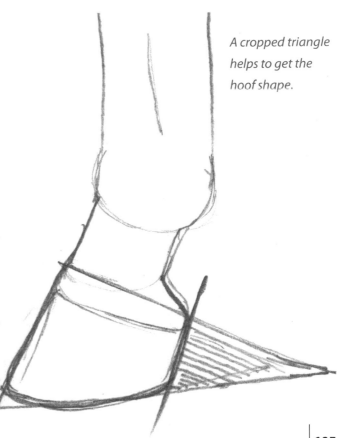

A cropped triangle helps to get the hoof shape.

Drawing Horses and Riders

If working from a photograph, select a shot that shows the rider seated well with the horse under control—a rising trot or unbalanced seat is difficult to draw successfully, and a horse that is fighting the bit won't make for a good drawing.

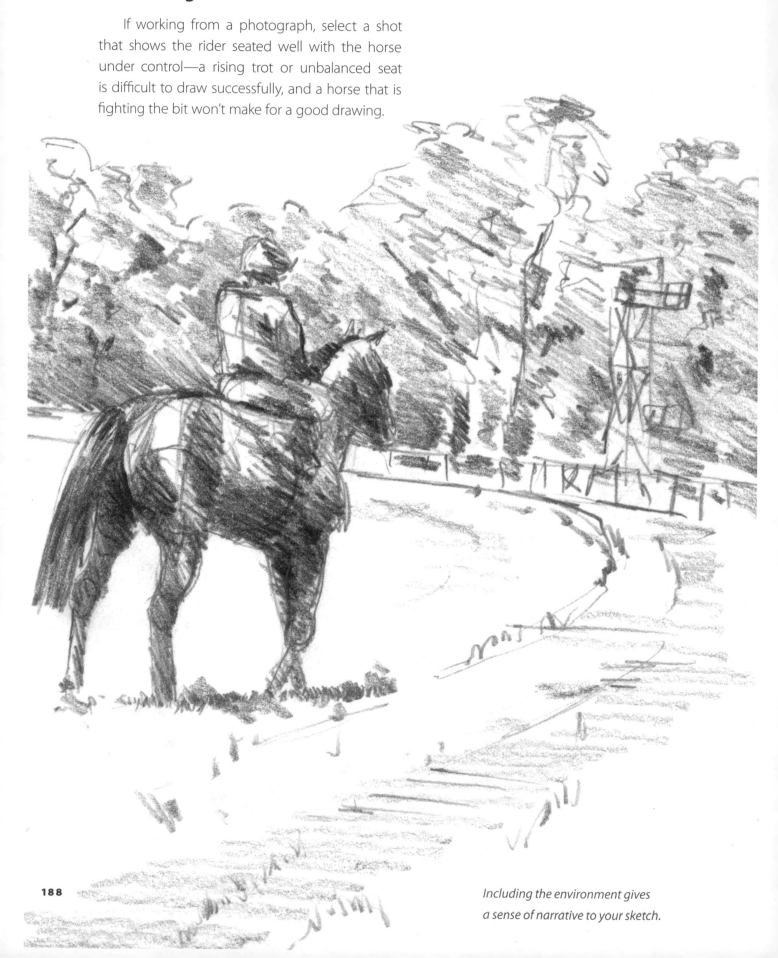

Including the environment gives
a sense of narrative to your sketch.

Begin drawing with a good structural sketch of the horse first. You want to indicate the solid roundness of the horse's body and visualize its form well. Make an imaginary line through the center of the rider onto the horse, so that the figure is centered. From there, you can place the saddle and rider, ensuring that the form of the saddle follows that of the horse, and that the rider's legs similarly follow the saddle and horse. Take your time and carefully observe the proportions of the horse and rider. A common fault is to make the legs too long, as the thighs are often slightly foreshortened, depending on the angle of view. Use points you have already drawn to check the position and angle of the hands.

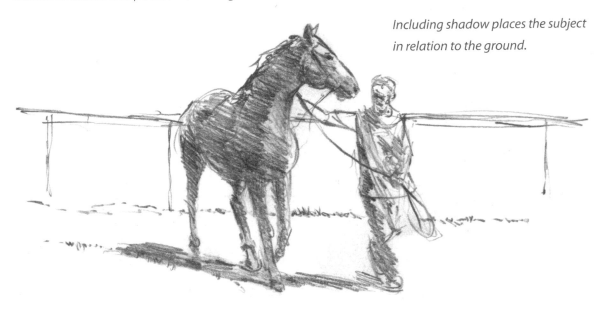

Including shadow places the subject in relation to the ground.

Of course, your subject will influence the finished result.

Pen and ink is an ideal medium for sketching horses in action. The fluid nature of an ink wash helps to create a fresh, lively feel. There are many opportunities for sketching and photographing horses, even if you don't have access to a horse on a regular basis. A day at the racetrack or rodeo or a polo match make for excellent reference material.

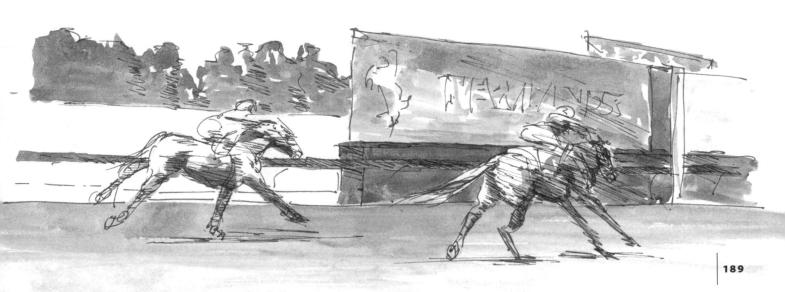

A Horse and Rider Continuous-Line Drawing

Aim: To draw a horse and rider with a sense of unity and fluidity

Materials: Large paper, pencil or pen, and a reference photo

Time: 10 minutes

Start Drawing: Sketch the horse and rider using a continuous unbroken line. Use the whole arm as much as possible, keeping the movement free and loose. Boldly sketch the main shapes of the horse in sweeping strokes and circles, and immediately do the same for the rider and tack. Continue working over the whole drawing, gradually adding in more detail, switching back and forth between horse and rider, so that all parts of the drawing are similarly treated.

Review: The finished sketch won't be particularly realistic, but it should be full of energy. The rider should clearly belong with the horse, and be working in unity with the animal. The rider should not appear "stuck on."

Chapter 13

Portraiture: Capturing Character

Drawing a portrait offers many fascinating challenges for the artist, as the infinite variety of human characteristics makes every portrait unique. At first, correct structure of the head and placement of features are the main concerns, but once you are comfortable with these aspects of portrait drawing, the subtle differences in physique and expression that create a true likeness become quite absorbing. Soon you will find yourself studying the faces of people you meet, and television interviews become art lessons as you observe the bone structure of the speaker and note the reflected light on his or her face.

More Than a Likeness

What is the task of the portrait artist? Most would say, "To create a good likeness,'" but few would be able to define what a likeness is. To create a representation of the sitter with the head and shoulders correctly proportioned and the features in the right places and in the right shape—that is a basic likeness. However, a drawn portrait, unlike a snapshot, expresses a great deal about the sitter's personality, his history, and his place in the world. Sometimes this can be achieved by planning ahead—choosing the type of clothing, background, lighting, and pose. These all contribute to the overall impression.

Often, a portrait will seek to express a particular aspect of a person's character or role in society: a proud military soldier or a beautiful society belle. The artist must keep the aim of her portrait in mind so that these requirements are satisfied. Most interesting are the portraits that manage to express the inner life of the sitter: the soldier with warm and laughing eyes, or the socialite with a generous heart. Interestingly, students' drawings, however incorrectly proportioned or poor in technique, will often express the personality of the sitter, because they are sensitive to more than the surface characteristics of their subjects. As people age, their habitual expressions etch into their faces. This tells much about a person, and an artist can bring out these subtle signs in the portrait. Look for expressions that seem to best reflect the sitter's nature—a certain curl of the lip, a sideways glance, a flare of the nostrils. Which lines on the sitter's face are more deeply etched than others? If the sitter is young, lines might not stay on his or her face but will fleetingly show up in a furrowed brow or crinkle-eyed laugh.

Portraits of Children

Drawing children requires a sensitive touch. Their delicate features look strange if delineated too severely. Sensitive doesn't mean weak; you can still use solid, dark values to describe shadows or strong lines. Good use of lighting is important to give you enough information to correctly model a child's head. As always, avoid flash photography; use natural light instead. Often, a quick sketch can capture the spirit of a child better than a labored drawing.

Drawing from Life

There is no substitute for working from life to develop your skills in portrait drawing. Being able to perceive depth enables you to make your own judgments about the form. A photograph may make it difficult to identify how subtle changes of plane shape the face, but when working from a live model you can simply move around the model to see for yourself what is really happening. Ask friends and family to pose for you, but make it clear that you are still practicing and may not produce a finished portrait. They might be used to seeing sidewalk artists quickly produce a sketch, so they may be disappointed if you do not do likewise. Explain to them that you are studying all the little planes and edges of the human face and that for now, it might not look like them at all. Once you've taken the pressure off yourself to "perform," you can relax and concentrate on your study of portraiture.

Make sure your model is relaxed and comfortable. You can sketch people as they read, watch television, or knit. Just ask that they keep their heads as still as possible, which should be in an upright position, as the head is too heavy to keep tilted for any length of time. If you want to get an interesting angle, change your own position—sit on the floor while the model stands, or stand above the model holding your sketchbook in your arm.

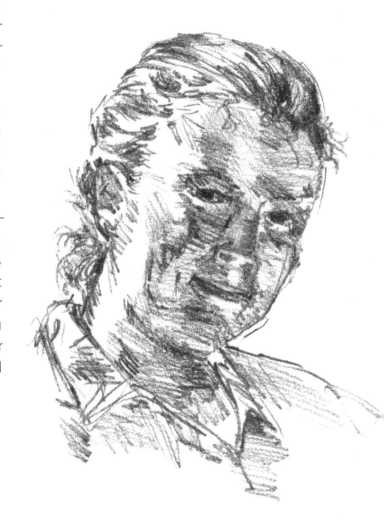

Essential

While physical traits are often linked with psychological ones, the anatomy we are born with doesn't always express our inner nature. The portrait artist can look beyond the structure of flesh and bone and seek to reveal the true character of his or her sitter.

The face divided into thirds and halves

Face and Head Proportions

The ideal proportions of the human head are well established in artistic tradition, based on the classical ideal of Greek and Roman art. When first gaining an understanding of the human form, the traditional rules of proportion are worth knowing, like the basic breakdown of the main structure of the head. However, while it is useful for roughly positioning the key points of the face, to achieve a good likeness, it is important to closely observe the structure of your individual sitter. These proportions give you a starting point, but you have to adjust the structure—sometimes quite a bit—to suit the individual.

Note that the eyes sit about halfway down the head. A common mistake is to make the forehead too short. The base of the nose is about two-thirds of the way down the face.

The distance from the forehead to the back of the head is about the same as the distance from the top of the head to the chin. Squashing the back of the head is one of the most common errors when drawing the profile view.

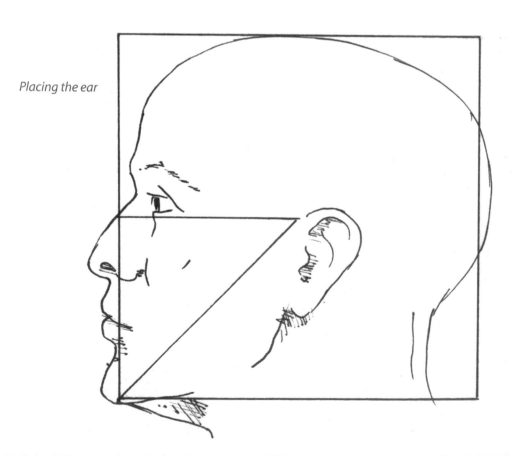

Placing the ear

Essential

When drawing from life, the change of view between your eyes can be confusing. Try closing your nondominant eye when positioning foreshortened details in the face, and be sure to keep your head very still, as a slight change of position dramatically changes the view.

Note that babies and children have much higher foreheads and the distance is shorter across the nose and chin, particularly before their teeth come in.

Use the "thumb and pencil" method to assist with judging relative proportions of your model. Visualize imaginary lines through the corners of the nose, eye, and eyebrow, and check them against your drawing. You'll be surprised how quickly the likeness of your subject begins to take shape just by locating the key structural points of the face.

Across the simple basic structure of the head are many subtle changes of plane. Some of these are more obvious than others, such as the jaw line or creases in the edges of the nostrils. Some, such as cheekbones or the bridge of the nose, will be obvious from one viewpoint, while from another they will seem to disappear. A typical snapshot view, with the sitter squarely facing the camera or viewer, is probably the most troublesome, as key planes are foreshortened and the face appears broad and flat. Add to that poor lighting, and you'll be in for a tough time. With just a slight change of angle, you have a far more opportunities to develop the structure of the face. Sure, the foreshortening through the eyes and mouth when the face is at an angle can be tricky, but it's worth the effort for the opportunity to clearly model the planes of the head.

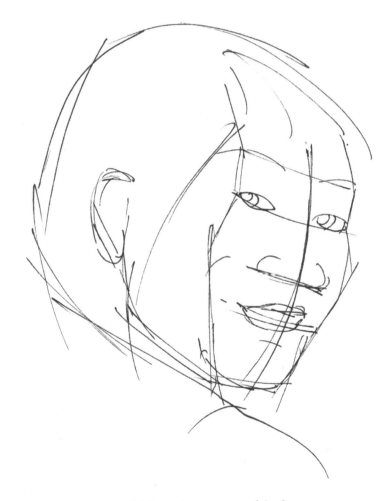

Establishing the structure of the face

Planar Analysis

To develop your understanding of the planes of the head, the process of planar analysis can be used. Don't let the fancy name daunt you; it just means breaking down the form of the head into simple planes. It's a bit like using shapes in a step-by-step, but because you are trying to see the head as a three-dimensional form, you are drawing it using planes rather than lines. Planes are defined by the lines around their edges, but you are still visualizing planes in space rather than the flat lines.

Imagine that you have a big block of stone that you are going to use to make a sculpture of the head. First, you have to carve out big chunks of stone to get something like the shape of a head that you can then refine. Once the big pieces are gone, you use a broad chisel to slice off large pieces. You can't create curved edges yet—only flat chips.

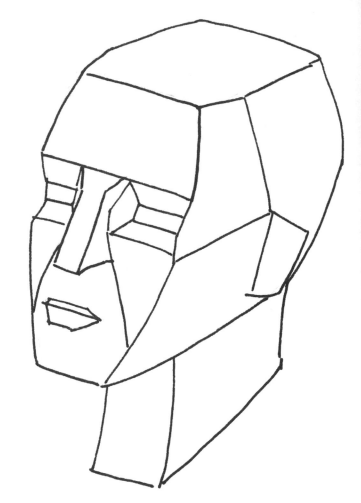

A simple planar analysis of the face

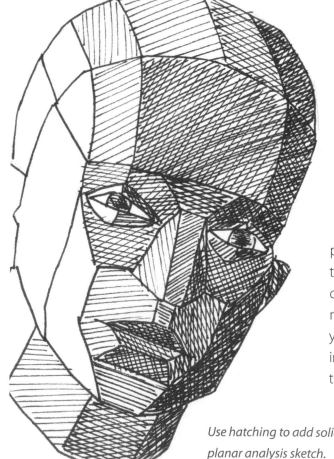

Once you are comfortable with identifying planes on the face, you can use this information in your drawing. You can use hatching and crosshatching following the planes of the face to model a head three-dimensionally. Used subtly, you can get a high degree of realism using hatching in this way, but even used briskly, modeling the form can be most satisfying.

Use hatching to add solidity to the planar analysis sketch.

This example, which shows two stages of the sketch, was created from an Ansel Adams's photograph of Katsumi Yoshimura, from a historical collection at the Library of Congress. The clarity and detail in the photograph facilitated strong three-dimensional modeling of the head. Once the basic structure was laid down, brisk hatching and crosshatching was used to define the planes. A kneaded eraser was used to lift off some areas of graphite prior to a second layer of hatching. Interestingly, while this drawing doesn't appear realistic in many ways, the fresh and immediate handling and solid modeling results in a pleasing sketch.

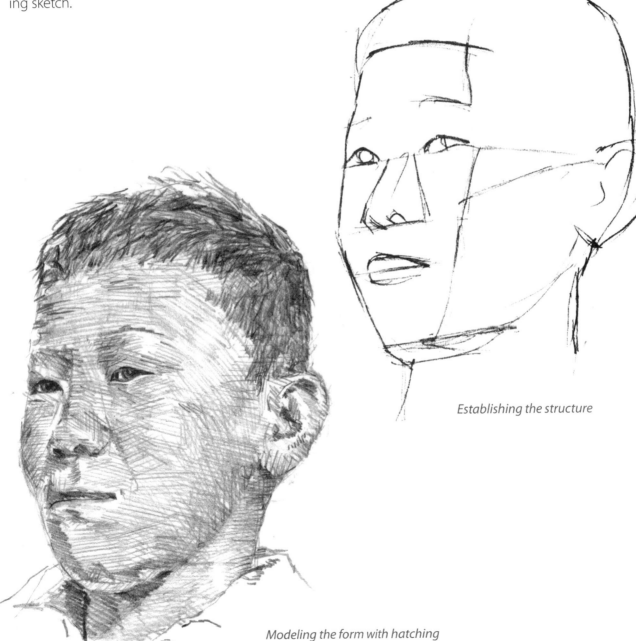

Establishing the structure

Modeling the form with hatching

Drawing Eyes

It is essential that eyes are correctly placed in the head. They must be in line with the plane of the face, the same size, and correctly foreshortened if the face is tilted at any angle. Sketching the eyes can be quite tricky, as the shape of the eye can change dramatically as the head is turned. To place the eyes correctly, position the irises first, drawing the upper lid and then indicating the lower, then drawing the pupils and locating the highlights. Artists favor different approaches, depending on their preferred medium. Painters often work from the outside in, structuring the planes of the face and working in toward the eyes. Pay attention to the lines, wrinkles, and shadows around the eyes, as these give information about expression and help to shape the eye socket, placing the eye securely in the head so it isn't floating loose on the face.

Practice drawing eyes from every angle.

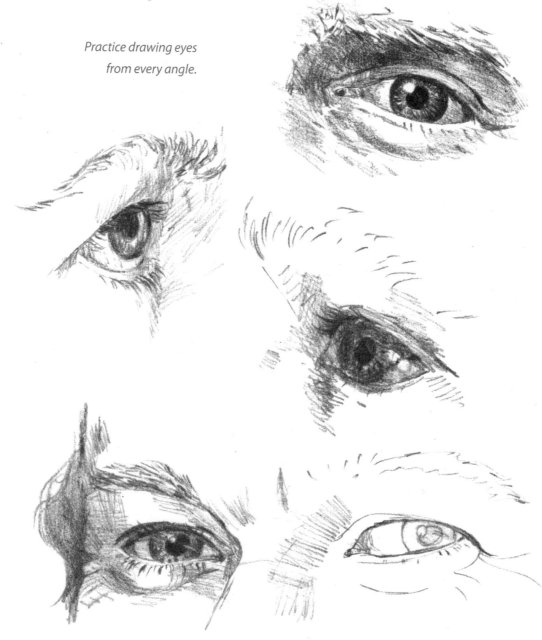

It isn't always obvious, but if you look closely in the mirror, you'll see that your eyeball isn't quite spherical. It nearly is, but the cornea bulges out over the iris. The iris is actually quite flat, so when the eyes are seen in perspective (as when viewed from an angle), they will appear elliptical in shape. The bulge of the corneal surface makes highlights and reflections sit on a different plane to the iris, and paying attention to this effect gives lifelike, three-dimensional eyes. It is helpful to ensure that a light source is placed to give you good highlights on the eyes, which cut partially across the pupil and iris, shaping the surface of the eye without obscuring the pupil. Don't draw the pupil too small, as dilated pupils give the sitter a warmer and more open expression. Ensure that both pupils are the same size. Even though the subject's pupils might not be identical, sometimes what is believable in a photograph is not believable in a drawing.

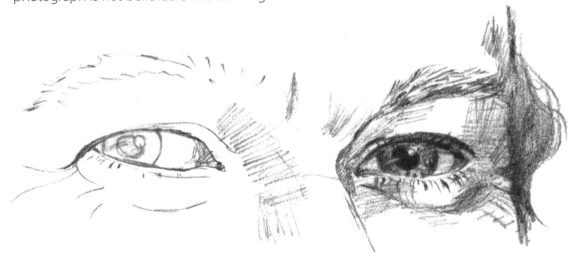

Gaze

A direct, front-on gaze suggests the sitter as engaging the viewer. When a person's head is drawn in three-quarter view, or even slightly so, and still looks straight out at the viewer, this is more arresting—as it might suggest an otherwise-occupied person stopping to look at you. Most people stand around four feet away from a portrait to view it, a little less for a small image. If you have the sitter look at your face from this distance as you draw the eyes, it will make it appear as though the subject in the portrait is making eye contact with the viewer. Have the sitter look at a point on a far wall, over your shoulder, for a more distant gaze. A downcast gaze might suggest shyness or introspection.

Essential

Spend some time in front of the mirror making different expressions and observing how these change your face. The effect of an expression will vary immensely between individuals, but being aware of the key muscle movements will help give you an idea of what to look for.

ASSIGNMENT: PRACTICING THE EYES

Draw a page of eyes. Sketch the head structure and practice positioning the eyes correctly, and draw single eyes in detail. Use the people around you and photographic references to find eyes of different types—deep-set, small, large, old, and young.

Drawing the Nose

When sketching the structure of the face, artists often draw the nose in a basic wedge shape. This is a good way to place the nose on the face, but you will need to add quite a lot more detail to fully model it. Observe the subtle changes in plane that occur across the cartilages of the nose, referring to an anatomy reference if possible. They tend to be more apparent in older people. You will also notice that some individuals have very obvious development of some sections of the nose, while others have quite smooth, almost featureless noses—but the tiny differences will still be observable.

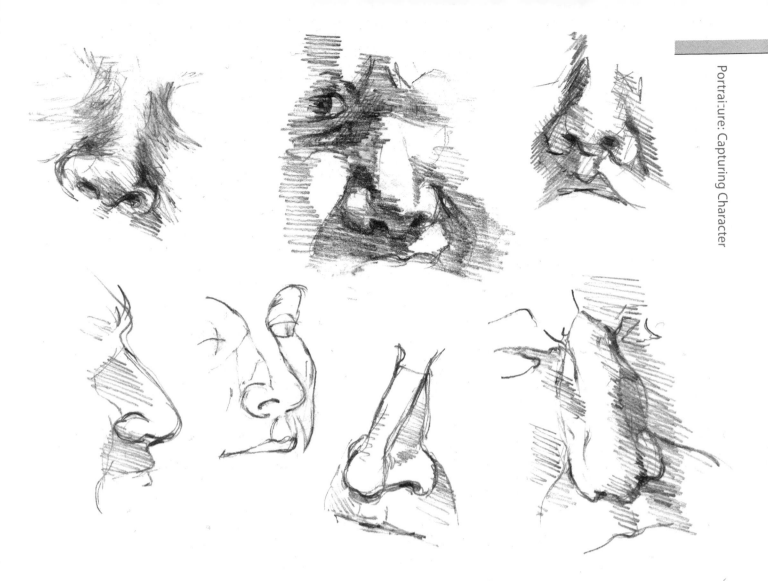

Be aware of reflected light when drawing the nose. Often the darkest area of shadow will be just along the ridge of the nose, with reflected light from the face brightening the sides of the nose slightly. There is often also a little reflected light under the nose on the nasal septum. The nose will also cast a shadow, depending on the type of lighting used. Pay attention to this as you place the model, as an unfortunate shadow can detract from the drawing, while a good one helps to describe the form.

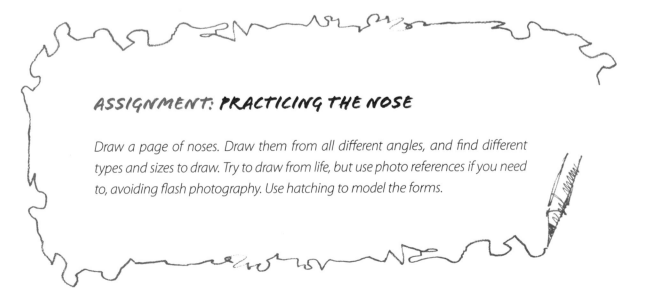

ASSIGNMENT: PRACTICING THE NOSE

Draw a page of noses. Draw them from all different angles, and find different types and sizes to draw. Try to draw from life, but use photo references if you need to, avoiding flash photography. Use hatching to model the forms.

Drawing the Mouth

Common problems with drawing the mouth include heavily outlined lips and teeth, lack of shadow on the gums and teeth, and inadequate modeling of the area around the mouth. Correct lighting of the subject helps to prevent these problems—drawing from flat, flash-lit photographs flattens the subject. If you do a drawing of the skull, or even look at your own teeth, you can see how three-dimensional this part of the face is; it is not at all flat. Take your time and carefully observe the shadows in and around the mouth, as accurately drawing these will solve most of the problem. There is often not much difference in actual tonal value between lip, tooth, and gum, especially when these areas are shaded or highlighted. Use an eraser to soften the edge of the lower lip, and lightly render the upper lip, avoiding outlining. When possible, ask your subject to remove lipstick, as the artificial shine and color emphasizes the lips too much. If drawing lipstick, use a blending stump to create a smooth sheen, reserving white highlights.

Smiling generally involves the whole face, with the corners of the eyes crinkling and the upward movement of the cheeks pushing the lower lids up.

Contemporary style tends to be hard-edged and encourages immediacy of line, so that the mark you place on the paper is left as is. If you want a more traditional look, consider using the blending stump and using soft edges wherever appropriate for a gentle "sfumato" (soft, smoky) effect.

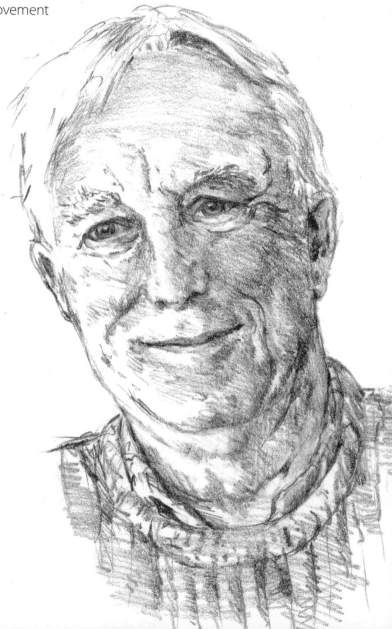

With a closed-mouth smile, there is a sideways tension that pulls the mouth out slightly and compresses the lips, with the cheeks rising slightly. Most people show their teeth when they smile, revealing varying amounts of tooth and gum, with the top lip straight across and the lower lip curved in the classic smile shape. Correctly shading the teeth is the key here—avoid harsh outlines.

Note how the cheeks rise, crinkling the eye area. Some people, especially models and actors, tighten the lower lip downward as they smile, minimizing the distortion of the eye area and revealing less of the upper teeth and gums. With a big, open-mouthed smile—as when laughing or expressing surprise—the point of the chin drops as the muscles of the face pull upward and outward.

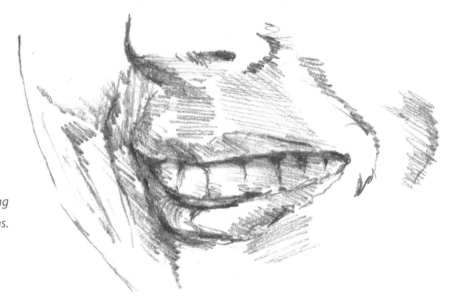

Practice drawing various expressions.

ASSIGNMENT: PRACTICE THE MOUTH

Draw a page of mouths from all kinds of angles and in different expressions. Look for interesting subjects of different ages and nationalities. Avoid bland magazine photographs, as the lighting won't help you. Remember that lips are three-dimensional, not flat across the face.

Drawing Skin

What tonal value should you use when drawing skin? This is as impossible to answer as the related question from painters, "What color is skin?" This is because the values change so dramatically, according to the light, environment, and the ethnic background of the subject. Don't look for a blanket solution. Just observe your subject, noting all the values you can see. Be sure to observe small areas, from highlight to darkest shadow, and represent these accurately. Don't be afraid to use very light or very dark values on skin, no matter if you are drawing an albino or an Afro-Caribbean. If it looks dark, draw it dark; if it looks light, draw it light!

When doing a value drawing of a baby, use a very smooth paper, as the coarse texture of sketch paper doesn't lend itself well to the fine, even values that are needed for a baby's perfect skin.

When drawing adults, observe how the wrinkles on their faces follow the form of the skull beneath, and be careful to draw them accurately. Be sensitive to the vanity of your sitter—some might prefer a more subtle rendering of laugh lines, however charming you find them as an artist! You can draw freckles, moles, and other marks as well; this depends on whether you are drawing a structural, modeled sketch or a value drawing that focuses on surface detail.

When traveling, make sure you are aware of any customs with regard to image-making and portraiture. Some religions, for instance, forbid or disapprove of portrait images, while some cultures find representations of people who have died to be offensive.

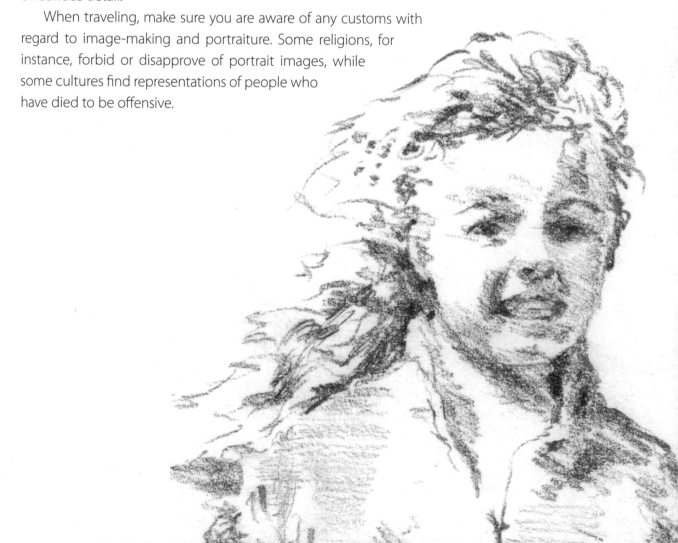

Self-Portrait

Aim: To practice drawing the face and to explore self-image

Materials: Mirror, large-size sketchbook or paper and drawing board, drawing materials (ink, graphite, or charcoal)

Time: 2 hours

Set Up: Use as large a mirror as you have available, ideally a dresser mirror. A tall kitchen stool may be high enough for comfortable drawing using a bathroom mirror. Preferably, work on paper larger than size A4 to allow for generous mark-making and expression. Use a portable light source such as a lamp or flashlight to improve lighting if necessary. Consider the points discussed earlier in this chapter, and try to use pose, expression, lighting, and environment creatively.

Start Drawing: Begin with a structural drawing, establishing correct proportions, then begin contour drawing. Be sure to line up the eyes correctly. Sketch lightly at first, then develop the drawing. Quickly establish some strong darks once you begin modeling the form. You can use strong directional hatching or shaded tonal value drawing, whichever you prefer.

Portrait Study with Reflected Light

Aim: To create a portrait carefully observing the fall of light—highlight, reflected light, and shadow

Materials: Size A4 paper; HB, 2B, and 4B pencils; eraser; blending stump; model or photograph

Time: 1 to 3 hours

Set Up: You will need to arrange your model so that she has reflected light on part of her face. Position the sitter so that you have strong, direct light from one side, with visible reflected light on the other—for example, coming from a painted wall. Alternatively, a white T-shirt worn in sunlight can provide good reflected light on the throat and chin. You could also try having the model sit under a reading lamp, holding a book.

Start Drawing: Lightly sketch the structure of your model's head and shoulders, taking your time and cross-referencing key points using the "thumb and pencil" method. Build the form and add the shading, closely observing the values. Make sure that the core shadow—probably along the side of the nose and cheek and under the point of the chin—is dark enough. Look closely for areas of reflected light. Chances are that you will initially shade these too dark, since they look to be in a shadow. Use an eraser to lift out lighter areas, working back over them if necessary.

Drawing Hair

How you handle the hair can make or break a portrait drawing. It deserves at least as much attention as the rest of your drawing, and sometimes requires more. Short hair is relatively straightforward to draw, with short, flicking pencil-strokes working against the direction of growth, using "negative space" drawing to reserve light hairs. If you look at Chapter 12, there are several examples of fur drawn using this same technique.

Long Hair

The trick with drawing long hair is that rather than trying to draw every strand, you draw the hair in "ribbons." Drawing the light and shadow that falls on these ribbons of hair, then separating out strands by drawing the shadows between them, results in natural-looking, three-dimensional hair. Ideally, the model should have well-conditioned, styled hair that falls naturally into curls or wedges. Good lighting, as always, can help to make the artist's job easier, creating highlights and shadows.

Drawing Hair

1 Look at the hair and identify the main shapes, sketching the separate sheets or ribbons of hair that you can identify. When starting, ignore stray strands.

2 Look for the darkest areas and shade those in, feathering off toward lighter areas and being careful to reserve highlights.

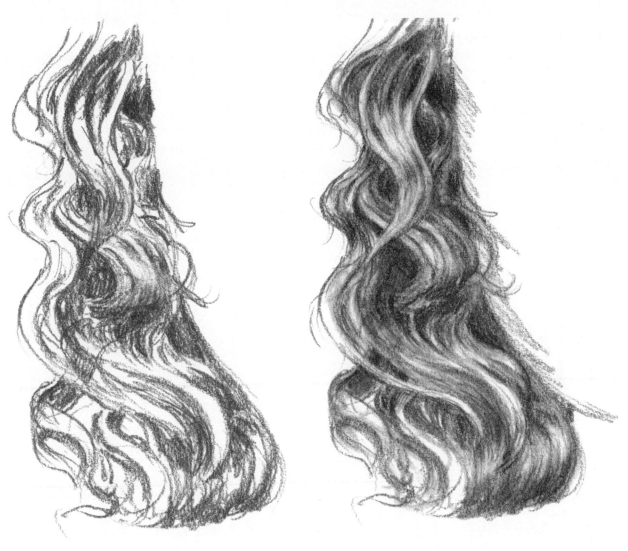

3 Shade the main values of the hair, reserving highlights and working along the direction of hair growth. You can blend these with a stump for a smooth sheen. Lift off lighter areas with an eraser, smudging slightly toward the edges of highlights.

4 Work in any strands of dark along the hair, adding texture, carrying a few strokes through areas of highlight—but not too many, just enough to create texture. Use a harder pencil to graduate some areas of tone and to strengthen dark values. You can add a few stray hairs with pencil strokes and erased highlights to create a softer effect.

The Background

An important function of the background in portraiture is to blend or contrast with the foreground.

This depends on the pose—a well-lit profile against a dark background works well, while hair highlights dropping into a white area can create an airy feel. A vague halo of shading added to a portrait is seldom successful. If you don't want to attempt a background, leave the background a crisp white. However, if your source photo is lit with a front flash, this can make it difficult to model the form, as the white highlights are in the foreground and the white paper tends to sit on the same visual plane. Most portraitists favor a background of middle to dark value because it enables them to use shading and softened detail to model the form of the figure. A more complex background, whether outdoors or inside, can work well, but keep it as simple as possible when you start out.

Whichever approach you favor, the background deserves as much attention as any other part of the drawing. There is no point in pouring hours of tender loving care into the rest of your portrait, only to do a vague scribbled background. The energy in briskly applied marks actually draws the eye away from more detailed areas of the drawing, too, making the contrast doubly apparent.

Chapter 14

Figure Drawing

People are fascinating subjects. Part of what makes them so interesting to draw—their variety and individuality—is also what makes them so difficult to draw. There are no rules or formulas that are of much help with figure drawing, as every person and every pose is so unique. It's important not to feel anxious when drawing people. Take a mental step back and look at people as a collection of shapes and values, and you'll soon be drawing them as confidently as any other subject.

It is certainly true that figure drawing is wonderful training, but if you don't have access to a figure-drawing class, it doesn't spell doom for your artistic ability. Practice drawing arms, hands, feet, heads, and the clothed figure. Visit an art gallery and draw from sculptures, and use swimwear catalogues and sports magazines as reference material.

Approaching Figure Drawing

The human figure can be complex and challenging, but like any other object, it can be simplified into basic structures. Because the body changes so dramatically with every pose, the approach needed to create this simple structure must be modified for every drawing. The sheer size of the human body can cause problems. First, you need to stand far away enough to be able to see the whole pose clearly. Then there is the mental baggage that we take to figure drawing—expectations of how the figure ought to look overriding our short-term visual memory as we draw. Using strategies like blind contour drawing, "thumb and pencil" measurement, and negative-space drawing can help you develop the habit of accurately seeing the subject.

Babies are delightful, but difficult, subjects to draw.

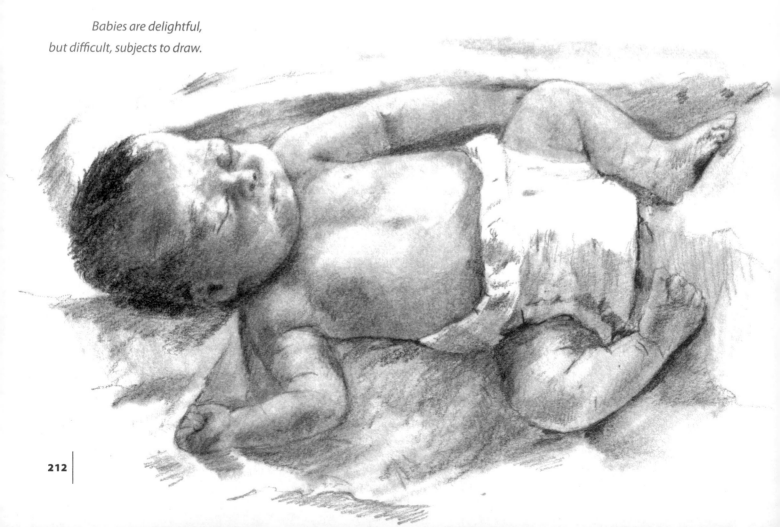

Proportions of the Body

Traditional rules of proportion state that the average human figure is seven and a half heads tall, though seven might be more realistic for many. Heroic figures are drawn eight heads tall, with the extra length in the chest and legs, and classical Gods (and superheroes) can reach nine heads. If using these proportions, be careful not to make the head look too small. Fashion models are also drawn exceptionally tall and thin, with extra length in the legs, through the center of the torso, and neck. The fingertips should reach about one-third down the thigh.

The standard figure, seven and a half heads tall.

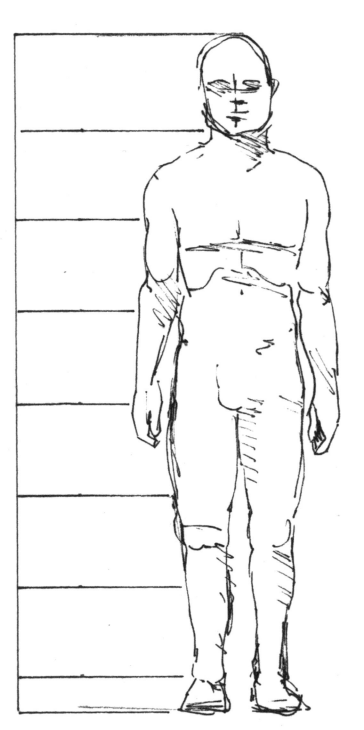

The head is a useful unit of measure in figure drawing, but you need to use it to check the relative placement of actual details on the figure. It is a good idea to establish the proportions of the figure first, ensuring that you will fit the whole figure on the page and avoid awkward cropping.

Remember that people have different body shapes, too. Often when constructing figures from imagination, you will follow unrealistic fashion-doll or cartoon-character proportions. Taking these artificial ideas into life drawing can be a hindrance, as the idealized forms usually diverge a great deal from actual shapes that you find on a real human.

Simplified sketches of the torso

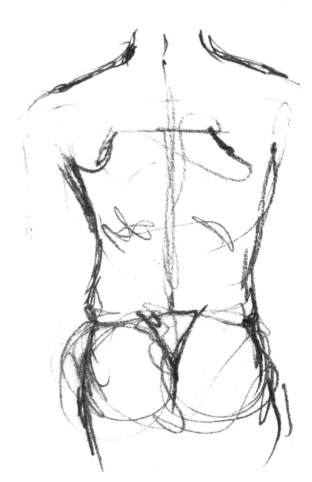

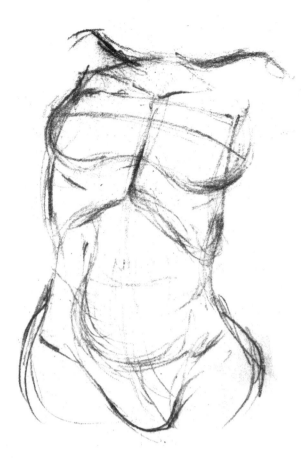

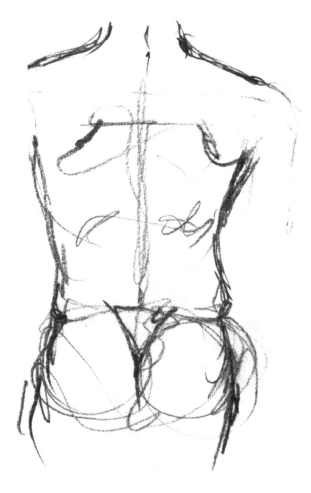

ASSIGNMENT: SEE-THROUGH

Try "seeing through" figures in photographic references, and sketching the imaginary unclothed figure. Look for models of varying body types. Don't try this with real people (except perhaps your spouse), as they are likely to take offense at even imaginary x-ray glasses!

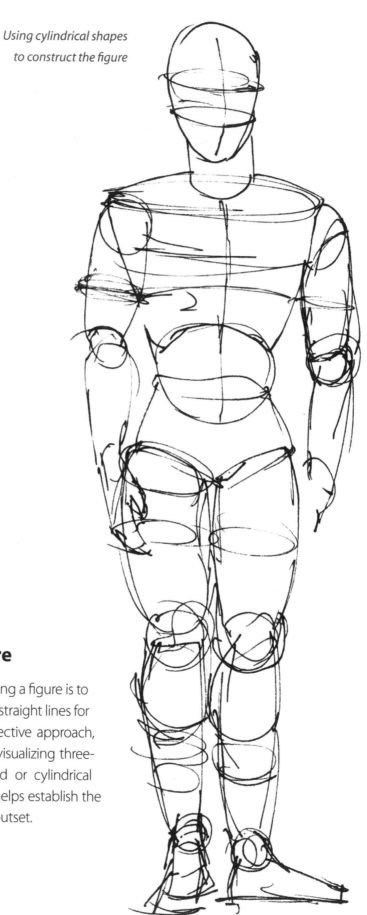

Using cylindrical shapes to construct the figure

Structuring the Figure

The most basic way of structuring a figure is to use the stick-figure approach, with straight lines for bones and ball joints. A more effective approach, especially if you need to practice visualizing three-dimensional form, is to use ovoid or cylindrical shapes to build up the form. This helps establish the sense of a form in space from the outset.

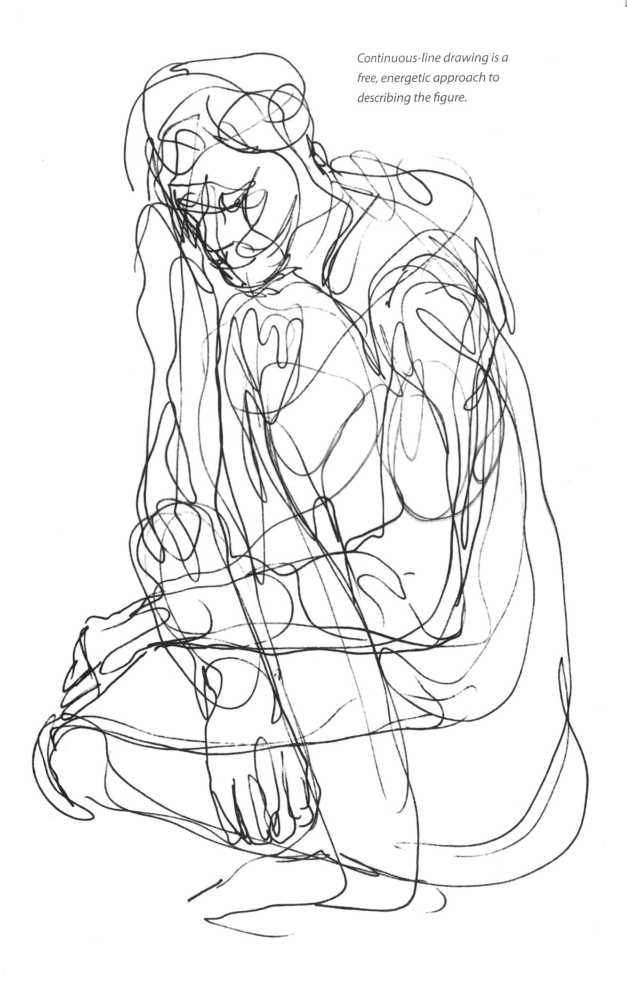

Continuous-line drawing is a free, energetic approach to describing the figure.

ASSIGNMENT: CONTINUOUS-LINE DRAWING

When combining contour, cross-contour, and structural drawing, a smooth, continuous line is used to rapidly describe the outline and form of the figure. Try drawing a figure using this approach.

ASSIGNMENT: SHADED CONTOUR DRAWING

Use the "thumb and pencil" method to build a correctly proportioned framework before commencing a detailed contour drawing. Use shading to describe the form of the model.

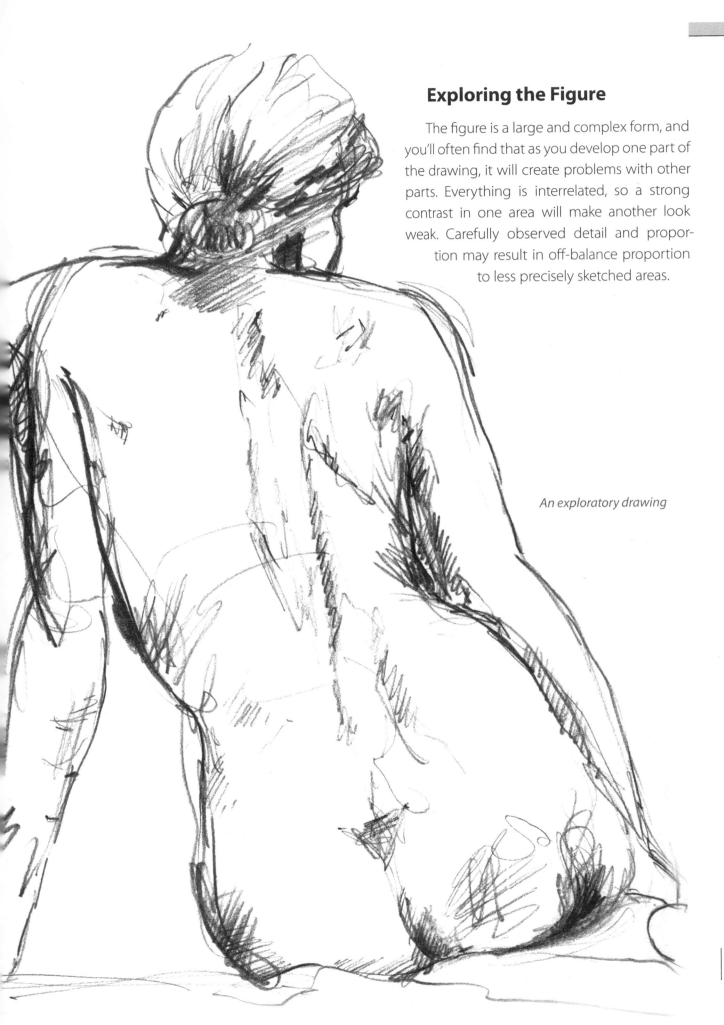

Exploring the Figure

The figure is a large and complex form, and you'll often find that as you develop one part of the drawing, it will create problems with other parts. Everything is interrelated, so a strong contrast in one area will make another look weak. Carefully observed detail and proportion may result in off-balance proportion to less precisely sketched areas.

An exploratory drawing

Drawing Hands

The hands can be difficult to draw, with their complex collection of bones, joints, tendons, and small muscles. However, you only need one hand to draw, which leaves you with your nondominant hand as a captive subject, so get plenty of practice drawing the hand in as many postures as you can devise. Try making expressive gestures and holding objects.

When figure drawing, remember to handle the whole figure equally. A common fault is to pay too much attention to the hands, so that they are overworked in comparison to the rest of the drawing. This is especially true of toenails and fingernails—only suggest them, don't outline them.

Rather than drawing each finger in isolation, remember that they are joined together and tend to operate as a group. To simplify drawing the hand, imagine it as a complete unit, contained as if enclosed in a mitten. Look for the big forms—the planes across the fingers, the plane of the hand, the ball of the thumb. Sketch these structural units first before defining individual fingers.

Using simplified shapes to establish the structure of the hand

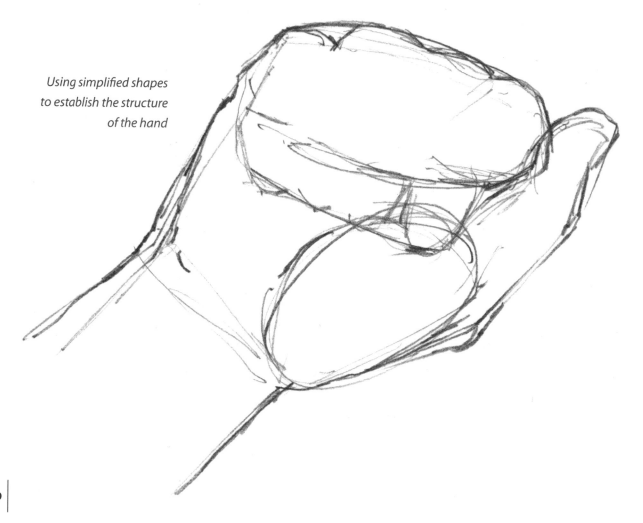

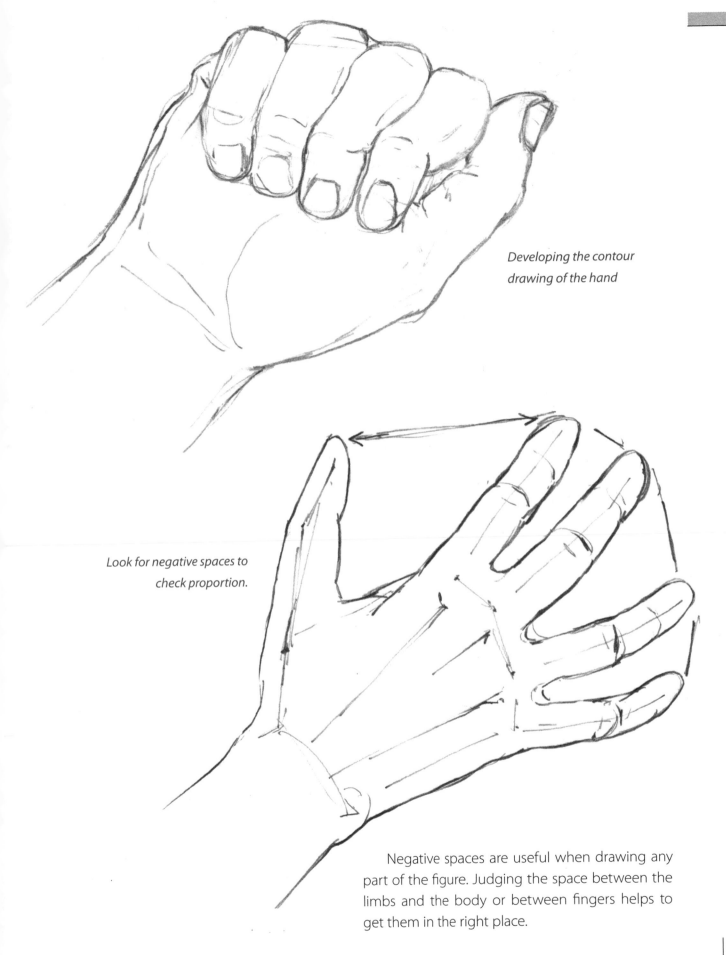

Developing the contour drawing of the hand

Look for negative spaces to check proportion.

Negative spaces are useful when drawing any part of the figure. Judging the space between the limbs and the body or between fingers helps to get them in the right place.

Drawing Feet

Feet are awkward to draw, often inelegant and stumpy looking. The toes look strange and misshapen, and the broad form of the middle of the foot looks too large and shapeless. You can resolve these problems by simplifying the foot and observing the changes of the plane along its form. The top of the foot, when lit by overhead lighting, looks featureless in a drawing, so it seems too large and flat. By observing the shape of the form and by using directional hatching or cross-contours to suggest the shape, you can create a much more three-dimensional drawing. Sketch the toes as a single block, then indicate the separations. As with hands, give the feet a similar amount of attention as the rest of the figure. However, as the support that holds the figure up, they do attract the eye. Practice drawing feet from every angle so that you can give your figure a secure grip on the earth.

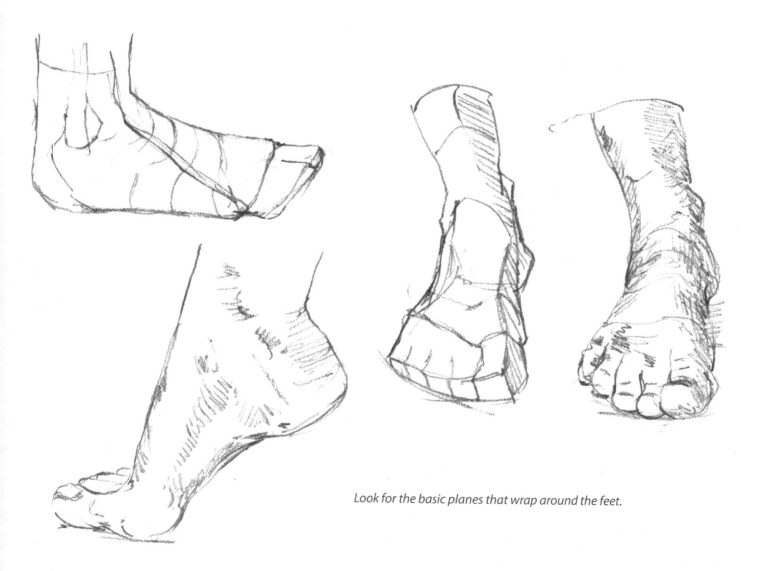

Look for the basic planes that wrap around the feet.

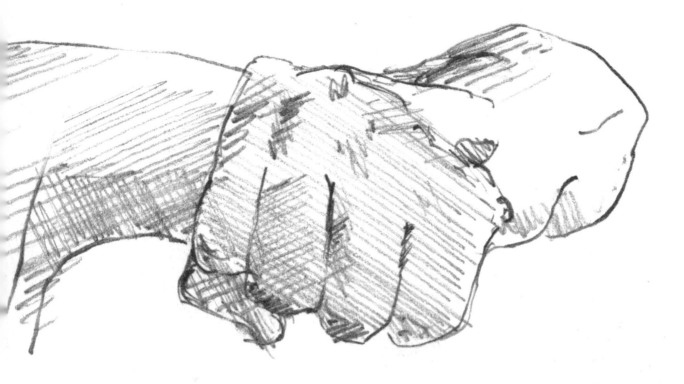

Foreshortening

Foreshortening is another problem area for artists. The trick is not to let it daunt you, but to trust your eyes and draw exactly what you see. Beware of parallax, that is, the different view that your two eyes see. Close your nondominant eye when drawing a foreshortened area, so that the further elements stay in the same position relative to the near ones.

Line weight is useful when drawing a foreshortened area. Lines delineating elements that are farther away lighten as a heavy line cuts in front of them, suggesting that they are dropping behind the heavier line. Closer parts of the model may tend to look a little larger than those behind, and can be more crisply defined. When you commence drawing, the shapes formed by foreshortened parts of the body may look odd and out of proportion, but you'll find that as you complete the drawing they will all begin to fit together and make sense.

Attending a Figure-Drawing Class

If you are over eighteen and are keen to learn to draw the figure, attending a class is the best idea. Many colleges and community centers run figure-drawing classes with tuition, and you can also find artist's groups with figure-drawing workshops, which may not have an instructor.

Make sure you know what materials are required. Usually this will include large paper, bulldog clips, possibly your own drawing board, charcoal, and a kneaded eraser. Always arrive on time—your session with the model is valuable, and you don't want to waste your time or others'. This might seem obvious, but you'd be amazed how often students wander in fifteen minutes after class commences.

A two-hour figure drawing class may include several thirty-second and one-minute warmup poses for gestural and structural sketches, a twenty-minute pose for more developed drawing, and one or two long poses.

Some drawing classes will include very long poses to enable students to create very detailed value drawings. Classical ateliers may return to the same pose continually for several sessions.

Alert

Drawing at an easel can be tiring when you aren't used to it. Practice drawing for an hour on an easel or on a wall at home the week before your life class, and take a sketchbook to work in, should your drawing arm get too sore.

Perhaps you feel uneasy about a class with a nude person modeling? There is no need—just remember that your model is probably a professional who is quite accustomed to posing for artists. Modeling is much harder than you imagine, and a good professional model is hard to find. They are experienced at finding good poses and holding poses for a long period. The majority of models are female, but a good drawing class will try to obtain a male model on occasion. Once you start drawing, you'll find that you are so busy studying the shapes and forms that you soon forget any embarrassment.

If you have an instructor, he or she will provide you with guidance and may have a structured course in place. Students often discuss their work with each other, which is a great opportunity to exchange ideas.

Sketching People in Action

The best way to gain confidence and develop skills in drawing people in action is to draw them! Carry a sketchbook everywhere and use every opportunity to practice on the people around you. Watch your subjects as they move, and make quick assessments as to their proportions, direction of movement, and balance.

Quickly jot down the essentials. At first, you might find that you can only remember enough to get the general direction of limbs and torso, but with practice, your visual memory will improve.

When sketching figures playing sports, try to draw balls, bats, and other equipment in a similar fashion to the figure, within reason. This helps to create a sense of unity in the composition. Shadows, action lines, or a sketched indication of background or surface can help to connect elements (figures, balls, goalposts, distant spectators) in the picture. It is important to include items that make sense in a scene. If someone has just kicked a ball, for example, include the ball in the picture, preferably close enough to relate to the figure—otherwise you'll have an off-balance figure caught midaction for no apparent reason.

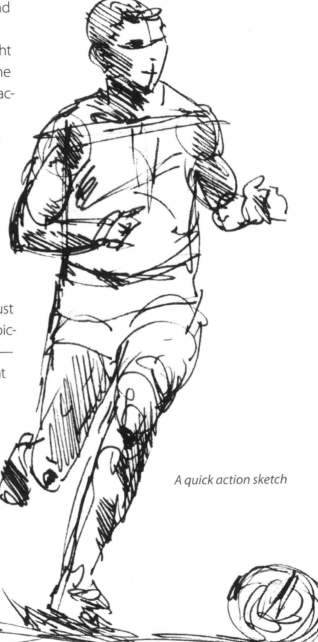

A quick action sketch

Dramatic composition, foreshortening, directional lines, and motion blurs can be used to develop the sense of movement in an action sketch. The look of a motion blur, common in photography, needs to make sense when used in drawing—don't randomly smudge parts of the drawing. A blur occurs when something is moving faster than the camera shutter, blurring more the faster it moves, or when the camera is panned during a slower shot. The eye is familiar with this photographic convention, so you need to follow similar rules to make it work in drawing. To begin, use a photograph as a reference so you can see how the effect should look for your particular subject.

When drawing distant figures, you only need to suggest the main forms. Remember to reserve highlights. Sometimes all it takes is just a smudge to suggest eye sockets, or sometimes you may just want to suggest the shadow of the face. Often there is very little observable detail, so don't try to include too much information; too much detail can result in a heavy, awkward figure.

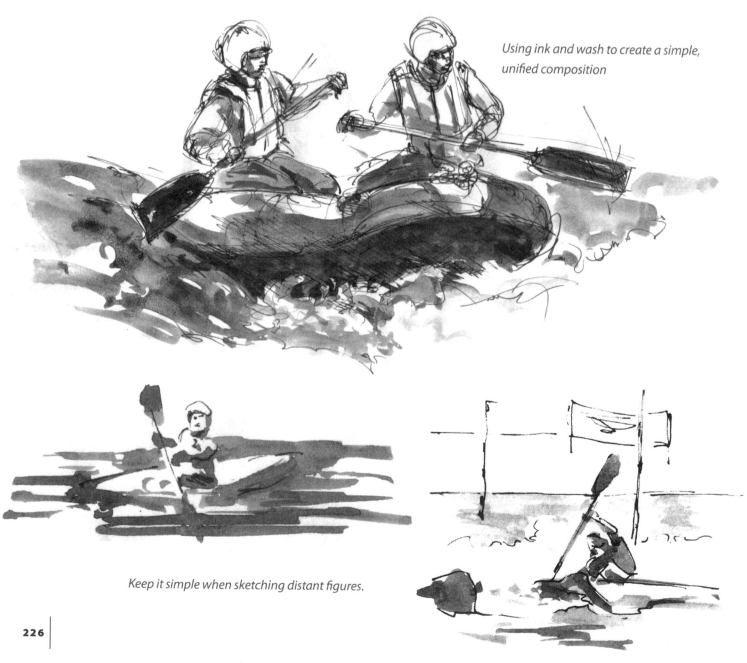

Using ink and wash to create a simple, unified composition

Keep it simple when sketching distant figures.

Studying Anatomy

The study of anatomy is a whole field in itself, which some art courses focus on in great detail and others almost completely neglect. Many artists get by fine without it, but if you are serious about figure drawing, you will need to get familiar with the structure and function of the human skeleton and musculature.

Spend some time observing how each joint of the body moves, bending or rotating. For example, you will observe that the knees are essentially a unidirectional joint, with any change in the lateral angle of the leg coming from the hip joint, which is much more mobile in most women than in men. In practice, this means that the foot will point in the same direction as the kneecap, though on occasion you'll notice a fair bit of twist in the ankle, as in the case of sportspeople, or from the hip, in the case of dancers.

The torso also moves through a fairly limited range, as the spine is not very flexible. The hip structure and rib cage are basically solid forms, that have a limited range of movement relative to each other. In contrast, the shoulder joint is held in place by a complex network of muscle and sinew, making it remarkably mobile. Closely study the behavior of the shoulder blade and associated musculature as the arm goes through a range of movement.

ASSIGNMENT: STUDYING ANATOMY

Using any photographic anatomy references from the library or Internet, embark on a study of human anatomy. You might even like to purchase a scale model of the skeleton. Do a little sketching each day if you can. Begin with detailed studies of the skull. Do a structural sketch, a contour and detailed value drawing of the skull from several different angles. Draw studies of hands, feet, torso, and the complete skeleton, and sketch the main musculature of the body. Don't worry about naming the parts unless you find this helps you to remember the forms.

Composing Figure Drawings

There are many creative possibilities for composing pictures of people. People don't exist in a vacuum, and giving your figure an environment in which to act can make for an interesting composition.

To emphasize a sense of forward movement—a ball about to be passed, a runner surging from the blocks, a ball about to leave the player's hand—allow room in front of your subject, giving the figure a space to move into. Often, as we read left-to-right, this will work most effectively with the figure on the left of the page, moving toward the right.

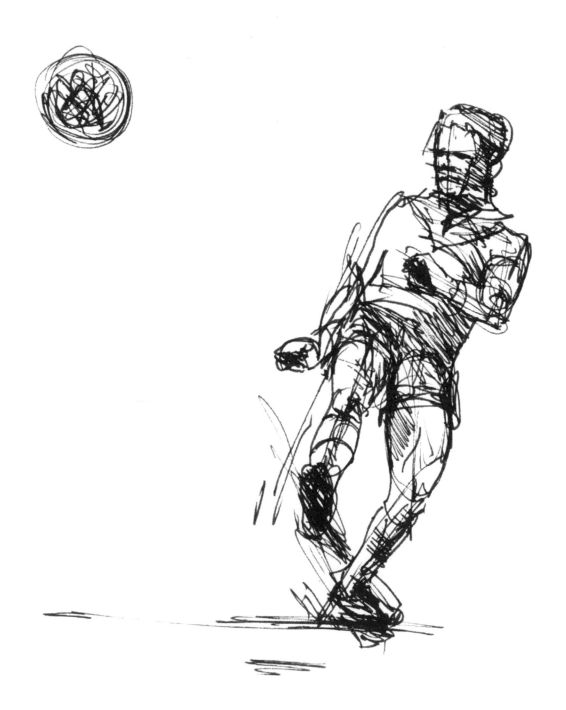

Create a feeling of moving away, or arrested movement—a backward glance over the shoulder, a dive into first base, a dancer landing on cue. You might imply where your figure has been, directing the viewer's eye to travel through the space that the figure has traveled, coming to rest where the figure does; perhaps even indicate the arc of movement with directional mark-making. Exaggerated perspective can add a feeling of drama to a picture. Strong foreshortening, when one element of the figure is much closer to the picture plane than another figure, also helps to create a strong sense of three-dimensional form.

Props can be useful, and they are often essential to make sense of a pose, such as when the model is sitting or leaning. Without the object that the model is sitting on or leaning against, the model will look awkward and unbalanced. Props and background elements also offer the opportunity to frame or counterbalance elements of the composition. Do try to ensure that they make sense: Often, you'll see nude figures set up in an interior.

alert

Check that you have correct perspective when placing figures in a setting. Project orthogonals through doorways or place natural features to cross-reference the correct height for your figure's location on the picture plane.

ASSIGNMENT: UNUSUAL LIGHTING

Draw some figures using unnatural or unusual lighting situations: someone in a darkened room in front of a computer screen or television, someone holding a candle, or someone sitting in front of a campfire. Challenge yourself to faithfully record the play of light on each face. For inspiration, take a look at the drawings of Degas.

Appendix

Resources

Here is a brief listing of books and Web sites that are quite helpful for expanding your knowledge of drawing techniques and methods.

Books

Drawing Realistic Textures in Pencil by J.D. Hillberry (Cincinnati: North Light Books, 1999). For assistance achieving the right look using pencil, refer to this book to examine the role of texture in your pieces.

How to Draw What You See by Rudy De Reyna (New York: Watson-Guptill, 1996). Just as the title implies, this text is packed full of useful information, both practical and easy to digest.

Keys to Drawing by Bert Dodson (Cincinnati: North Light Books, 1990). Use this book as a quick go-to guide for drawing help.

The New Drawing on the Right Side of the Brain by Betty Edwards (New York: Putnam Publishing Group, 1999). Sharing lots of insightful information on the brain and drawing, Edwards' bestselling book offers stellar troubleshooting advice.

Perspective Made Easy by Ernest Norling (New York: Dover Publications, 1999). An important concept to learning how to draw, in this text, perspective is explained in simple, yet engaging terms.

Web Sites

www.drawsketch.about.com. As the About.com's guide for drawing and sketching, I offer advice and tips relating to a variety of art topics on this site.

www.drawingcenter.org. This site offers a plethora of services, including exhibit listings, services for artists, and educational resources.

www.learn-to-draw.com. This is a useful text providing definitions and examples of drawing methods and applications.

www.portrait-artist.org. This site offers lessons for creating portraits as well as other techniques useful to artists.

www.wetcanvas.com. A smorgasbord of topics can be found here—from projects and techniques to art history and art business topics.

www.sibleyfineart.com. Mike Sibley is a master of realism, specializing in canine portraits. He shares his expertise in an extensive "studio tips" section.

Index

THE EVERYTHING SERIES!

BUSINESS

Everything® Business Planning Book
Everything® Coaching and Mentoring Book
Everything® Fundraising Book
Everything® Home-Based Business Book
Everything® Landlording Book
Everything® Leadership Book
Everything® Managing People Book
Everything® Negotiating Book
Everything® Online Business Book
Everything® Project Management Book
Everything® Robert's Rules Book, $7.95
Everything® Selling Book
Everything® Start Your Own Business Book
Everything® Time Management Book

COMPUTERS

Everything® Computer Book

COOKBOOKS

Everything® Barbecue Cookbook
Everything® Bartender's Book, $9.95
Everything® Chinese Cookbook
Everything® Chocolate Cookbook
Everything® Cookbook
Everything® Dessert Cookbook
Everything® Diabetes Cookbook
Everything® Fondue Cookbook
Everything® Grilling Cookbook
Everything® Holiday Cookbook
Everything® Indian Cookbook
Everything® Low-Carb Cookbook
Everything® Low-Fat High-Flavor
 Cookbook
Everything® Low-Salt Cookbook
Everything® Mediterranean Cookbook
Everything® Mexican Cookbook
Everything® One-Pot Cookbook
Everything® Pasta Cookbook
Everything® Quick Meals Cookbook
Everything® Slow Cooker Cookbook
Everything® Soup Cookbook
Everything® Thai Cookbook
Everything® Vegetarian Cookbook
Everything® Wine Book

HEALTH

Everything® Alzheimer's Book
Everything® Anti-Aging Book
Everything® Diabetes Book
Everything® Dieting Book
Everything® Hypnosis Book
Everything® Low Cholesterol Book
Everything® Massage Book
Everything® Menopause Book
Everything® Nutrition Book
Everything® Reflexology Book
Everything® Reiki Book
Everything® Stress Management Book
Everything® Vitamins, Minerals, and
 Nutritional Supplements Book

HISTORY

Everything® American Government Book
Everything® American History Book
Everything® Civil War Book
Everything® Irish History & Heritage Book
Everything® Mafia Book
Everything® Middle East Book

HOBBIES & GAMES

Everything® Bridge Book
Everything® Candlemaking Book
Everything® Card Games Book
Everything® Cartooning Book
Everything® Casino Gambling Book,
 2nd Ed.
Everything® Chess Basics Book
Everything® Crossword and Puzzle Book
Everything® Crossword Challenge Book
Everything® Drawing Book
Everything® Digital Photography Book
Everything® Easy Crosswords Book
Everything® Family Tree Book
Everything® Games Book
Everything® Knitting Book
Everything® Magic Book
Everything® Motorcycle Book
Everything® Online Genealogy Book
Everything® Photography Book

Everything® Poker Strategy Book
Everything® Pool & Billiards Book
Everything® Quilting Book
Everything® Scrapbooking Book
Everything® Sewing Book
Everything® Soapmaking Book

HOME IMPROVEMENT

Everything® Feng Shui Book
Everything® Feng Shui Decluttering Book,
 $9.95
Everything® Fix-It Book
Everything® Homebuilding Book
Everything® Home Decorating Book
Everything® Landscaping Book
Everything® Lawn Care Book
Everything® Organize Your Home Book

EVERYTHING® KIDS' BOOKS

All titles are $6.95

Everything® Kids' Baseball Book, 3rd Ed.
Everything® Kids' Bible Trivia Book
Everything® Kids' Bugs Book
Everything® Kids' Christmas Puzzle
 & Activity Book
Everything® Kids' Cookbook
Everything® Kids' Halloween Puzzle
 & Activity Book
Everything® Kids' Hidden Pictures Book
 Everything® Kids' Joke Book
Everything® Kids' Knock Knock Book
Everything® Kids' Math Puzzles Book
Everything® Kids' Mazes Book
Everything® Kids' Money Book
Everything® Kids' Monsters Book
Everything® Kids' Nature Book
Everything® Kids' Puzzle Book
Everything® Kids' Riddles & Brain Teasers
 Book
Everything® Kids' Science Experiments
 Book
Everything® Kids' Soccer Book
Everything® Kids' Travel Activity Book

All Everything® books are priced at $12.95 or $14.95, unless otherwise stated. Prices subject to change without notice.

KIDS' STORY BOOKS

Everything® Bedtime Story Book
Everything® Bible Stories Book
Everything® Fairy Tales Book

LANGUAGE

Everything® Conversational Japanese Book (with CD), $19.95
Everything® Inglés Book
Everything® French Phrase Book, $9.95
Everything® Learning French Book
Everything® Learning German Book
Everything® Learning Italian Book
Everything® Learning Latin Book
Everything® Learning Spanish Book
Everything® Sign Language Book
Everything® Spanish Phrase Book, $9.95
Everything® Spanish Verb Book, $9.95

MUSIC

Everything® Drums Book (with CD), $19.95
Everything® Guitar Book
Everything® Home Recording Book
Everything® Playing Piano and Keyboards Book
Everything® Rock & Blues Guitar Book (with CD), $19.95
Everything® Songwriting Book

NEW AGE

Everything® Astrology Book
Everything® Dreams Book
Everything® Ghost Book
Everything® Love Signs Book, $9.95
Everything® Meditation Book
Everything® Numerology Book
Everything® Paganism Book
Everything® Palmistry Book
Everything® Psychic Book
Everything® Spells & Charms Book
Everything® Tarot Book
Everything® Wicca and Witchcraft Book

PARENTING

Everything® Baby Names Book
Everything® Baby Shower Book
Everything® Baby's First Food Book
Everything® Baby's First Year Book
Everything® Birthing Book
Everything® Breastfeeding Book
Everything® Father-to-Be Book

Everything® Get Ready for Baby Book
Everything® Getting Pregnant Book
Everything® Homeschooling Book
Everything® Parent's Guide to Children with Asperger's Syndrome
Everything® Parent's Guide to Children with Autism
Everything® Parent's Guide to Children with Dyslexia
Everything® Parent's Guide to Positive Discipline
Everything® Parent's Guide to Raising a Successful Child
Everything® Parenting a Teenager Book
Everything® Potty Training Book, $9.95
Everything® Pregnancy Book, 2nd Ed.
Everything® Pregnancy Fitness Book
Everything® Pregnancy Nutrition Book
Everything® Pregnancy Organizer, $15.00
Everything® Toddler Book
Everything® Tween Book

PERSONAL FINANCE

Everything® Budgeting Book
Everything® Get Out of Debt Book
Everything® Homebuying Book, 2nd Ed.
Everything® Homeselling Book
Everything® Investing Book
Everything® Online Business Book
Everything® Personal Finance Book
Everything® Personal Finance in Your 20s & 30s Book
Everything® Real Estate Investing Book
Everything® Wills & Estate Planning Book

PETS

Everything® Cat Book
Everything® Dog Book
Everything® Dog Training and Tricks Book
Everything® Golden Retriever Book
Everything® Horse Book
Everything® Labrador Retriever Book
Everything® Poodle Book
Everything® Puppy Book
Everything® Rottweiler Book
Everything® Tropical Fish Book

REFERENCE

Everything® Car Care Book
Everything® Classical Mythology Book
Everything® Einstein Book
Everything® Etiquette Book
Everything® Great Thinkers Book

Everything® Philosophy Book
Everything® Psychology Book
Everything® Shakespeare Book
Everything® Toasts Book

RELIGION

Everything® Angels Book
Everything® Bible Book
Everything® Buddhism Book
Everything® Catholicism Book
Everything® Christianity Book
Everything® Jewish History & Heritage Book
Everything® Judaism Book
Everything® Koran Book
Everything® Prayer Book
Everything® Saints Book
Everything® Understanding Islam Book
Everything® World's Religions Book
Everything® Zen Book

SCHOOL & CAREERS

Everything® After College Book
Everything® Alternative Careers Book
Everything® College Survival Book
Everything® Cover Letter Book
Everything® Get-a-Job Book
Everything® Job Interview Book
Everything® New Teacher Book
Everything® Online Job Search Book
Everything® Personal Finance Book
Everything® Practice Interview Book
Everything® Resume Book, 2nd Ed.
Everything® Study Book

SELF-HELP/ RELATIONSHIPS

Everything® Dating Book
Everything® Divorce Book
Everything® Great Sex Book
Everything® Kama Sutra Book
Everything® Self-Esteem Book

SPORTS & FITNESS

Everything® Body Shaping Book
Everything® Fishing Book
Everything® Fly-Fishing Book
Everything® Golf Book
Everything® Golf Instruction Book
Everything® Knots Book
Everything® Pilates Book
Everything® Running Book
Everything® T'ai Chi and QiGong Book

All Everything® books are priced at $12.95 or $14.95, unless otherwise stated. Prices subject to change without notice.

Everything® Total Fitness Book
Everything® Weight Training Book
Everything® Yoga Book

TRAVEL

Everything® Family Guide to Hawaii
Everything® Family Guide to New York City, 2nd Ed.
Everything® Family Guide to Washington D.C., 2nd Ed.
Everything® Family Guide to the Walt Disney World Resort®, Universal Studios®, and Greater Orlando, 4th Ed.
Everything® Guide to Las Vegas
Everything® Guide to New England

Everything® Travel Guide to the Disneyland Resort®, California Adventure®, Universal Studios®, and the Anaheim Area

WEDDINGS

Everything® Bachelorette Party Book, $9.95
Everything® Bridesmaid Book, $9.95
Everything® Creative Wedding Ideas Book
Everything® Elopement Book, $9.95
Everything® Father of the Bride Book, $9.95
Everything® Groom Book, $9.95
Everything® Jewish Wedding Book
Everything® Mother of the Bride Book, $9.95
Everything® Wedding Book, 3rd Ed.
Everything® Wedding Checklist, $7.95
Everything® Wedding Etiquette Book, $7.95

Everything® Wedding Organizer, $15.00
Everything® Wedding Shower Book, $7.95
Everything® Wedding Vows Book, $7.95
Everything® Weddings on a Budget Book, $9.95

WRITING

Everything® Creative Writing Book
Everything® Get Published Book
Everything® Grammar and Style Book
Everything® Grant Writing Book
Everything® Guide to Writing a Novel
Everything® Guide to Writing Children's Books
Everything® Screenwriting Book
Everything® Writing Well Book

Introducing an exceptional new line of beginner craft books from the *Everything*® series!

EVERYTHING C·R·A·F·T·S®

All titles are $14.95.

Everything® Crafts—Create Your Own Greeting Cards
1-59337-226-4

Everything® Crafts—Polymer Clay for Beginners
1-59337-230-2

Everything® Crafts—Rubberstamping Made Easy
1-59337-229-9

Everything® Crafts—Wedding Decorations and Keepsakes
1-59337-227-2

Available wherever books are sold!
To order, call 800-872-5627, or visit us at *www.everything.com*
Everything® and everything.com® are registered trademarks of F+W Publications, Inc.